SHADOWS ON GLASS
The Indian World of Ben Wittick

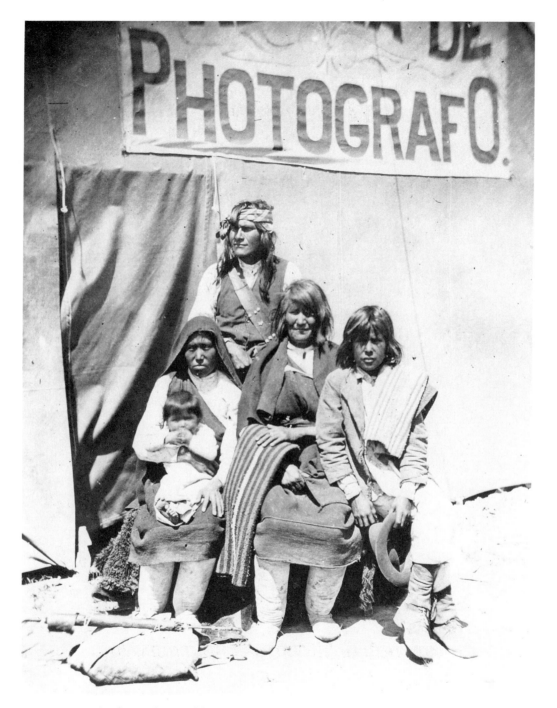

Group of Indians, Isleta Pueblo. C. 1885. Photo: School of American Research

Collections in the Museum of New Mexico, Santa Fe

SHADOWS ON GLASS

The Indian World of Ben Wittick

□

Patricia Janis Broder

□ □ □

Foreword by
Frederick J. Dockstader

Rowman & Littlefield Publishers, Inc.

ROWMAN & LITTLEFIELD PUBLISHERS, INC.

Published in the United States of America
by Rowman & Littlefield Publishers, Inc.
8705 Bollman Place, Savage, Maryland 20763

British Cataloging in Publication Information Available

Library of Congress Cataloging-in-Publication Data

Broder, Patricia Janis.
Shadows on glass : the Indian world of Ben Wittick /
Patricia Janis Broder ; foreword by Frederick J. Dockstader.
p. cm.
Includes bibliographical references (p.).
1. Indians of North America—Southwest, New—
Pictorial works. 2. Wittick, Ben, 1843–1903.
I. Wittick, Ben 1845–1903. II. Title.
E78.S7B75 1990 305.8'97079—dc20 89–27731 CIP

ISBN 0-8476-7631-5
ISBN 0-8476-7701-X (pbk. alk. paper)

Printed in the United States of America

BOOKS BY PATRICIA JANIS BRODER

Bronzes of the American West
Hopi Painting Today: The World of the Hopis
Dean Cornwell: Dean of Illustrators
Great Paintings of the Old American West
Taos: A Painter's Dream
American Indian Painting and Sculpture
The American West: The Modern Vision
Shadows on Glass: The Indian World of Ben Wittick

Dedicated
to
MARY FRANCES LESH
the granddaughter of
Ben Wittick

Contents

◨

ACKNOWLEDGMENTS

I wish to thank the many individuals and institutions without whose help and cooperation my work would not have been possible:

Mary Frances Lesh, granddaughter of Ben Wittick, and the late Alexander Lesh for their cooperation and for their invaluable contributions to this book.

Frederick Dockstader, for his enthusiasm, interest, and advice during the course of my work and for his important contributions to this book.

Richard Rudisill, Curator of Photographic History, and Arthur Olivas, Photographic Archivist, both of the Museum of New Mexico, Santa Fe, for their interest in my work from its earliest days and for their cooperation and advice throughout the many stages of the preparation of this book.

The specialists in the field of Photographic History for their cooperation with my research and for their advice: Alfred Bush, Curator, Princeton Collection of Western Americana, Princeton University, Princeton, New Jersey; Louis B. Casagrande, Head, Department of Anthropology, the Science Museum of Minnesota, St. Paul; Michael Coe, Professor of Archeology and Chairman of the Council on Archeological Studies, Yale University, New Haven, Connecticut; Lee C. Mitchell, Director, American Studies Program, Princeton University, Princeton, New Jersey; Beaumont Newhall, Santa Fe, New Mexico; Elliot Porter, Santa Fe, New Mexico.

The directors and staffs of museums, libraries, art associations, and universities throughout the United States for biographical, historical, and statistical information and for photographs from their collections: Joan M. Metzger, Researcher, Arizona Historical Society, Tucson; Sharon Alexandra, Cataloging Department, Center for Creative Photography, University of Arizona, Tucson; James M. Day, Past Director, El Paso Centennial Museum, University of Texas at El Paso; Pat Mora, Director, El Paso Centennial Museum, University of Texas at El Paso; Thomas O'Laughlin, Curator, El Paso Centennial Museum, University of Texas at El Paso; Jeffrey Carnahan, Assistant Curator, El Paso Centennial Museum, University of Texas at El Paso; Russell P. Hartman, Director-Curator, Navajo Tribal Museum, Window Rock, Arizona; Laura Holt, Librarian, Laboratory of Anthropology, Museum of New Mexico, Santa Fe; Elizabeth Deer, Educational Division, Museum of New Mexico, Santa Fe; Orlando Romero, Librarian, History Library, Museum of New Mexico, Santa Fe; Mary Lee Ervin Boyle, Chief Archivist, Oklahoma Historical Society, Oklahoma City, Oklahoma; Judith Dearing, Administrative Secretary, Museum of Art, University of Oklahoma, Norman; Jane Snedeker, Librarian, Department of Rare Books and Special Collections, Princeton University Library, Princeton University, Princeton, New Jersey; Kathleen Baxter, Reference Archivist, National Anthropology Archives, Smithsonian Institution, Washington, D.C.; Paula Fleming, Photo Archivist, National Anthropology Archives, Smithsonian Institution, Washington, D.C.; Craig Klyver, Photo Archivist, Southwest Museum, Los Angeles, California; Paul J. McDougal, Photo Archivist, American Heritage Research Center, University of Wyoming, Laramie; David Kiphoth, Curatorial Assistant, Peabody Museum of Archeology and Ethnology, New Haven, Connecticut.

My friends and professional associates for their interest in my work and their contributions to this book: Paul Anbinder, New York, New York; Donald Horn, Short Hills, New Jersey; Leon Kramer, St. Paul, Minnesota; Kay Lee and Marshall Lee, New York, New York; H. Fox McDougall, New Vernon, New Jersey; Marion Manning, Millburn, New Jersey; John Freeman Norton, Santa Fe, New Mexico; P. B. Snifter, Peapack, New Jersey.

My husband, Stanley, for his support and cooperation and my son, Peter, and my daughter, Helen, for their interest in this book and help with the preparation.

Patricia Janis Broder

Short Hills, New Jersey
January 1989

Foreword

◘

The visual presentation of the historic past, or of a nonliterate culture, has always been a difficult problem. If made from afar, and from an alien point of view, there is the ever-present danger of error in selection, resulting in misrepresentation or misinterpretation; often, the needed information may not be at hand, or the desired subject may not be immediately available. At a closer distance, even when sympathetically examined, the result can be equally unrepresentative. If reestablishing history, there is the difficulty of assuring fidelity to that past: reconstructions or "reproductions" can as readily betray the original as provide an accurate link with the past. Some of the best views are those made by native artists themselves, although these, too, can be full of error, sometimes deliberate. All too often these represent what the native artist thinks the inquirer wants to see, rather than what is actually true. And it should not be forgotten that not all Indians are artists.

Although the Pueblo people are among the most prolific native producers of remarkably detailed paintings of their own customs and culture, these works are always suspect when absolute accuracy is concerned. The viewer is never certain as to the artist's point of view: Has he altered or eliminated certain elements of a given ritual for religious reasons? Is his memory mirror perfect? Does he really know all of the specifics of a given ceremony? Although with most nonliterate peoples trained memories are vital, and can be remarkable, not all Indian people are equally able to recall every detail of a social or religious performance; and as for recollecting the past, they are not infallible. Nor do all individuals belong to every society; they are as unfamiliar with some details as any outsider would be.

Therefore, early photographs of people, villages, structures, ceremonial pageantry, and objects have been a treasured archive in the effort to re-create and understand the past. Fortunately, in the Southwest there are a fair number of such photographs that have survived over the decades. Some aspects and lifeways have been photographed far more diligently than others, of course, and some of these give a distorted view of the importance of the event. From the Hopi, a plethora of Snake Dance pictures exist, for example, as against such little-known ceremonies as the Shalako (as compared with the more frequently seen Zuni Shalako).

Most of these represent the work of amateur and professional photographers who visited the Southwest in the general period of 1875–1915. Some of these individuals came and went fairly quickly; others moved in for a while, and spent many years with those whose lives they recorded; a few stayed permanently. Ben Wittick was one of the most important of the longer-term visitors, and this book is a reflection of his devotion to the establishment of a visual record of the people he came to know. One should also bear in mind the equipment of the period: heavy tripods; large, bulky cameras; glass-plate negatives, which were heavy and had to be handled with ex-

treme care. The operator had to mix and apply the emulsion, take the picture, and develop his own prints under conditions that sometimes were impossible to control properly or comfortably. One must make astonished tribute and admiration to the perseverance of these pioneers in viewing the results of their skilled artistry.

At one time, among most of the native population there was little objection to the practice of photographing religious events; today, there is no longer an open door. Since 1910, for example, the Hopi do not permit photographing of their religious ceremonies. This ban followed the visit of a contingent of village representatives dispatched to Washington to confer with Bureau of Indian Affairs officials, in but another vain effort to redress their grievances. They were surprised to find the walls of the congressional hearing room plastered with a selection of photographs of religious ceremonies—some of them by Wittick. Since this was a fairly common event of the day, it did not seriously trouble them until they found, to their dismay, that these were being used by Bureau officials and missionaries to discredit their religion, aimed at proving how savage and barbaric these ceremonies were and arguing for their suppression. Among these, of course, were views of the Snake Dance, which has always disproportionately fascinated white visitors.

Upon their return home, the elders reported the episode, and the people decided not to allow any further photographs of any ceremony, a prohibition that continues to the present day. The misuse of the photographs, the abuse of Hopi hospitality and the insult to their way of life, intensified by a suspicion that many of these photographers had been profiting financially by their work, all combined to effectively close the door to white cameras. This has had both good and bad results, as do most absolutes: While it frees the ceremonies from the nuisance of tripods, the explosive flash powder, and the aggressive tactics of most camera buffs, it denies a visual record of these dramatic pageants, which include some of the most colorful in America,

as well as losing for the Hopi people themselves a permanent record of their own ancestry and costume artistry. Even today, these early photographs remain our only visual record of some of the ritual activities that at one time were commonly available to viewing by all. It is true that today younger Hopi people have become skilled photographers, and may in time fill this vacuum, but one feels that the built-in internal limitations that the Hopi levy upon themselves may considerably affect their results.

An additional product of the Wittick lens was the practice of making studio portraits of important individuals among the native and white population of the region. Many of these are superb visual images that erase the indignity of invisibility; we can see just what these people looked like, recognize their virtues and their strengths, as well as their weaknesses, and in many cases more deeply appreciate the impact they made upon the period. These dramatic portraits, perhaps more than any other evidence, give a feeling of humanity, vitality, and character that we would not have from any other source. They are among the best of Wittick's work, and had he not photographed anything else, they would have secured his place in early Western history.

The first of anything is always subject to new discoveries, and one cannot rest in comfort upon such a claim, since new finds continue to change the historical record. Certainly, among the early photographers Ben Wittick figures prominently; his photos of the Hopi Snake Dance are commonly regarded as the first such views, and in many other instances, he was an early participant. His work speaks for itself, and since he was willing to go to great length to achieve a goal, some of his photographs of the isolated areas he visited remain among the best—and in some instances, the only—such views in existence. These are among the most prized records of this small area of pre-Columbian culture that still survive in the United States.

Many of the early photographic archives have, for various

reasons, succumbed to the wrecking ball of Time; not so with Wittick. Fortunately, his negatives have been preserved in several collections throughout the Southwest. Patricia Broder has explored all of these in her preparatory research, as well as selecting from additional small groups of his work not previously known. It is refreshing to note that he was an eclectic enthusiast: Every subject was grist for his lens, and the wide range of his interests reflects the flavor of the period remarkably. His archives are a superb cross-cultural picture of almost every aspect of early Southwestern life. Wittick's artistry is thoroughly professional and, judged in the context of the times and the equipment available, of excellent quality. One might condemn his overreaching artistic vanity in retouching the work more than might be desired; he fancied himself an artist, and frequently touched up his negatives to make them more salable, a practice that one suspects he would have defended on the grounds that it was done only to increase clarity and accuracy for the uninitiated viewer. Nevertheless, the Wittick prints remain among the best-known and most frequently reproduced products of the early photographers of the Southwest.

This book is a graphic tribute to the indefatigable work of a major figure in Western history, whose skill and tenacity were responsible for a prime source of visual information relating to the turn-of-the-century Southwest. In view of his interest in the life of the Indian people, and his devotion to their culture, it is indeed ironic that he died from the bite of a rattlesnake that he was taking to his Hopi friends for use in a ceremony.

Dr. Frederick J. Dockstader
Adjunct Professor
Arizona State University

December 1987

9

Illustrations

NOTE: In the text, the illustration numbers appear in the margins alongside the line in which the illustration subject is mentioned. If there is more than one subject mentioned on a line, the numbers are separated by a slash (/). If there is more than one illustration for a subject, the numbers are separated by a comma.

◘

SHADOWS ON GLASS
The Indian World of Ben Wittick

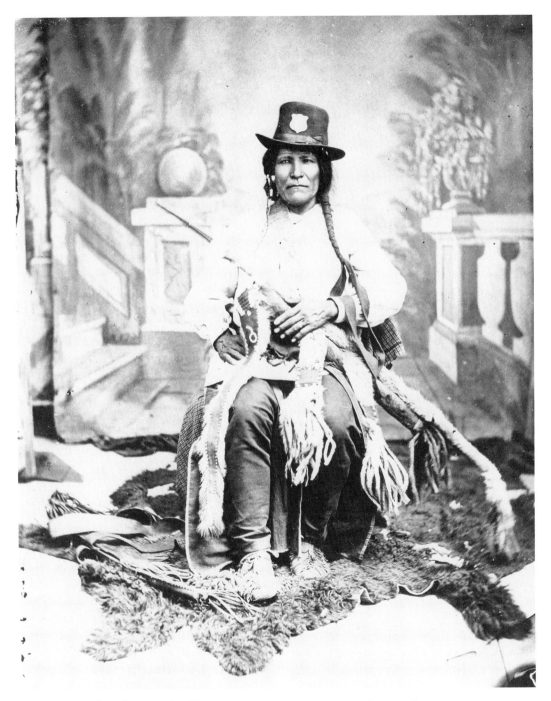

1. *Apache Policeman.* C. 1883. Photo: School of American Research Collections in the
Museum of New Mexico, Santa Fe

1. Portraits of Change

For a quarter of a century Ben Wittick photographed the Indian world of the Southwest. His images, made on glass plates, stand today as unique testimony to a land and people in transition. Wittick photographed the closing days of the Southwest frontier, days marked by the final military victories of government troops over the Indians, the completion of a network of railroads crossing the continent, the boom in Anglo-American settlement, and the beginning of tourism in the West. His photographs capture the historical, cultural, and psychological realities of a transitional era—the prejudices and ideals, incongruities and ambivalences of a period of irrevocable change.

Wittick's outstanding contribution to America's cultural legacy is his Indian photography, images of individuals and ceremonies that serve as a documentary portrait of an age. The pioneer photographers often were called *shadow catchers* because they used the light of the sun to capture on a surface of metal or glass a permanent image of their chosen subject. Wittick's photographs of the Indian people of the desert, canyons, and woodlands of the Southwest—sun shadows cast on glass—endure as a visual record of a world that was but a shadow of the past.

Ben Wittick arrived in the West in 1878, fifteen years after the tragic Long Walk of the Navajo people, two years after the defeat of Custer by the Sioux at Little Big Horn, and during the height of the confrontation between the Apache and the United States Cavalry. By 1903, the year of Wittick's death, the surviving Chiricahua Apache warriors had lived as prisoners of the United States government for seventeen years. After the massacre at Wounded Knee in 1890 and the defeat of Sitting Bull in 1891, it was no longer reasonable to fear the Indian as a threat to the march of civilization. By the turn of the century, the majority of Indians in the Southwest had been confined to reservations under a system supervised by the Bureau of Indian Affairs (BIA). Federal officials, rather than traditional tribal leaders, held the power to determine the daily and ceremonial life of the defeated tribes. Forced to adjust to life in a land dominated by foreign cultural and spiritual values, the Indian people were expected to make fundamental changes in their personal as well as in their tribal lives, reshape their perception of the world, and thus take the initial steps in developing a new cultural identity.

During the last quarter of the nineteenth century, Indians throughout the Southwest struggled to reconfirm their tribal bonds and traditional values yet accept the realities of life in a new age. Forced to adjust to a world dominated by Anglo-European prejudices, ideals, and beliefs, they experienced social and psychological upheaval and unmitigated confusion. The inconsistent policies and actions of the United States government agencies, the zeal of missionary churches, and the intellectual arrogance of anthropologists and ethnol-

ogists intensified their dilemma and heightened their anger.

For over three centuries the Indians of the Southwest had lived as a conquered people, forced to accept the laws and the limitations of an alien culture. In 1540 Francisco Vasquez de Coronado, with about three hundred soldiers and some Christianized Mexican servants, had come to the Southwest hoping to find the fabled Seven Cities of Cibola, win converts, and take possession of the land and riches of the New World for the glory of His Most Christian Majesty, Emperor Charles V of Spain. Finding only the Pueblo of Zuni, Coronado dispatched one of his officers, Captain Hernando de Alvarado, north to explore the Pueblo of Acoma, then to continue on a 350-mile-long journey through the Rio Grande Valley to Taos, the northernmost pueblo.

Spain's formal program for the conquest and Christianization of the Indians and the colonization of the land began in 1595, when the Spanish crown gave royal approval to Juan de Onate for the conquest in the name of Spain of all Indian settlements. In 1598 Onate established a claim on eighty-seven thousand square miles from Taos to El Paso and from the Pecos Valley to the Hopi villages. For the next three centuries the Spanish attempted to colonize the area and missionaries baptized the Indians, built churches, and claimed souls for the Catholic Church. Although the Spanish promised to protect the Pueblo people from the raids of the surrounding nomadic tribes, they created far greater problems by forcing the Apache and Comanche west.

In 1680 the Pueblo Indians mounted a revolt in which they destroyed all of the missions and killed 21 of the 33 missionaries and 375 colonists. The Spaniards fled South to El Paso, but in 1692 Don Diego de Vargas recaptured New Mexico and reestablished the domain of the Spanish crown and the Catholic Church. Only the Pueblo of Zuni and Hopi rejected Catholicism and retained their traditional religion—a right that they maintain to this day.

In 1821, with the signing of the Treaty of Cordova, Mexico became a new independent nation with control over the land that theretofore had been the Spanish territory in North America. New Mexico remained part of the Mexican nation until the end of the war between Mexico and the United States, when, with the signing of the Treaty of Guadalupe Hidalgo in 1848, Mexico accepted the Rio Grande River as its boundary and gave the United States the northern provinces of New Mexico and California.

The United States Government, like the Spanish before it, consistently broke treaty after treaty, promise upon promise to the Indian people. The nations negotiating for these territories paid little attention to the rights and concerns of the Indians. Throughout the nineteenth century Americans continued to believe in the doctrine of Manifest Destiny, that it was determined by God that the American flag would proclaim the sovereignty of the United States Government from the Atlantic Ocean to the Pacific. Like the Spanish before them, they looked upon the Indians as savages, members of a primitive race who were a threat to progress and must be conquered and given the gift of civilization. At best they saw the Indians as children of nature who needed the protection and care of the Great White Father in Washington. They believed it was destined that the Indians should abandon their pagan beliefs and rituals and be transformed into the nearest facsimile of Anglo-Europeans. Indians were expected to change their mode of dress, abandon traditional forms of tribal government, end all traditional sacred and social ceremonies, and pledge their full allegiance to the United States Government.

Wittick arrived in the Southwest more than twenty years after the first photographers had recorded for posterity images of the land and the Indian people. Although he had the distinction of being the first to photograph successfully the Acoma Pueblo and was among the first of his profession to complete expeditions to the land of the Havasupai, Hualapai, Mohave,

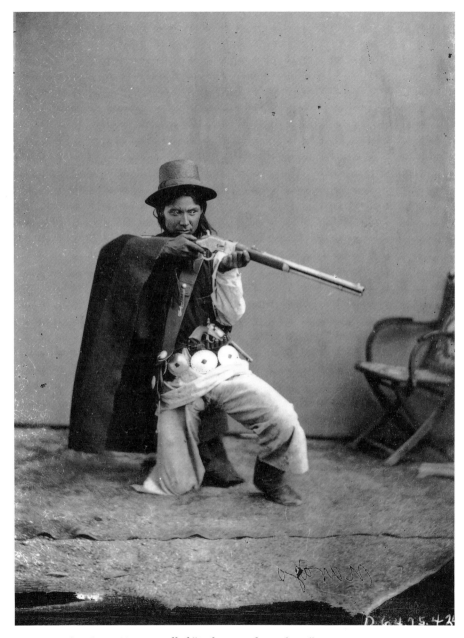

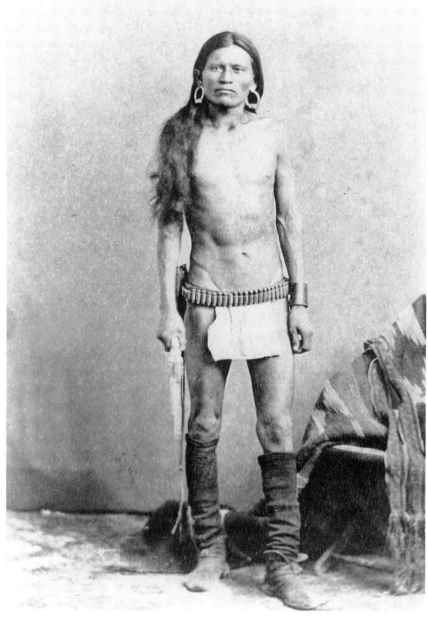

2. *Juan, Navajo, called "Indian Ready to Shoot."* C. 1885. Photo: El Paso
Centennial Museum, El Paso, Texas

3. *Charlie, Navajo scout under Lieutenant Guilfoyle and Lieutenant Wright.*
C. 1885. Wearing a loincloth, cartridge belt, and holster, Charlie posed in
fighting trim. Charlie, an accomplished silversmith, was a nephew of
Manuelito. Photo: Private Collection

and Yuma Indians, the importance of his work lies outside of these pioneer efforts. Wittick's greatest achievement was to document the dilemma of Indian life during a critical period of transition.

Wittick's Indian photographs fall into two distinct categories—field studies and posed portraits. Although the field studies focus on daily life in the Indian world—the housing, dress, and daily activities of the people—the portraits offer greater insight into the fundamental truths of Indian life in the Southwest, because they capture not only the physical likeness of the Indian subjects, but the cultural and the psychological realities that defined the lives of these people.

With the exception of a few bands of renegade Apache, the Indian people of the Southwest were learning to accept the realities and limitations of reservation life. Although the Navajo had been permitted to return to their homeland, they returned to a land ravaged by the Kit Carson campaign and had to struggle to survive with only minimal herds. In the Pueblo world, the United States Government agents who had replaced Spanish and Mexican authorities were determined to enforce a policy of cultural assimilation. Although the inhabitants of the Rio Grande pueblos and the western pueblos of Zia, Laguna, and Acoma had long ago been converted to Catholicism by the Spanish missionaries, they continued to retain many of the fundamental beliefs and rituals of the precontact world. While they were willing to observe traditional Christian rituals and holidays, they continued to pray to traditional spirits and deities for the fertilization, germination, and growth of their crops and the propagation of life in the Pueblo world. Only the Hopi and Zuni fully retained their traditional religious beliefs.

The Wittick photographs were taken in a period when the United States Government had absolute power to control the destiny of the Indian people. Throughout the Southwest the Indian people experienced conflict and despair as they faced a life in which government agencies determined every facet of economic and political well-being—where they could live, what they would eat, how they should dress and cut their hair, and what work they must do to support themselves. The United States Government determined the structure of their governments and decreed which ceremonies they should observe, who should educate their children, and what the children should learn.

Those who lived on the reservations were expected to obey the regulations of the government agents rather than their own tribal leaders. Many Indians learned the lessons of pragmatism—that survival, even economic prosperity, was possible if they accepted many of the teachings and values of the dominant American culture. These apostates came into direct conflict with traditional Indian leaders who feared the loss of all tribal identity.

These were years of confusion. While conservative tribal leaders warned the Indians to remain faithful to traditional ways and beliefs and reject the promises and plans of the white man, more practical leaders tried to make the best of a losing situation and attempted to negotiate with the United States Government. Many chiefs visited the Great White Father in Washington and returned with signed treaties and new ideas. When these treaties and promises were broken, these leaders reexamined their allegiances to Washington and to their own people and often became the most hostile and conservative of their tribes.

The Apache and Navajo who posed as subjects for Wittick were the protagonists in a drama in which it was impossible to distinguish hero from villain, patriot from traitor, friend from foe. Among those who came into Wittick's Fort Wingate studio were Apache and Navajo War Chiefs negotiating peace treaties and Apache and Navajo braves turned United States scouts. During these years many Indian men volunteered to serve as army scouts, helping to track not only historic enemies but

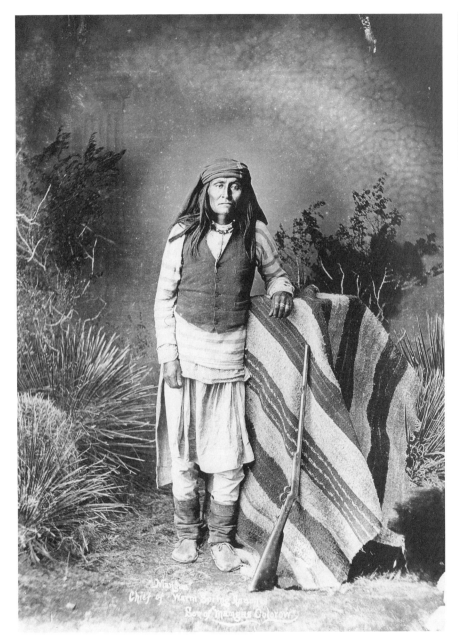

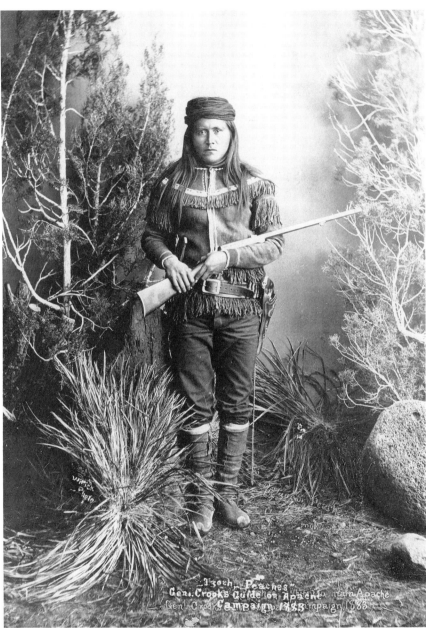

4. *Mangas, Chief of Warm Springs Apache.* C. 1883. Son of Chief Mangas Colorado, Mangas and his followers hid in the mountains for several weeks after Geronimo had surrendered and were among the last of the Apache to be captured. Photo: School of American Research Collections in the Museum of New Mexico, Santa Fe

5. *Penaltish* or *Tzoch, called "Peaches" by the U.S. Military, Navajo.* C. 1885. In 1883 Peaches deserted Chatto's band and served as General Crook's guide on 1883 Apache Campaign. He was the scout who led General Crook to the Chiricahua hideout in the Sierra Madre Mountains. Photo: School of American Research Collections in the Museum of New Mexico, Santa Fe

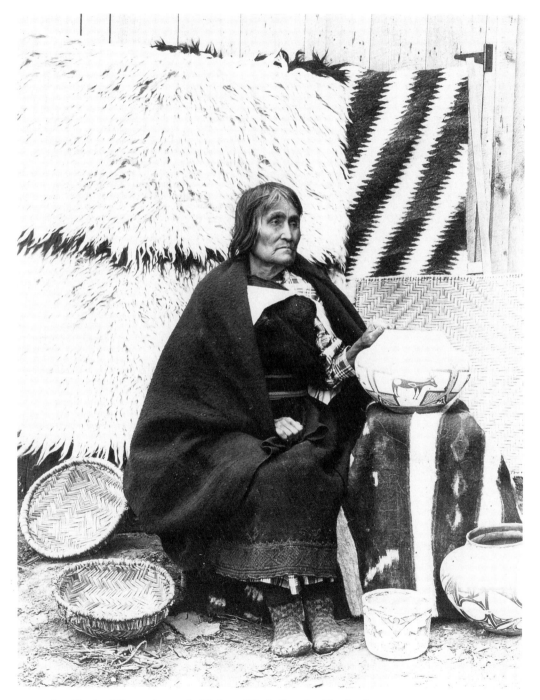

6. *Marita, Woman Accused of Being a Witch, Zuni Pueblo.* C. 1890. Photo:
School of American Research Collections in the Museum of New Mexico, Santa Fe

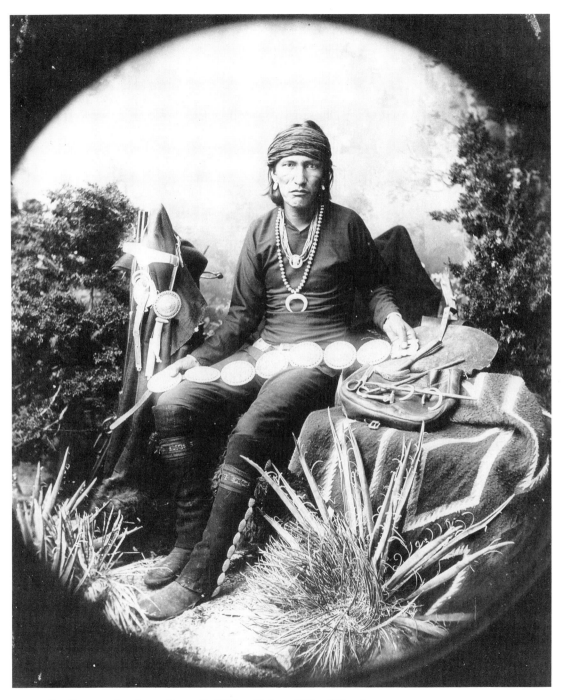

7. *Bae-ie-schiuch-a-ichin, called "Slim, Maker of Silver," Navajo.*
C. 1885. Photo: School of American Research Collections in the Museum of New Mexico,
Santa Fe

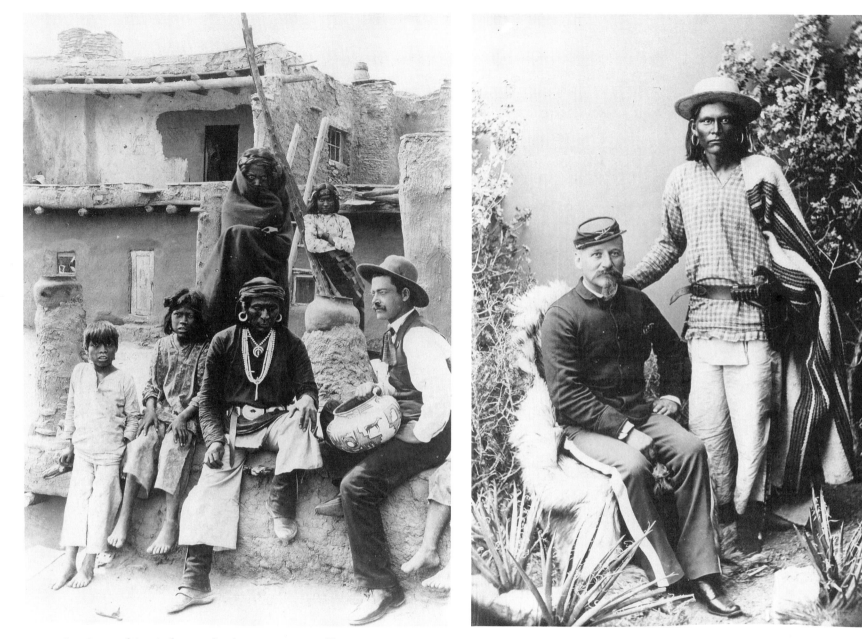

8. *Group of Zuni Indians with White Man, Zuni Pueblo.* C. 1885.
Photo: School of American Research Collections in the Museum of New Mexico, Santa Fe

9. *Captain Ben Rogers, Officer at Fort Wingate, and Largo, a Navajo Scout.*
C. 1885. Note that Largo wears a loincloth outside his trousers.
Photo: School of American Research Collections in the Museum of New Mexico, Santa Fe

renegade members of their own tribes. Realizing that defeat was inevitable, these Indian leaders accepted promises of leniency and special treatment and agreed to serve as scouts against their own tribesmen. For some this was a choice they would always regret.

Wittick's photographs document this incredible confusion over cultural identity, a confusion shared by portrait subject, photographer, and photographic audience. For many of the Indian people, fantasy was indeed the primary characteristic of this time. Many of Wittick's subjects tried to appear as fierce and formidable as possible, posing with handguns and rifles. Some appeared in fighting trim (wearing only a loincloth), others in full Indian dress. Many of the Indians identified with the white man and wore fringed buckskin and store-bought white man's shirts, trousers, and hats. Since women had less contact with white society, they continued to wear traditional tribal dress for a longer time.

The backgrounds for Wittick's photographs, like the costumes of his subjects, were a strange mixture of the natural and architectural elements of the Anglo-European and Indian worlds. Wittick's subjects often stood before painted backdrops suggesting an idealized woodland, yet at their feet were desert rocks and cacti. Those who lived in traditional adobe houses believed it a sign of stature and civilization to pose in front of a Victorian frame house. Here was an American fantasy land, an amazing mixture of the real and the ideal.

Nineteenth-century white Americans thought that all Indians, regardless of tribe, shared a common bond. They believed that all Indians looked alike, practiced similar ceremonies and rituals, and used the same weapons and artifacts. The average American citizen identified the Indian with the war bonnet, the tomahawk, the teepee, and the canoe. These beliefs were a direct contradiction of reality. Prior to the arrival of the Anglo-Europeans, the native inhabitants of the American continent had no concept of a pan-tribal identity. They were members of a specific group, Apache, Hopi, Sioux, or Kiowa. Another tribe might be friendly or unfriendly, but they had little sense of sharing common spiritual or secular traditions or identification with a shared history. It was not until the twentieth century, when the Indian children were forced to attend Indian boarding schools and many Indians moved to urban centers, that they began to recognize a common bond of historic defeat, problems and pressure of forced assimilation, economic hardship, and social prejudice.

Wittick's customers believed in the reality of the stereotype Indian. Those who purchased Wittick's photographs believed that all Indians were hunters or warriors who carried bows and arrows and wore feathers and beads, that peaceful Indians made pottery and baskets while the more warlike fought with tomahawks and rifles captured from the white man. For this audience it made very little difference which type of pottery, clothing, or ceremonial object was included in a portrait.

Wittick, like his contemporaries, traveled with a collection of costumes, artifacts, painted backdrops, and foreground props. The final choice had to be acceptable to both the photographer and the portrait subject. The choice of costume, backdrop, and props and the willingness to accept a fantasy photograph tell far more about those who were photographed than about the photographer. Those who had experienced the greatest cultural upheaval accepted the most incongruous setting and selected the most stereotypical artifacts and poses. During these transitional years the Indians received clothing from missionaries, government agents, and the military, and the men's clothes were primarily individual adaptations of white man's dress with a few reminders of tradition—for example, a loincloth hanging outside store-bought trousers. Many of Wittick's subjects proudly displayed a special hat, a leather vest, or medals that confirmed their status in the white man's world.

Wittick's field photographs, like his studio portraits, are a composite of reality and illusion, fact and fantasy. Intended as an

9

ethnological record of the aboriginal inhabitants of the land in their native setting, these photographs document details of daily dress, types of housing, and general living conditions. Nevertheless, the fact that these Indians consented to pose for the photographer reveals some degree of cultural assimilation. In the traditional Indian world, it was a common belief that making a likeness of an individual, whether by painting, drawing, or photography, would deprive the individual of part of his or her spirit, ultimately resulting in sickness and death. Thus, the response of the subject to the photographer tells as much about the degree of cultural assimilation as does cut of hair or style of dress. It makes little difference that in the field studies the Indians appear to have been photographed in a natural state, wearing traditional clothing and living in the types of housing used for centuries. The fact that these people have agreed to pose for the photographer indicates the beginning of the acceptance of the values of another culture.

The photographers, like the ethnologists and anthropologists, looked upon the Indians as living museum specimens, available for study. Without hesitation they intruded upon their personal and ceremonial lives, and in the interest of science they forced their way into forbidden ceremonies and collected sacred religious paraphernalia. By breaking sacred taboos, they deprived the people they studied of human dignity and peace of mind. The photographers, like the ethnologists and anthropologists, never questioned their right to make a permanent record of all aspects of daily and ceremonial family and tribal life. By 1903, the year of Wittick's death, there were so many photographers in the Southwest that tribal officials had begun to post and enforce regulations limiting the area in which they were permitted to work and defining which subjects they could photograph.

Gradually the Indians became aware that the photographers looked upon them as an exotic species of Western wildlife. As the Indian subjects grew more sophisticated, many demanded payment for posing. The photographers frequently gave dupli-

cate prints to the subjects. In areas with a resident photographer, sitting for a photographic portrait became an accepted ritual of Indian life, a ritual in which photographer and subject participated in creating a fantasy of Indian life.

During Wittick's lifetime and throughout most of the twentieth century, historic Indian photographs were advertised and sold as images of a primitive world untouched by the white man's civilization, regardless of whether there was any validity to the claim. As time passed and the Indian world changed, field photographers sought out and focused on isolated vignettes of Indian life that deleted all signs of modern life. Portrait photographers and their subjects often cooperated in sustaining an illusion that each successive generation of Indians lived in a world seemingly untouched by time or history.[1]

When Wittick arrived in the Southwest, more than three hundred and fifty years had passed since the Indians' first contact with European civilization. All Americans, regardless of ethnic origin, faced the dawn of the twentieth century, a century that promised accelerated changes in every aspect of life. Despite the futility of denying the changes that had transformed the social, economic, political, and psychological reality of the Indian people, late-nineteenth-century and early-twentieth-century Indian photographers focused on sustaining fundamental myths. The fantasy of children of Nature or untamed savages dwelling in the last remnants of an Eden-like wilderness or an exotic world of innocence and harmony had undeniable appeal. Even today, books and exhibitions of historic Indian photographs feature images of an idealized Indian world, in which landscapes are seemingly untouched by an urban industrial society and portrait subjects appear to have had minimal contact with the white man's civilization.

Ben Wittick's Indian photographs offer visual confirmation of the belief, prejudices, and fantasies of an age of transition and acculturation. Ironically, it is the absurdities of costume and setting, the contrivances of pose and expression, that cap-

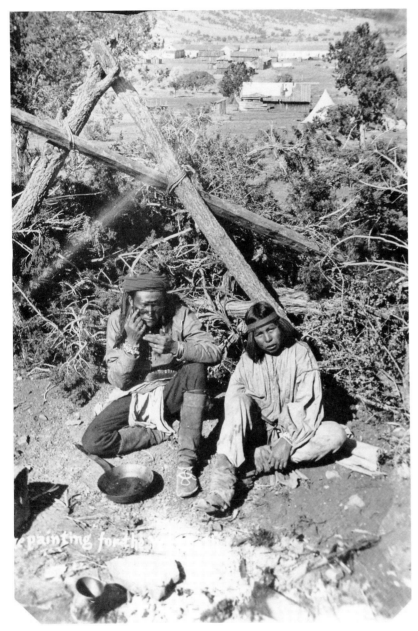

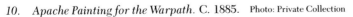

10. *Apache Painting for the Warpath.* C. 1885. Photo: Private Collection

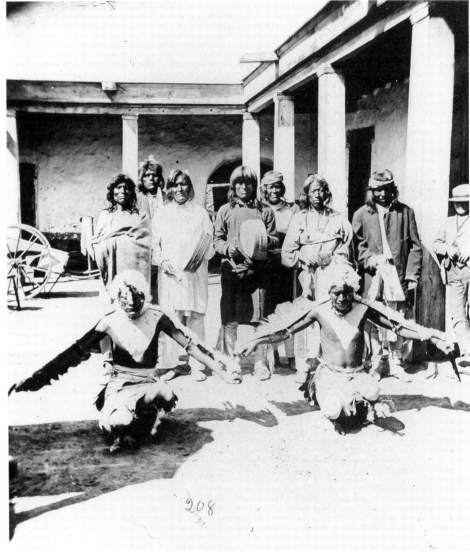

11. *"Feather Dance" (Eagle Dance), Tesuque Pueblo Group, Santa Fe.*
C. 1883. Photo: School of American Research Collections in the Museum of New Mexico,
Santa Fe

ture the essence of this period of Indian history. Wittick's work documents a period of confusion and change, offering indisputable evidence of the dreams and illusions of both the Indian and the white man. These shadows on glass capture the reality of an era when the lives of the Indian people of the Southwest were shrouded by two giant shadows: the shadow of the past, memories of a traditional world that gave order, dignity, and purpose to their lives; and the shadow of the future, hopes and fears of an unknown world that promised only uncertainty and inevitable change.

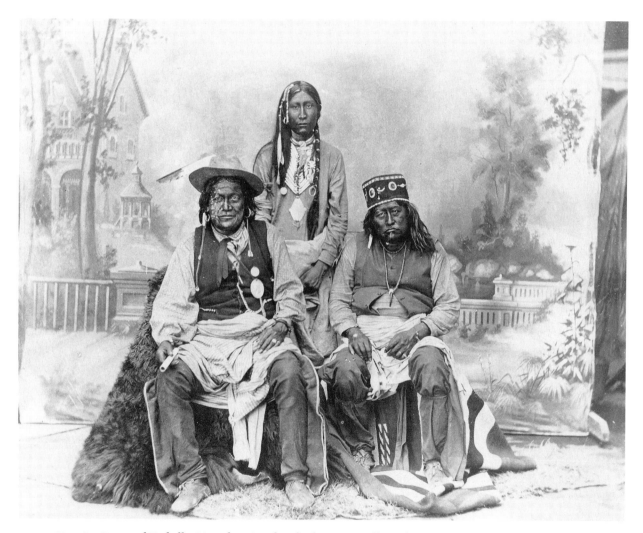

12. *San Juan and Nodzilla, Mescalero Apache Chiefs, Tertio-Millennial Celebration, Santa Fe. 1883.* Photo: School of American Research Collections in the Museum of New Mexico, Santa Fe

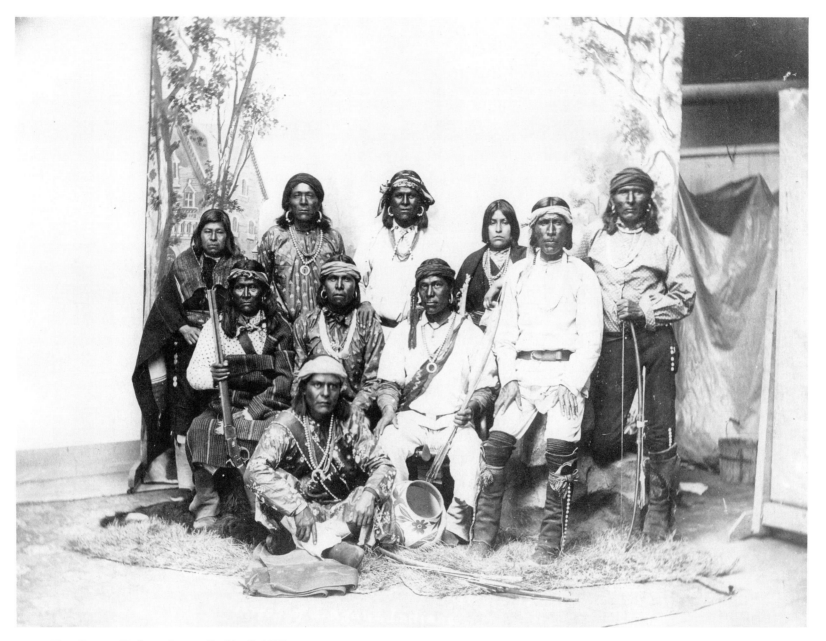

13. *Group of Indians, Laguna Pueblo.* C. 1885. Photo: School of American Research
Collections in the Museum of New Mexico, Santa Fe

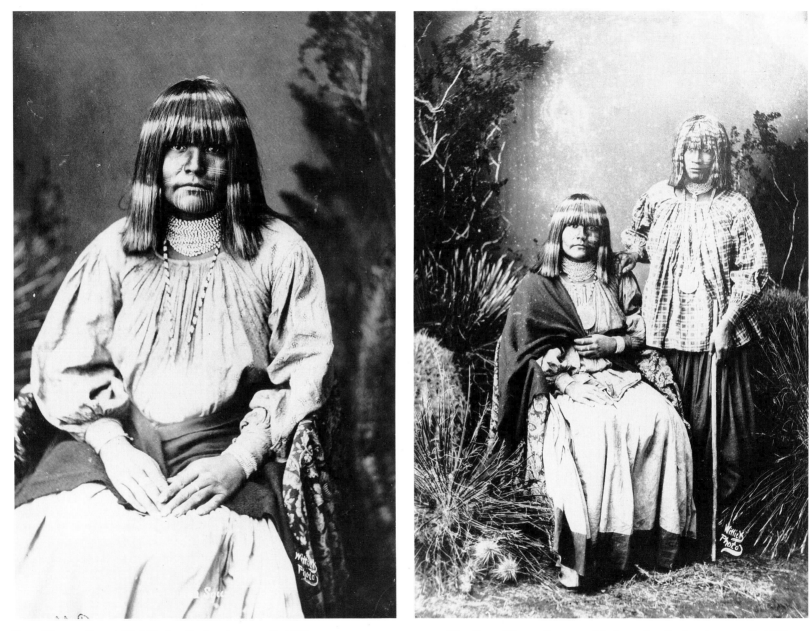

14. *Yuma Woman, Pau-ai ("Poly"), San Carlos, Arizona.* C. 1885. Photo: School
of American Research Collections in the Museum of New Mexico, Santa Fe

15. *Yuma Women, Pau-ai and Luli-pa, San Carlos, Arizona.* C. 1885.
Photo: School of American Research Collections in the Museum of New Mexico, Santa Fe

28

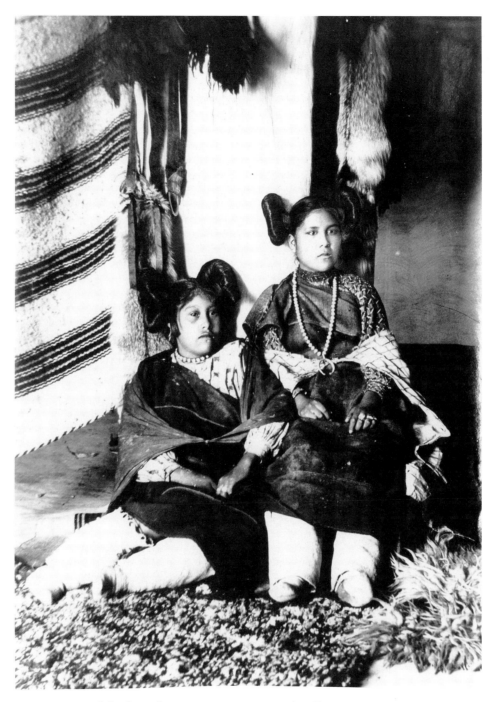

16. *Mash-honka and Ng-nue-si at Home in Oraibi Village, Hopi Mesas.*
C. 1885. Photo: Private Collection.

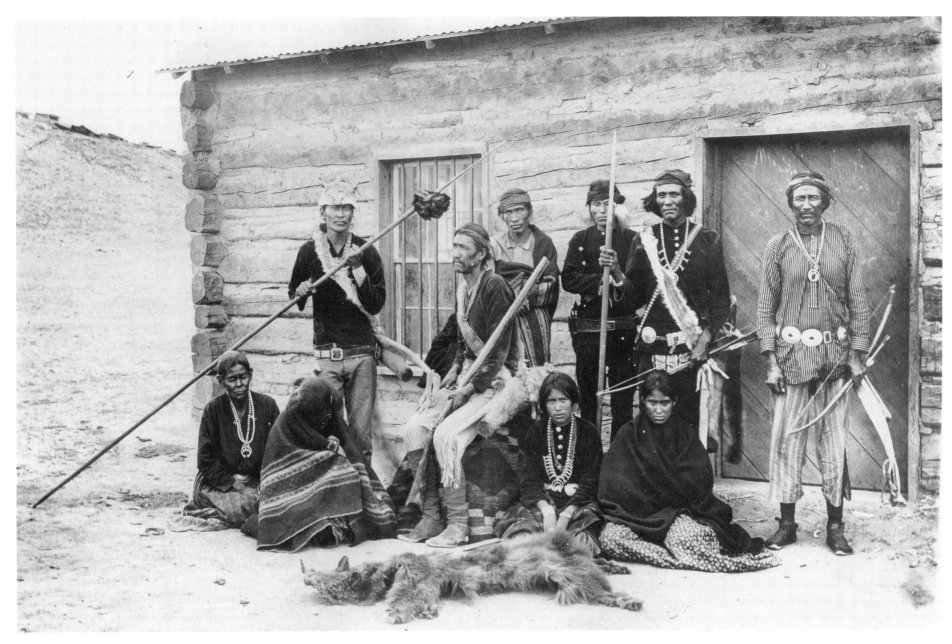

17. *Navajo Group, "Return of the Bear Hunters," Chinle Trading Post (Sam Day's), Chinle, Arizona.* C. 1885–90. Standing left, Dinet-tsosi; seated center, Naskaii Nez (Tall Mexican); standing second right, Hosteen Kliz-ini (Black Man); standing right, "The Gambler"; seated left, wife of Tse-nun-eskai, (Man with Trimmed Hair). Photo: School of American Research Collections in the Museum of New Mexico, Santa Fe

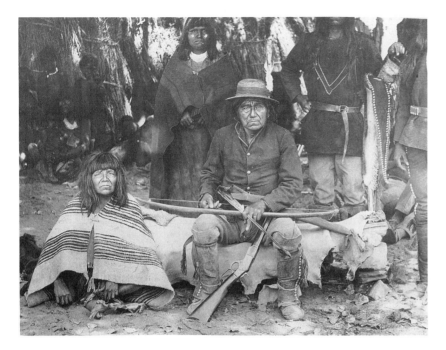

18.	*Captain Jack and his Wife, Havasupai Indians, Arizona.* 1885.	Photo: School of American Research Collections in the Museum of New Mexico, Santa Fe

19.	*Mohave Group outside Brush House, Arizona.* 1883.	Photo: Smithsonian Institution, National Anthropological Archives, Bureau of American Ethnology Collection, Washington, D.C.

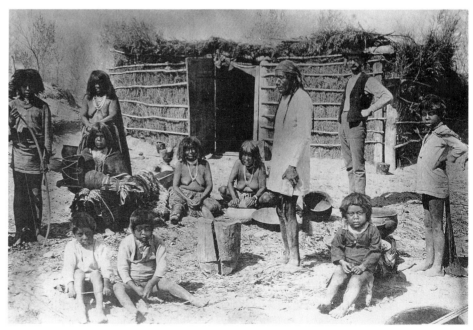

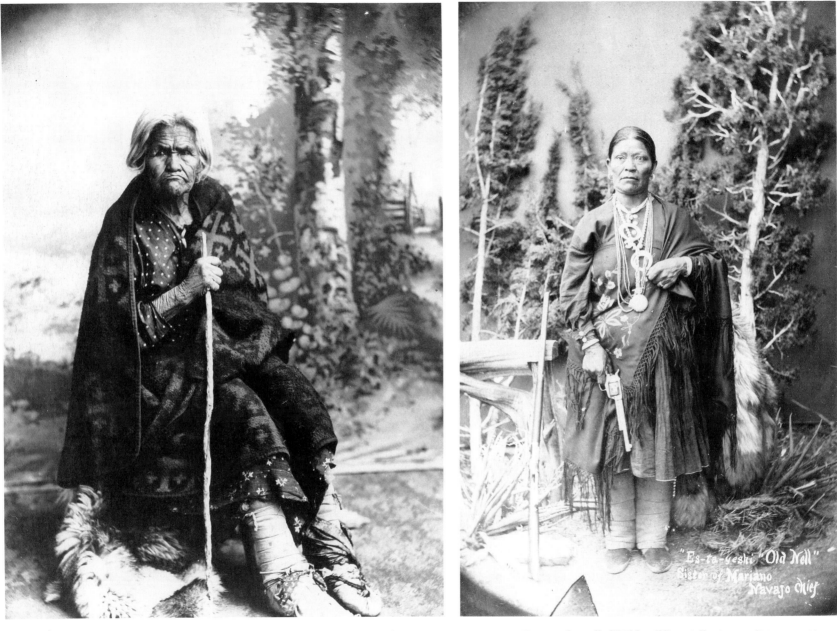

20. *Old Washie, Navajo Woman, Savior of Fort Fauntleroy (Fort Wingate) in the 1860s.* C. 1885. Photo: School of American Research Collections in the Museum of New Mexico, Santa Fe

21. *Es-ta-yeshi, called "Old Nell," or Nelly, Sister of Mariano, Navajo Chief.* C. 1885. Photo: School of American Research Collections in the Museum of New Mexico, Santa Fe

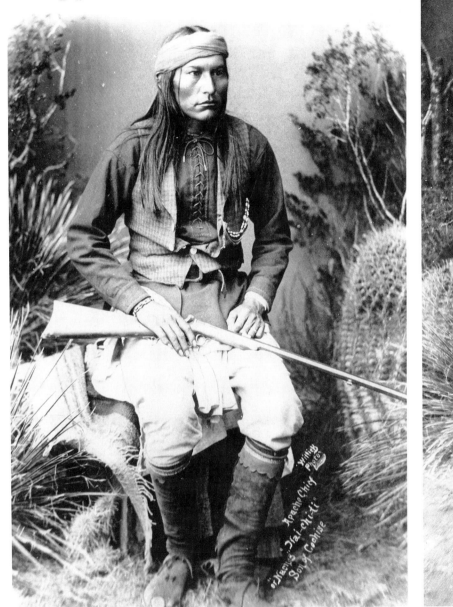

22. *Nai-chi-ti (Nachez), Son of Cochise, Chiricahua Apache Chief*. C. 1883.
Nachez was one of the leaders in the 1885–86 uprising. Photo: Private
Collection

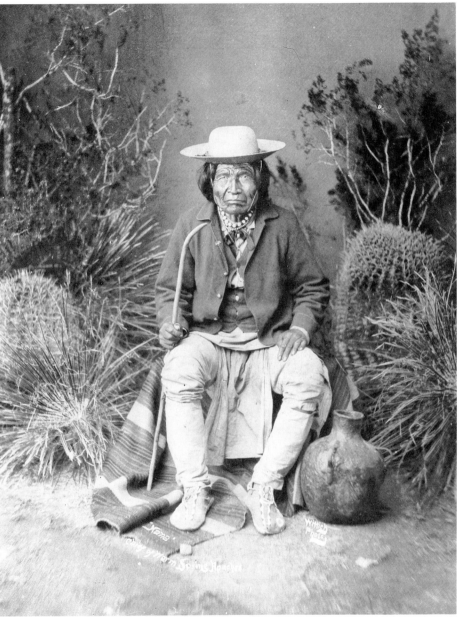

23. *Nana, called "Little Old Boy Dwarf," Chief of Warm Springs Apache*.
C. 1885. At age seventy-three, Nana became Chief following the death of
his father-in-law, Chief Victorio. Famed for his skill as a military strategist,
Nana fought with Geronimo in 1885 and 1886. Following the Apache
surrender in 1886, he was exempted from prison, thanks to his age.
Photo: Museum of New Mexico, Santa Fe.

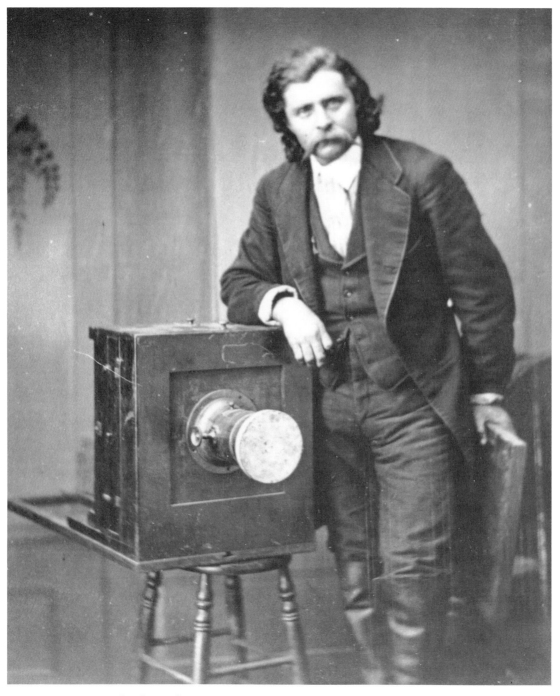

24. *Ben Wittick in his Studio.* Photo: Private Collection

2. A Search for Adventure: The Life of Ben Wittick

◘

At noon on a hot sunny day in mid-August 1891, Ben Wittick climbed down the ladder into an underground ceremonial chamber, the Kiva of the Snake Society in the village of Walpi on First Mesa on the Hopi Reservation. Until the minute Wittick entered the Kiva, there had been heated controversy over whether he would be permitted admission, and there was still considerable doubt whether he would be allowed to remain and so become the first white man to witness the Washing of the Snakes, the most sacred ritual in the nine-day Snake Ceremony.

In 1880, on his first visit to the Mesas, Wittick had been the first to photograph the Hopi Snake Dance, a public ceremony held in the village plaza. During the Snake Ceremony, which includes complex rituals of gathering, washing, and blessing the snakes, the Hopi pray for the late summer rains that will nourish the crops and ensure the perpetuation of life in the Hopi world. Snakes, usually rattlesnakes and sidewinders, are messengers who carry the prayers of the Hopi to the Underworld, the center of the Hopi spirit world. As the Hopi Priests dance with snakes hanging from their mouths, the jagged outline of the moving snakes is similar to that of lightning, which often appears in the sky during the Snake Dance. Fascinated by this mysterious religious dance, Wittick had returned to the Mesas almost every year to attend this most important ritual of the Hopi ceremonial year.

Wittick soon discovered that the dance in the plaza was only the conclusion of a series of sacred ceremonies and that the most important rituals took place inside the Kiva. When he learned that these rituals were closed to all but initiated Hopi, and certainly were closed to members of an alien race, he became obsessed with witnessing them.

In time Wittick made friends with several of the Hopi elders, and in 1891, thanks to his friendship with Wiki, one of the Walpi Snake Priests, he was able to meet with several other Snake Priests and win tentative permission to attend the Washing of the Snakes. It was agreed that he should enter the Kiva with another man, Mr. O, who would remain on the ladder at the entrance to the Kiva; Wittick would be permitted to stand in the room.

In his detailed account of the ceremony, Wittick wrote, "At the very last moment, I was again warned to leave and told that I would swell up and burst, or that other direful troubles would come to me, as a consequence of beholding rites which no one not a priest had ever witnessed."[1] Disregarding the warning, Wittick described in detail the ritual objects, the altar, and the dress and every gesture and movement of the Snake Priests. Only the words of the sacred prayers, which were chanted in the Hopi language and therefore were unintelligible to him, do not appear in his report.

In the years that followed, each August Wittick was drawn to the Mesas. Over the years he made a detailed photographic and written record of the public Snake Dance in the Hopi

villages of Oraibi, Mishongnovi, and Walpi. His copyrighted photographs of the Snake Dance include several of the best-known views of the historic ceremony. Wittick also made many panoramic views of the Mesas and studies of the Hopi villages built from the stones of the Mesas.

In August 1903, Wittick decided to bring a special gift to the Mesas to please his Hopi friends. He had captured a rattlesnake in the fields near Fort Wingate, New Mexico, and had kept it in his cabin until the time of the Snake Dance. On the afternoon of his departure for the Mesas, as he reached for the snake, attempting to put it in a special box for the trip, the snake coiled, sprang, and sank its fangs into his thumb. Wittick was rushed to the Fort Wingate hospital, but the wound proved fatal, and three weeks later he died of snake venom poisoning.

The Hopi prophecy had come true. His sons Charlie and Archie were at his bedside, and in a 1942 newspaper interview Charlie recalled the threatening words of the Snake Priest, which his father had repeated many times: "You have not been initiated. Death shall come to you from the fangs of our little brothers."[2]

Wittick was buried in Moline, Illinois, in a cemetery plot overlooking the Mississippi River. His death was an ironic conclusion to a life of wandering in search of adventure, knowledge, and, often, experience for its own sake. To capture the elusive view over the next hill, to attend the ceremony never before witnessed by a white man, to be the first to photograph the native inhabitants of an unexplored territory—these were the dreams and realities that determined the life of Ben Wittick, a frontier photographer who made thousands of glass images of the land and people of the Southwest.

Ben Wittick was born in Huntington County in south-central Pennsylvania on January 1, 1845. Huntington was an industrial community on the Blue Juniata, a 150-mile-long river that flows east from Huntington County into the Susque-hanna River. Although his parents, Conrad and Barbara Petri Wittick, christened him George Benjamin Wittick, he was known to family and friends as Ben.

The Witticks shared the optimism of mid-nineteenth-century America and believed that as the United States evolved into an industrial nation, the rapidly growing communities of the Midwest offered the greatest opportunities for economic success. When Ben was nine, the Wittick family loaded all of their possessions onto a covered wagon and set out for Illinois. They settled in Moline, a community in northwestern Illinois on the Mississippi River, just above Rock Island. Conrad Wittick, a contract builder, worked on the first large bridge across the Mississippi River, connecting Rock Island to Davenport, Iowa. Within a few years the Witticks became respected members of the community, and Conrad Wittick helped plan and build Moline's East End.

Young Ben spent his boyhood hunting, fishing, and dreaming of the days when Moline had been Indian Territory—a land of romance and mystery. Although he had almost no formal schooling (indeed, in later years he boasted that his entire education consisted of three months of school), he was an active, curious child who especially liked to draw. By trial and error he taught himself to make pencil and pen-and-ink sketches, but his parents did little to encourage this interest, believing that "marking" was a waste of time.

Conrad Wittick instilled in Ben a sense of patriotism and a belief in America's Manifest Destiny. Like most Americans, father and son believed that it was the mission of the American people to bring the gift of civilization to the American continent and that it was a truly heroic task to defeat in battle those savage Indians who refused to accept their destined salvation. They were confident that America's progress was inevitable, and that thanks to the valiant effort of the military, within a few years every tribe across the United States would surrender; then every possible acre of the American continent would be open for settlement and industry.

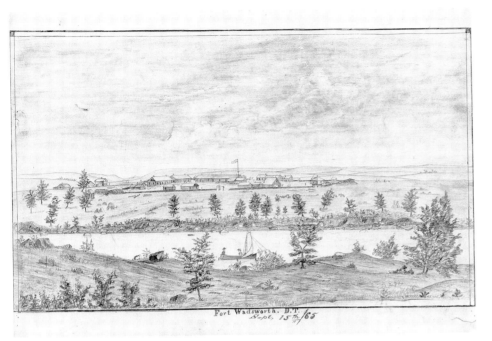

25. *Fort Wadsworth, Dakota Territory.* Drawing by Ben Wittick, 1865.
Photo: Photograph courtesy Kramer Gallery, Inc., Saint Paul, Minnesota.

26. *Pueblo Indian Loom, Territorial Fair, Albuquerque, New Mexico.* October 1881. Photo: Museum of New Mexico, Santa Fe

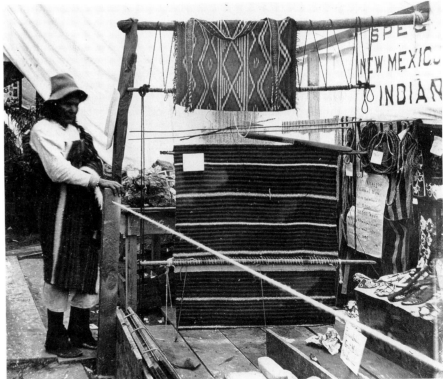

As he entered his teens, Ben longed for travel and adventure. In 1861, when the Civil War broke out, Cônrad Wittick enlisted in the Union Army and his sixteen-year-old son followed his example. Ben left home and traveled to Fort Snelling, Minnesota, where, without either parent's knowledge or consent, he enlisted in the A Company, First Minnesota Mounted Rangers, using the name of Ben Wallace. When, a year later, he was mustered out of service, he enlisted in the Second Minnesota Mounted Rangers, the voluntary cavalry regiment of the Indian Service Division.

The Indian Service offered Wittick the fulfillment of his dreams. He had the opportunity to participate in a military campaign against the Dakota Sioux and in 1863 was witness to the battle of Big Mound. During these years he made pen-and-ink sketches of the Minnesota countryside and drawings of forts and encampments. When he left the service, Wittick kept the best drawings as reminders of his first adventures.

While serving in the cavalry at Fort Snelling, Wittick met Frances Lelia Averill, a young woman from Minneapolis, whose family had traveled to the Midwest from Oldtown, Maine. When he was mustered out of the military in 1865, they were married, and for a brief time Wittick tried to settle down to family life in Minneapolis. He soon decided to return to Moline, where for a few years he attempted to follow in his father's footsteps and learn the trade of carpentry. However, he was never able to develop an interest in the work, and when a photographer named Mangold opened a daguerreotype gallery in town, Wittick took a job as his apprentice in order to learn the techniques of this new (for this part of the country) profession. He was hopeful that photography would give him the opportunity to earn a living and support his family, yet enable him to escape from the confinement of a daily routine. Here at last was a challenge that would give meaning to his life.

Wittick learned quickly and soon opened his own photographic studio on First Street, the same street as the Mangold gallery. There, in direct competition with his former employer, he sold contact prints made by the wet-plate collodion process. (See page 202.) When his new business thrived, he moved to larger quarters at Third Street and Third Avenue in Moline, but, despite his success, he discovered that once again he was caught in a life of routine and repetition. In 1875 he was thirty years old and, after ten years of married life, had a family of five sons and a daughter (Tom, born in 1865; Charlie, 1866; Claude, 1869; Archie, 1871; Mamie, 1873; and Roy, 1875).

Each day Wittick grew more and more restless, dreaming of his past life on the Dakota plains and longing to break all bonds and set out in search of adventure. He knew that the era of the cavalry-Indian campaigns was drawing to a close, and followed with interest each new development of the Apache conflict in the Southwest. He searched for an answer to his dilemma, and found the answer in the patronage of the railroads. During these years the railroads hired artists and photographers to travel along their western routes. In return for transportation and board, the artists agreed to provide the railroads with drawings, paintings, and photographs extolling the beauty and wonders of nature and offering a glimpse of the exotic Indian inhabitants of each area and their mysterious ceremonial rituals. If anyone dared to pronounce the work of the painters unbelievable, overly romantic, or fantastic, the photographers' prints offered absolute proof of their validity.

In 1878, when the Atlantic & Pacific Railroad (later known as the Atchison, Topeka and Santa Fe Railroad) offered Wittick the position of official photographer, a job offering a chance to travel to New Mexico, make a record of the progress of the railroad from Santa Fe west to California, and photograph the land and the Indian inhabitants of each area, he accepted without hesitation. He bade farewell to life in Moline, promising to write to his family, to send money home, and to return in a few years. He had found the key to freedom and adventure. From this time until his death in 1903, Wittick never returned on a permanent basis to his family in the Midwest or established a family residence in the West.[3]

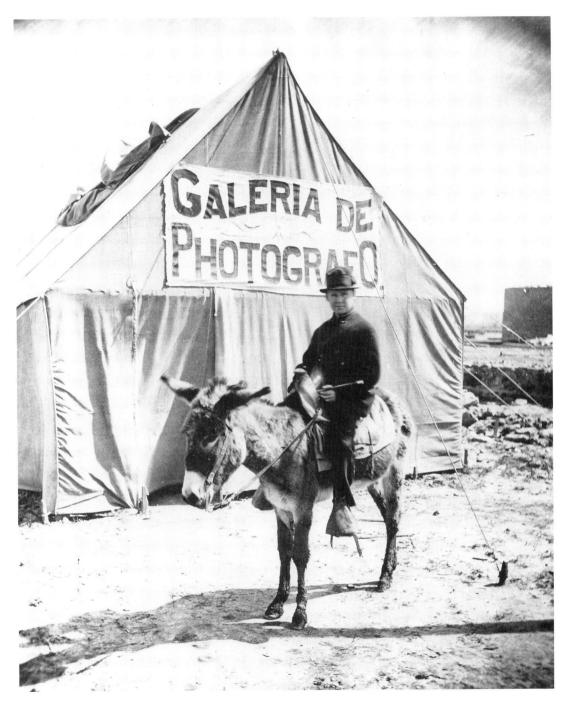

27. *Our Burro.* In front of Wittick's Photo Tent, Albuquerque, New Mexico.
C. 1882. Photo: School of American Research Collections in the Museum of New Mexico,
Santa Fe

28. *Old Town, Albuquerque, New Mexico.* C. 1882. Photo: School of American
Research Collections in the Museum of New Mexico, Santa Fe

29. *Old Women of Laguna Pueblo.* C. 1883. Photo: Photograph courtesy Kramer
Gallery, Inc., Saint Paul, Minnesota

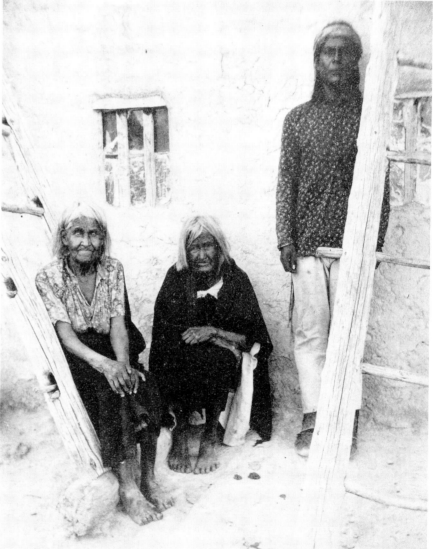

Although the railroad was not expected to arrive in Santa Fe until 1880, Wittick left Moline as soon as he signed his contract. In 1878 he arrived in the frontier town of Santa Fe with his oldest sons, Charlie and Tom. For almost two years prior to the arrival of the railroad, the three Witticks enjoyed a life of adventure in the high desert country of the New Mexico–Arizona Territory. Wittick explored the streets of Santa Fe and visited many of the Rio Grande pueblos; however, during these first years in the West his primary interest was the spectacular scenery. In 1879 he opened a photographic gallery in Santa Fe, where he supported himself by making portraits of the local residents and of the Indians from the nearby pueblos who came into town. In January 1880, in anticipation of the arrival of the railway, Wittick sent his sons home.

From 1880 until 1883, Wittick documented the Atlantic & Pacific Railroad's progress in laying track across New Mexico and Arizona west to the California border. The railroad's route had followed the Santa Fe Trail from Kansas over the Great Plains, crossed Glorieta Pass, then continued through the Pecos Valley. The railroad actually bypassed Santa Fe, building the district station nineteen miles south in Lamy. On February 9, 1880, with great pomp and ceremony, the railroad arrived in Lamy. Two months later, on April 22, it reached Albuquerque. From Albuquerque the Atlantic & Pacific laid track in two directions. During 1881 the railroad completed a southern branch extending from Albuquerque through Deming, New Mexico, to El Paso, Texas, a frontier town on the Mexican border. However, the primary route of the railroad was west to California, with stations in Grants and Gallup, New Mexico, and Holbrook, Winslow, and Flagstaff, Arizona, as well as in many other locations selected as supply and service depots. The Atlantic & Pacific Railroad competed with the Southern Pacific Railroad, which laid track from California eastward across Arizona and New Mexico to El Paso. Laying about one and a half miles of track a day, the Atlantic & Pacific Railroad

reached the Colorado River on the Arizona-California border in the summer of 1883.

In the course of his work Wittick photographed the scenery and historic points along the railroad route and documented each of the frontier settlements that had become accessible by train. He photographed any scene that he believed would be of interest to those who had never traveled to the West—views of panoramic landscapes, geological phenomena, village streets, historic battlefields, and military forts.

During the first half of 1880, Wittick followed the railroad's route over Glorieta Pass, photographing the stagecoach stop of Pigeons Ranch, the scene of the battle that turned the tide of the Civil War in New Mexico. He next documented the route through the Pecos Valley, and then concentrated on landmarks and street scenes in and around Santa Fe and Albuquerque. Today the archives of the Museum of New Mexico house Wittick's extensive photographic record of these cities in the early 1880s—views of private residences and hotels, government buildings, churches and jails, even local band parades and funerals. Wittick next traveled south on the railroad to the town of El Paso (incorporated 1873), which, since the treaty of Guadalupe Hidalgo in 1848, had become an American border town on the Rio Grande River, across from the Mexican city of Paso del Norte, known today as Ciudad Juarez.

During his first years in the West, Wittick concentrated on landscape photography. He had a love of the picturesque, and his views of the vast desert country exhibit many of the conventions of contemporary landscape painting. However, during the three years that Wittick documented the progress of the railroad west from Albuquerque to the Colorado River, he also photographed the major points of interest in the many railhead towns that, thanks to the railroad, would soon be transformed into thriving commercial centers. In northwest Arizona Wittick photographed the new towns of Flagstaff, Williams, and Kingman. He was interested in every aspect of life in each area he visited, photographing log-

ging camps and mining projects, homesteads and ranches.

Whenever possible, Wittick made extensive detours into the land that for centuries had been the home of the Pueblo people and Athapascan-speaking tribes. During the early years of his career in the West, Wittick photographed the majority of the New Mexican pueblos: the eastern Rio Grande pueblos of Isleta, San Felipe, Santo Domingo, Tesuque, and Taos and the western pueblos of Zia, Laguna, Jemez, and Zuni.

In August 1880 Wittick made his first visit to the Hopi Mesas and stayed in the village of Shungopovi. En route to the Hopi Reservation, located eighty miles north of the railroad stop of Winslow, Arizona, he photographed the Petrified Forest and the incredible sand formations of the Painted Desert. It was during this visit to the Mesas that Wittick became the first person to photograph the Snake Dance.

During his years with the railroad Wittick had many opportunities to explore the vast homelands of the Navajo people. He photographed the wealth of geological wonders on the Navajo Reservation—canyons, lava flows, window rocks, sandstone spires, and volcanic extrusions. In 1881 he toured the Navajo settlements on the land between Albuquerque and Gallup, then traveled northwest from Gallup to the area that today is the Navajo capital, Window Rock. He then continued west to the trading post in Ganado, Arizona. Wittick recognized the importance of the trading post in contemporary Navajo life and in the course of his career made an extensive photographic record of trading posts throughout the Navajo
137 Reservation, including Sam Day's trading post in Chinle, near
125 the entrance to Canyon de Chelly, and the Chindi-lih and Tze-he-lih trading posts. In Ganado he photographed both the in-
138, 139 terior and exterior of Hubbel's trading post, classified today as a National Monument.

In 1882 Wittick explored Canyon de Chelly, traveling to the end of the main canyon and to the end of Canyon del Muerto, which branches off Canyon de Chelly. He photographed the historic petroglyphs at Mummy Cave and at White House Ruins.

Wittick was driven by tremendous intellectual curiosity and was willing and able to seek out details of the history and culture of each of the people and places he encountered. Despite his lack of formal schooling, he was a self-educated man who had a love of poetry and history and an interest in chemistry, geology, and ethnology. Each time he encountered a different Indian tribe, he made every possible effort to study the customs and daily life, dress, artifacts, and craft arts of the people. For example, in 1890 he wrote to Tom Hughes, editor of the *Albuquerque Citizen*, describing his concentrated effort to learn the basic vocabulary of the Havasupai: "While among these people I made up a vocabulary of their language—or I ought to say a sort of a vocabulary—the names of articles—and utensils used by them—names of animals—insects, birds and reptiles, the elements, etc."[4]

Wittick was one of the first to appreciate the historic and aesthetic value of the craft arts of the Pueblo and Navajo people. He photographed Hopi baskets, pottery, and weaving, pottery from the Rio Grande and Western Pueblos, Navajo weaving, and Apache baskets and weapons. He also made a series of photographs of prehistoric Indian pottery. He was particularly fascinated by the ceremonial costumes and dance masks of the Hopi. Among his papers are accounts of both the Washing of the Snakes and the public Snake Dance, describing in detail the dress, ceremonial paraphernalia, and ritual movements of each of the participants in the ceremonies. These reports include meticulous pen sketches of the sand paintings, prayer sticks, and altar.

In the course of his Southwest career, Wittick acquired a comprehensive collection of Indian craft arts, traditional costumes, and artifacts. His collection included Navajo and Hopi weaving, Pueblo pottery, and the personal clothing and possessions of many of the famous Indian chiefs who were his

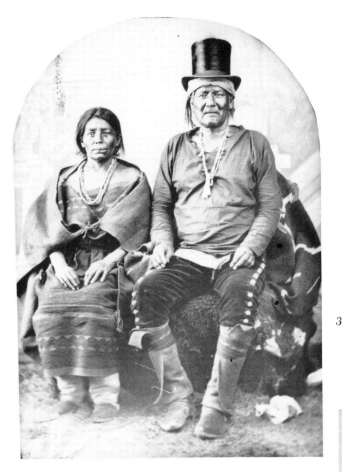

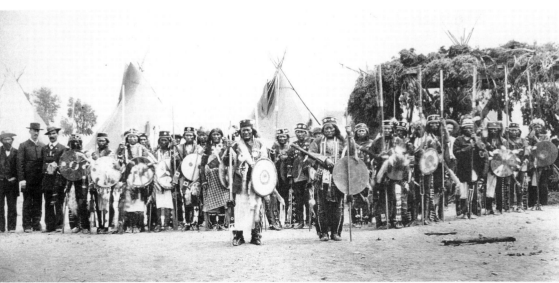

30. *Manuelito, Chief of the Navajo, and his favorite wife, Juanita.*
 C. 1882. Photo: Private Collection

31. *Mescalero Apache of New Mexico, Tertio-Millennial Celebration, Santa Fe.*
 1883. Photo: Private Collection

portrait subjects. Whenever possible, he purchased or exchanged photographs for some of his subject's most interesting possessions—items of clothing, artifacts, or pieces of pottery. In October 1881 Wittick had the opportunity to attend the Territorial Fair in Albuquerque and photograph the Navajo women at their looms. When, in 1882, Wittick again attended the Territorial Fair, he met Manuelito, the Navajo leader. Wittick not only persuaded him to pose, but purchased his bow, fur quiver, moccasins, and several other parts of his attire.

Wittick used many of the artifacts in his collection as studio props. He traveled with a full assortment of costumes, backdrops, and artifacts, and therefore was able to make Indian portraits on his field trips similar to those made in the studio. Wittick found Indian portraiture especially profitable, for not only did these photographs have excellent sales potential, they frequently provided trade opportunities, enabling him to add to his collection of artifacts and craft arts.

Wittick was a friendly man and from the beginning developed a fine rapport with his subjects. He tried to learn as much as possible about the world in which they lived, and in the course of time developed personal friendships with many of those he photographed. He never insisted on a prop or costume that would be offensive or embarrassing to his subject.

Wittick's photographs, especially his portraits, are easily identifiable by certain distinctive characteristics. He worked outdoors in bright sunlight, where he carefully posed his subject in front of a painted backdrop, then added shrubbery and artifacts for foreground interest. The majority of Wittick's posed portraits featuring painted backdrops were taken during the first decade of his career in his Santa Fe and Albuquerque studios or on field trips to the nearby pueblos. He had neither the knowledge nor the equipment for candid photography; even in his fieldwork, his subjects were always carefully posed. Even in the brightest sunlight, the subjects had to hold absolutely still for what must have seemed an endless time. In his fieldwork, as in his studio portraits, Wittick's style is evident in the careful placement of the foreground objects and the inclusion of ceremonial paraphernalia, items of clothing, tools, and artifacts.

Wittick's portrait subjects had the opportunity to select parts of their costumes and props, i.e., guns, bows, and arrows, and agreed to pose in front of a painted backdrop that featured a Victorian house, neoclassical architecture, or a desert-woodland fantasy. However, Wittick frequently suggested the costume and setting with the greatest commercial appeal. The same backdrops, items of clothing, and props appear in photograph after photograph and have little relation to the tribal origin of the subject.

Because of, rather than despite, their incongruities, Wittick's Indian photographs offer significant insight into the lives of the subjects and the cultural integrity of the different tribes of this time in history. There is little doubt that all of Wittick's subjects, both the portrait subjects and those who appear in the field studies, lived in an age of transition, because Indians who had had little or no previous contact with Anglo-European society never would have agreed to pose for portraits or even to be included in field studies.

The willingness of an Indian to wear a costume, utilize props, and pose in front of a painted backdrop is a clear indication of the degree of the subject's acculturation and development of a dual cultural identity. Indians from the Rio Grande Pueblos who three centuries before had been converted to Catholicism and subsequently accepted the domination of the Spanish, Mexican, and United States governments, Navajo who worked as guides for the United States Army, Apache who helped the army to track their tribesmen who resisted capture —all were willing participants in Wittick's photographic pageant. Their choice of clothing, props, and backdrop—loincloths, trousers, feathers, hats, guns, and bows and arrows — mirrors the fundamental confusion of their lives during these years. For example, Wittick's photograph of an Apache

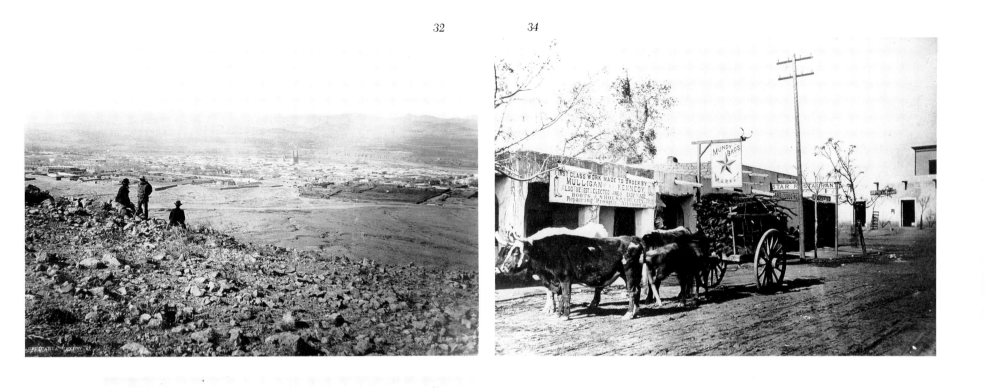

33

32. *View of Chihuahua, Mexico.* December 1882. Photo: Private Collection

33. *Rio Grande Crossing at Paso del Norte (Ciudad Juarez), Mexico.*
 December 1882. Photo: School of American Research Collections in the Museum of New
 Mexico, Santa Fe

34. *Oxen Wood Wagon, El Paso, Texas.* December 1882. Photo: School of American
 Research Collections in the Museum of New Mexico, Santa Fe

police officer sitting on a bearskin rug in front of a romantic backdrop of neoclassical architecture, wearing a military hat and badge, Anglo work pants, a traditional fringed woven dance sash, and moccasins, suggests the psychological reality of an Indian who was working for a United States Army regiment. Wittick's portraits of Old Washie, a Navajo woman surrounded by Pueblo pottery in a woodland setting; Es-ta-yeshi (Old Nell or Nelly), a Navajo woman with a pistol, posed in front of a background of woodland trees and a foreground of desert cacti; and Peggy, a Navajo woman wearing full European dress decorated with Navajo jewelry, all testify to the cultural confusion of the day.

There is little doubt that many of Wittick's subjects enjoyed participating in this costume pageant, masquerading as fierce, heroic, or noble protagonists in the drama of the West. In a period of Indian history characterized by a confusion of cultural identity, Wittick's portrait subjects were willing participants in a world of make-believe. Cultural accuracy was never a consideration.

The ethnological inaccuracies and cultural confusion in Wittick's portraits are indicative more of prevailing cultural attitudes than of ignorance on the photographer's part. Displaying a wide range of stereotypical artifacts, Wittick's photographs appealed to the prospective purchaser as authentic images of the aboriginal inhabitants of the West. For Wittick's customers, an Indian was an Indian, and the more dramatic and ornate the setting and costume the better.

During his first years in the West many of Wittick's subjects were simply examples of ethnic types; photographs of this period carry such labels as *Apache Buck*, *Mojave Belle*, and *Squaws of Isleta*.[5] In time Wittick developed an understanding of his subjects as individuals with tribal, family, and personal identities. Wittick often included the name, position of authority, and sometimes personal history of his subject either on the negative or on the back of the card used to mount his print. The Navajo Woman, Chuna, and the Laguna Woman, Tzashima,

became favorite subjects who appear repeatedly in his work.

In contrast with the majority of Southwest tribes, the Hopi, who during Wittick's lifetime enjoyed the greatest cultural continuity of any Indian people (as they do even today), refused to participate in Wittick's staged photographic productions. The Hopi have had the greatest success in retaining their cultural integrity. They continue to live in ancient stone houses of their ancestors and observe the ancient rituals in the cycle of the ceremonial year. Wittick's only Hopi portraits are of young girls in traditional Hopi dress. Wittick's photographs of the Hopi were limited to street scenes, public ceremonies photographed from a sanctioned location, and a few genre scenes of traditional Hopi life.[6]

During the summer of 1883 Wittick had the opportunity to photograph the Tertio Millennial Celebration in honor of the 333d anniversary of the settlement of Santa Fe, the oldest city in the Southwest. Tom Wittick described the event in a letter:

They call it the "Tertio-Millennial Celebration". It commenced July 3rd and will continue through August 15th. They have mining, agricultural and general industrial exhibits from all parts of the Territory, relics of the early settlement times, and Indian games and dances, historical pageants and lots other minor details. They have large grounds and race-track, and a very large exhibition hall....Among the relics were a lot of heavy, large-bore, flint-look "escopetas" and "pintolas," which were used by the Spanish knights who conquered the country over three hundred years ago, and some swords and lances. Also saw Kit Carson's rifle, a long, heavy, octagon-barrel, mizzle loader. On Friday afternoon they repeated the historical pageant of "The Knights of Coronado," illustrating the coming of the Spaniards under Coronado, the conquest of the natives, the Indian rebellion of 1682 and the expulsion of the Spaniards, the reconquest, the American occupation, the Santa Fe Trail, etc. They had the same procession on the 18th, 19th, and 20th of July, and it was a big affair then, as they had,

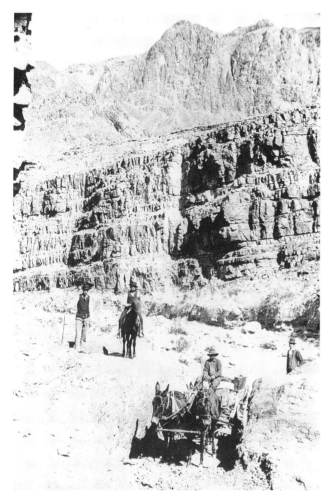

35. *En Route to the Grand Canyon, Arizona.* 1883. Photo: School of American
Research Collections in the Museum of New Mexico, Santa Fe

36. *Hualapai Indians, Grand Canyon, Arizona.* 1883. Photo: School of American
Research Collections in the Museum of New Mexico, Santa Fe

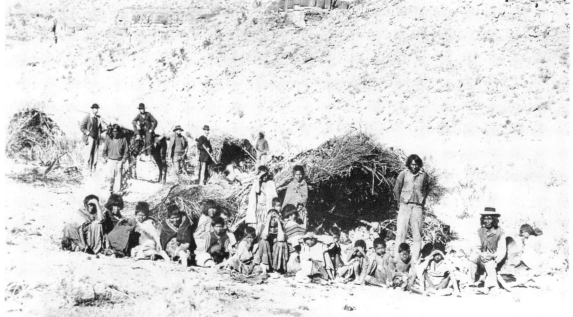

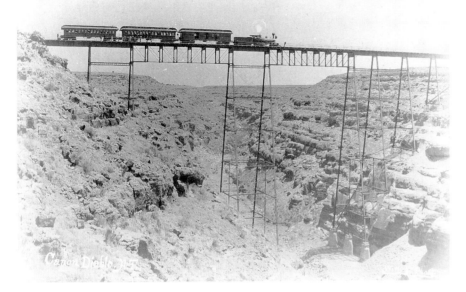

37. *Canyon Diablo, Arizona*. 1883. Photo: School of American Research Collections in the Museum of New Mexico, Santa Fe

38. *Mormon Settlers, Residence of J.N. Smith, Snowflake, Arizona*. 1883.
Photo: School of American Research Collections in the Museum of New Mexico, Santa Fe

…four or five big bands of Pueblos, a big band of Apaches, the "Laguna Rifles" (Indian cavalry) and Fountain's "rustler" killers, the "Don Ana Rangers".[7]

Wittick's photographs of the delegation of Mescalero Apache who participated in the celebration include group portraits of the entire Apache delegation posed with army officers and more intimate studies of the Mescalero Chiefs, San Juan and Nodzilla. At the fair Wittick also photographed the Crow Dance of the Tesuque Pueblo, which was performed in the courtyard of one of the government buildings.

About 1881, Wittick opened his second photographic studio, a "gallery" in partnership with R. W. Russell. The gallery on Gold Avenue in Albuquerque, between First and Second Streets, offered the services of "Wittick and Russell: Landscape and Portrait Artists." The two men then entered the publishing business. Their cards advertised single images and stereoscopic "Views of New Mexico and Arizona— Photographed by Ben Wittick—Ancient Ruins, The Pueblos, Curiosities, Indians, Etc." Wittick's first commercial stereo images include street scenes of Santa Fe and Albuquerque, views of the pueblos, Indian dances, and some human-interest features, such as photographs of the old women of the Laguna Pueblo, said to be one hundred years old.

Throughout his career Wittick was financially independent, supporting himself by the sale of his Southwest photographs: landscape views, images of Indian life, and Indian portraits. His only subsidy was the transportation provided by the Atlantic & Pacific Railroad during the early 1880s. Wittick supplemented his income from the sales of landscape and Indian photographs with orders for portraits of the local residents of the communities in which he operated galleries—Santa Fe, Albuquerque, Gallup, and Fort Wingate. In late 1883 Wittick ended his partnership with Russell and established his own publishing company. He advertised "Views in New Mexico, Arizona and Old Mexico: Photographed by Ben Wittick. Ancient Ruins of the Cave and Cliff Dwellers, the Pueblos, Grand Canyon of the Colorado, Walapai Indians, Supias, Apaches, Navajos, Mojave, Curiosities, etc., etc. Views along the Atlantic and Pacific Railroad in Arizona, views of the Petrified Forest in Arizona."

Wittick traveled with three sizes of Swiss lens board: 11 × 14 inches, 8 × 10 inches, and 5 × 8 inches. He also carried a stereoscopic lens board of 5 × 8 inches. Both the 5 × 8-inch and the 8 × 10-inch boards were used in the same camera. His standard traveling equipment included two cameras, a tripod, and a portable tent, the Blue Max, in which he prepared and developed his glass plates. Wittick's camera had no shutter, so he used the cover of his lens barrel to control the exposure time. In late 1882 or early 1883 Wittick switched from wet-plate to dry-plate equipment. This change made it possible for him to prepare the glass plates in advance and avoid carrying many of the heavy bottles of chemicals needed for the immediate development of the wet-plate photographs.

Wittick developed his own negatives and made his own contact prints. He mixed all of the chemicals, as no premixed photographic products were available. He was especially fond of gold toner (made from half a gold coin dropped into a solution of aqua regia), which gave a radiance and a sense of importance to the finished photograph.

Wittick photographed his portrait subjects from a sufficient distance to allow the scenic backdrop and the foreground props to appear on the original glass plate; however, he then masked out whatever part of the photograph he believed detracted from the impact of the subject. He often made glass-plate photographs of contact prints made from the original glass plates. As a result, many of the surviving Wittick glass plates are positives rather than negatives.

Wittick made extensive use of his retoucher, following the photographic fashion of the day. Although these forced

changes were intended to make his subjects more exotic, they detract from the quality of the finished photographs. The heavy hand of the retoucher gives Wittick's subjects a strange staring quality that deprives them of their fundamental humanity, one of the most important features of photography.

Even while working for the railroad, Wittick pursued independent adventures. On December 21, 1882, he and his son Tom boarded the Atlantic & Pacific Railroad and traveled south to Mexico. The next morning they arrived in El Paso, across the Rio Grande River from Paso del Norte. Wittick photographed the major landmarks of both border towns, and the next day father and son traveled to Chihuahua and spent a few days in the colorful Mexican city.

33

32

Tom kept a diary of their trip, which he used almost verbatim in a letter home to "Mammy and Grandmam and the boys." On Christmas day he recorded: "It will be an unlucky Christmas for some Mexican soldiers, for on Christmas morning a regiment of Mexican Cavalry rode out of town in pursuit of Apaches who had raided the town of Casa Grande, killing 75 Mexicans, and destroying the town.... I saw the man here who killed Victorio. He gets a pension, wears a nice uniform, and a badge and gold medal."[8] In the entry for December 26–27 he reported their progress in photographing the city and their friendship with a Mexican photographer, Velarde, who had traveled to Europe and Japan. In a letter from Chihuahua dated December 28, 1882, to "Dear old Mammy" Ben Wittick recalled a discussion with Velarde over the advantages of the dry-plate process.

On January 2 they returned to Paso del Norte, then spent the night in El Paso. The two Witticks incurred minimal travel expenses, for they traveled to Mexico on a pass from the Atlantic & Pacific Railroad and at Paso del Norte received a pass from the Mexican Central Railroad.

In his letter from Mexico Tom described the activity of his father's photographic business in Albuquerque, which had been a railroad stop for just two years:

Albuquerque is a rattling town and Wittick & Russell, the pioneer photographers of the whole southwestern U.S. "und dond you forgod id". They have the best gallery and a good location. Pay $50 rent and $75 to the retoucher. There are only two others in town now Mrs. E.L. Albright and "another fellow". All three galleries are near together, Mrs. Albright's about two or three doors from us, and the other one right across the street. W. P. Carter, the fourth photographer, died with the small-pox while we were gone.[9]

After the Mexican trip the Witticks returned to Albuquerque, then, in April, set out on a two-week trip to New Mexico and northern Arizona. Their primary destination was the Grand Canyon. From the train window Wittick viewed the Mormon towns of St. Joseph, Brigham City, and Sunset, which he planned to visit and photograph on a later trip. The highlight of the train ride was the crossing of the Canyon Diablo Bridge, which was completed in the summer of 1882, and the Johnson's Canyon Bridge. Tom described the experience:

37

During the day we passed over Canon Diablo Bridge, 312 miles west of Albuquerque, and Johnson's Canon Bridge, about 400 miles west. Canon Diablo is 60 miles in length, and about 265 feet deep at this point. It is a sort of big crack in the level country all around, and you can't see it until you are right onto it. The big iron bridge across it is 600 feet in length, and cost $250,000....Johnson's Canon is crossed by two iron bridges, each as big as Canon Diablo Bridge. There is a tunnel near Johnson's Canon, about 125 yards in length.[10]

The traveling party stopped in Peach Springs, which Tom described as "a place of about twenty rough buildings and tents, all business places, and all but one sell whiskey. It was pay-day there, and some of the rail-roaders were 'happy' and

39. *Wittick and Apache Scouts, Arizona.* C. 1885–86. Photo: Private Collection

51

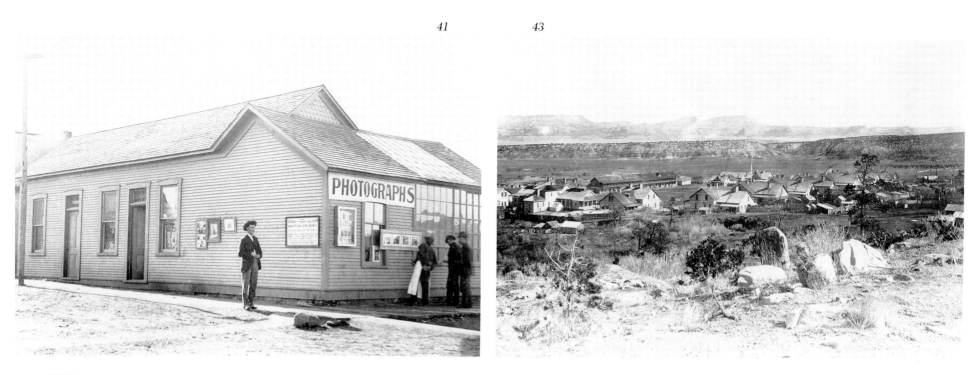

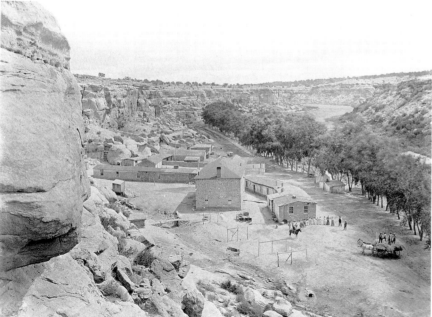

41. *Wittick's Studio, Gallup, New Mexico.* C. 1890. Photo: Private Collection

42. *Keams Trading Post, Keams Canyon, Arizona.* C. 1890. Photo: School of American Research Collections in the Museum of New Mexico, Santa Fe

43. *Fort Wingate, New Mexico.* March 1890. Photo: School of American Research Collections in the Museum of New Mexico, Santa Fe

'paralyzed,' and cavorting around and dancing jigs to admiring audiences."[11] There they met Will Brockway, the man who was supervising the laying of the pipeline from the springs to the railroad station. Brockway organized and led the expedition [35] into the Grand Canyon. Before entering the canyon, the Brockway party stopped at the Lower Springs, where Wittick [36] had the opportunity to visit a Hualapai (Walapai) encampment. Tom wrote of the adventure:

There were a lot of the Walapais camped there, a sort of nomad race of Arizona, something like the diggers. Some of the kids were picturesquely clothed in a necklace, and some with a piece of string through their ears. Their daddies were engaged in the romantic occupation of picking lice out of their heads. The famous "Captain Jack" of the Walapais, was one of the crowd. He was pretty well "heeled;" he had a Winchester, a "Colt's 45" and a bowie. "Cappum Zshack," (as he called himself) imparted to us the mournful information, that he was going first "to the nice place hackberry, and then me go way off where white man never see me no more, live dere all same, and all time die dere".[12]

Wittick returned from the trip with a detailed photographic record of the Hualapai, who were the least acculturated tribe he had encountered to date, and with a wide range of photographs of the rock formations and vistas of the canyon.

Four months later Wittick and Tom again boarded the Atlantic & Pacific Railroad, this time to Needles, California, where they photographed a Mohave village on the Colorado River. [52] En route they stopped in Flagstaff, a small town settled in 1878, where Wittick photographed the largest sawmill in the Arizona Territory. They proceeded to Fort Moroni, a Mormon settlement, where they visited the ranch of John Young, the third son of Brigham Young, then to Snowflake, another Mormon community, where Wittick photographed the family and

residence of J. N. Smith. The travelers then returned to the [38] railroad depot at Flagstaff and proceeded to Peach Springs, the final stop of the passenger railroad. They then set out, first by freight train, then by construction train, for the Colorado River, which was 110 miles away. Needles City lay at the end of the track, 6 miles from the river. Tom described the town as a "lot of tents, and mud-and-sticks houses, built in Mojave style, all saloons."[13]

He reported that between six hundred and eight hundred Mohave Indians were living at Needles and many more on a reservation located down the river, and described the area as "all sand and lava, and *I think never has cooled. The Colorado* desert is about the hottest place on the continent."[14]

Wittick spent the entire day photographing the Mohave people, their dwellings, and the marshland that was their home. In later years Wittick made formal portraits of several Mohave men and women. The women wore commercial fabric [82, 83] skirts, but only jewelry above the waist. On their faces were tattoos and painted lines, which were considered adornments of great beauty.

After Wittick had made several views of the landscape, they crossed by boat to the California side. Tom wrote of the area: "The channel of the river is about three hundred yards wide here, and twelve or fifteen feet deep. Here at the Needles it is about two hundred miles lower down toward the Gulf, than where we were in the Grand Canon. I didn't fall in love with the part of California which I saw. I fell in hate. It was like the Arizona side, only more so. Nothing but sand and 'malpais,' with a little chapparal near the river."[15] The Witticks then walked two miles to a town under construction by the Southern Pacific Railroad. There, for the first time, they saw Chinese railroad workers. The party remained in the area for several days in order to photograph the Needles, a volcanic formation of sharp peaks along the Colorado River. During the first days of their journey home, Wittick made a series of photographs of desert vegetation, including oco-

tillo, Spanish bayonet, yucca, and the pale green paloverde.

53 / 50 On the return trip they stopped at Kingman, Williams, and
51 Holbrook to photograph the towns. In Kingman they had an
unusual encounter with the Hualapai. Tom recalled: "In the
afternoon I saw a sort of a circus—a half dozen half-drunk Wala-
pai squaws came staggering up the street, arm-in-arm, singing
'Rally around the flag, boys.' They didn't know a word of what
they were singing, but they had got it down pretty fine from
hearing the railroaders sing it."[16]

Wittick returned to Albuquerque only long enough to pro-
cess his negatives, then traveled north to Colorado. On his
return from this trip, he made a special detour and became the
first to photograph successfully the pueblo of Acoma. (See Ap-
pendix page 204.) Tom described the community:

Acoma is one of the largest and, up to recent times, one of the
least known of the Pueblos. It is about seventeen miles south of
"Laguna."...The Pueblo of Acoma has about a thousand in-
habitants. The Indian name for it means, "The village on the
rock." The town is built upon a great rock, which rises two
hundred feet above the plain, and is inaccessible except by four
passage-ways, only one of which a horse can climb, and this
approach was built by the Indians. The other three are secret
passes, and are stairways and niches, cut in the face of the
rock, up through fissures.[17]

In a postscript to the letter, Tom wrote of his father's photo-
graphic record of the Southwest: "Father has a large collection
of characteristic views of this southwestern country (about two
thousand negatives) most everything. He has views of most all
the Pueblos and the Pueblo Indians, and a big collection of the
wild ones including Apaches, Navajos, Walapais, Mojaves,
Yumas and Kiowas. Also views in Mexico, and of the ancient
ruins of the cave and cliff dwellers, the Grand Canon and ev-
erything characteristic of the country and the natives."[18]

In 1885, as an unofficial member, Wittick joined Colonel
Stevenson's government-sponsored expedition to Canyon de
Chelly and the Grand Canyon. Once in the Grand Canyon, he
left the group to visit Cataract Canyon, a side branch of the
Grand Canyon. Havasu Canyon (then called Supai Canyon), a
side canyon of Cataract Canyon, served as the home of the
Havasupai Indians. Discovered in 1776 by Father Garcias, this
canyon has walls eight hundred feet high. Wittick descended
into the Havasupai settlement on a rope ladder, carrying his
cameras, glass plates, and full photographic equipment. An
1890 letter to Tom Hughes describing Havasupai Falls shows
Wittick's interest in the history and geology of the area and his
attention to detail. Wittick described the Havasupai settle-
ment and their leaders:

An old man by the name of "Nel-aho-" or "Navajo" as the min-
ers called him, was the Chief at the time of my visits, and
"Captain Tom" was a sub-chief and the only one I found who
could talk any English. Capt. Tom is the "Boss" really. He is
blind in the right eye—lost his eye by an arrow splitting on the
bow string, he told me. They numbered at that time about 270,
86 being males grown and among them eleven blind or par-
tially so. They claim to be pure blooded—allow no half breeds
among them—allow no other Indians—such as Wal-labais—
Mojaves or others to live in their Canon. Fear the Apaches and
Navajos as they do their evil spirit, are friendly with and visit
back and forth with the Moquis (Hopis) a band of whom visited
them while I was among them.[19]

On this trip Wittick also photographed Bridal Veil Falls, 66
Mooney Falls, and Beaver Falls.

Wittick had loved the military since boyhood, and during
the 1880s and 1890s he visited army camps throughout the
Arizona Territory and photographed military life at Fort Tho-
mas, Fort Defiance, Fort Apache, and Fort Huachuca. In 1886

he established a photographic studio at Fort Wingate, which served as his home base for the rest of his life.

During 1885 and 1886 Wittick had the opportunity to travel with the Fort Wingate troops and their Navajo scouts on their campaign against the Chiricahua Apache. The Fort Wingate troops were commanded by Captain Ben Rogers, and in the course of the campaign Wittick had the chance to photograph many of Rogers's scouts, including Largo, Pedro, Gayetenito, and Biziz. Wittick also photographed Chee Dodge, dressed in buckskin jacket and trousers, wearing a white man's hat and carrying a rifle. In 1884 Dodge succeeded Manuelito as the head of the Navajo Nation.

During the 1885–86 campaigns Wittick also photographed many of the Chiefs and Sub-Chiefs of the Chiricahua Apache who worked as scouts for the United States troops. Several of the Apache leaders, realizing that capture was inevitable, had agreed to surrender and cooperate with the United States government by serving as scouts for General Crook and his officers. It was only with the help of those Apache guides that the United States troops were able to capture the last renegade Apache. Following the final surrender of Geronimo and Mangas, the cooperative Apache leaders were sent to Washington, D.C., where they were received by President Grover Cleveland, presented with medals of honor, and dispatched to prison with the rest of their people.

During the last phase of the Apache wars, Wittick photographed not only Apache leaders who served as army scouts, but also captured chiefs, such as Nachez and Mangas. In 1886 Wittick photographed the Indian encampment at Fort Apache, an army camp established in Arizona in 1870 to serve as a base to supervise the Apache confined to the San Carlos Reservation. In October 1886 Fort Apache served as a debarkation base for the Chiricahua Apache prisoners. From there these Apache men, women, and children were sent by train across the nation. They were first imprisoned in Florida, then in Alabama, and finally transferred to Fort Sill, Oklahoma. It was twenty-seven years before the Chiricahua Apache prisoners were freed and given the choice of accepting a land allotment in Oklahoma or sharing the San Carlos Reservation with the Mescalero Apache.

During his years in the Southwest, Wittick remained fascinated by the ceremonial dances of the Pueblo people and had the opportunity to photograph a wide range of important rituals. In 1887 Wittick photographed the dance performed in honor of the inauguration of the Governor of the Laguna Pueblo. In December 1896 he made a trip to Zuni to photograph the Shalako Ceremony, the ritual blessing of new homes, which is the most colorful ceremony of the winter months. Performing from sundown until sunrise, the Shalakos, ten-foot-tall masked dancers, offer prayers for the health and happiness of the Zuni people and the sustenance and propagation of life in the Zuni world. The Shalakos are rain spirits that are sacred messengers for the Zuni prayers. In the summer of 1897 Wittick accompanied an army troop maneuver to an encampment near the Zuni Pueblo. During this trip he again had the opportunity to photograph the Kachina Dancers and made an extensive series of portrait and genre studies of the Zuni Pueblo.

During the 1890s Wittick continued to make his annual summer pilgrimage to the Hopi Reservation. In 1897 he made an extensive series of photographs of the Snake Dances at Walpi and at Mishongnovi, and in 1898 he photographed the Snake Dance at Oraibi. In 1903 Wittick again traveled into Canyon de Chelly, where he photographed the White House Ruins and Mummy Cave.

During the 1890s Wittick operated studios in both Gallup and Fort Wingate. During these years he was a familiar figure in these towns. Dressed as a prosperous Western gentleman with coat, vest, tie, and high leather boots, he sported a huge garnet ring, which he called his "Arizona ruby."

In 1900 Wittick sold his Gallup studio to two young men and

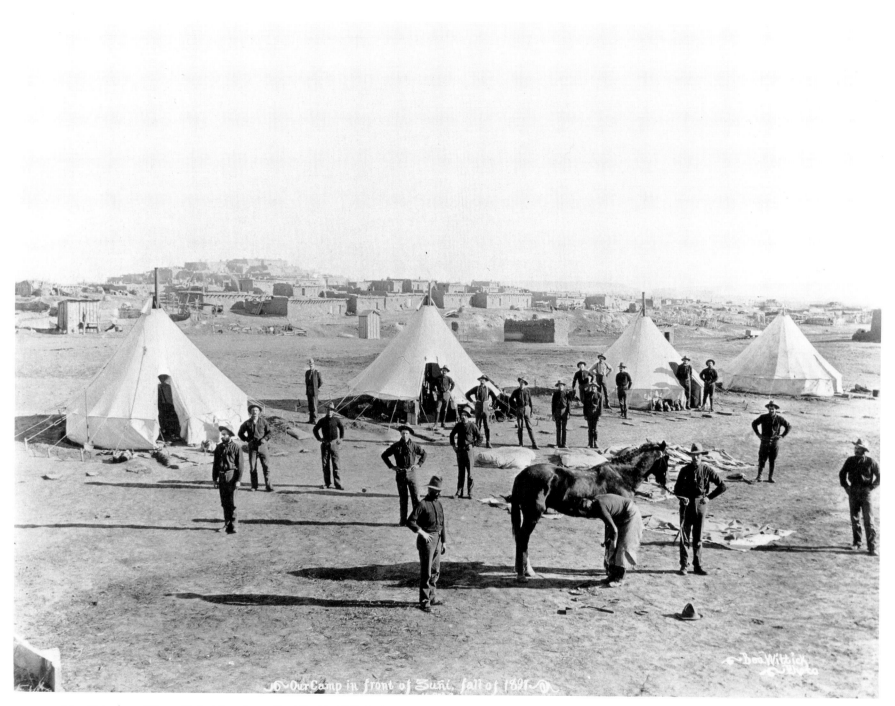

Our Camp in front of Zuñi, fall of 1897

44. *Detachment Troop K, 2nd Cavalry, at Zuni Pueblo.* Fall 1897. Photo: School
of American Research Collections in the Museum of New Mexico, Santa Fe

moved all of the photographic equipment into his gallery at Fort Wingate. Wittick continued to make periodic trips to the nearby Indian reservations and completed an extensive photographic study of life at the fort. [20]

Wittick traveled with Tom for many years, but as his son grew older and rebelled against the discipline and limitations of assisting his father, they quarreled and separated. [21] After his quarrel with Tom, Wittick periodically traveled with his sons Archie and Charlie. Both sons had inherited their father's artistic ability: Charlie carved wood figures and wrote short stories of travel and adventure in the Southwest, and Archie made detailed pen-and-ink sketches. Archie, who had been deaf since infancy, was killed at a railway crossing in 1912 when he failed to hear an approaching train.

Although in recent years Americans have turned to historic photographs with a new awareness of their importance as a part of the nation's cultural legacy, Wittick enjoyed recognition and success during his lifetime. He was financially secure and was admired by his contemporaries, who recognized the value of his contribution. Charles Lummis, one of the outstanding writers and photographers of his generation, paid tribute to Wittick by calling him "one of the best photographers ever in the Southwest." [22]

During his lifetime Wittick was well aware of the historic value of his photographs and carefully documented and stored his glass plates and prints, the fruit of twenty-five years' work. His ultimate goal was to write and illustrate a book on his Southwest travels—a book that would include anecdotes of his travels, descriptions of sacred ceremonies, and pen-and-ink sketches of sacred paraphernalia, and feature his choice of his outstanding photographs of the land and people of the Southwest during the final quarter of the nineteenth century. The fatal snake bite ended Wittick's dream. [23]

Although Wittick's sons had had the opportunity to travel and work with their father, ironically, it was his daughter, Mamie, who preserved the majority of his letters, glass plates, and prints, and saved his work from destruction and oblivion. Mamie Wittick Maxwell provided historians with all available biographical data, and her recollections, family papers, and some military documents are the primary surviving records of Wittick's life.

Over the years many other Wittick photographs have been located, and today there are extensive collections of Wittick's work in the photographic archives of the Science Museum of St. Paul, the Centennial Museum of the University of Texas, El Paso, the Arizona Historical Society, the University of Arizona, the Oklahoma Historical Society, the Southwest Museum, Yale University, Princeton University, and the Smithsonian Institution.

Before beginning a tribe-by-tribe study of the Indian world of Ben Wittick, it is important to confront several of the problems of attribution that have plagued those who study frontier photography of this period.

In August 1897, Adam Clark Vroman, Frederick Monsen, and Ben Wittick all visited the Hopi Mesas and photographed the Snake Dance at Walpi. Vroman described the scene: "Mr. Hayt and Mr. Munson [sic] both were so wrapped up in watching the Dancers that they forgot all about their cameras and at one time I had seven cameras to work from my point of view." [24] Vroman's account of the event and Wittick's photographs point out one of the difficulties in the attribution of historic photographs of the Southwest. By the end of the century there were so many photographers attending Indian events and their behavior often was so intrusive that the Indians had begun to confine them to special areas, thus forcing all photographers to record the same subject from the same viewpoint. For some of these ceremonies—for example, the one at Walpi—copyright marks, signatures, etc., offer little proof of who took which photograph.

45

The frontier photographers of Wittick's generation traded photographs, using one another's work in lectures, and occasionally even pirated photographs, selling others' work as their own. It is not surprising that scholars often have changed the attribution of photographs of this period and will continue to question and revise attributions as they try to solve the riddle of which photographer took which picture. Fortunately, in some cases research does result in positive identification and the rectification of mistakes. For example, the photograph of Geronimo that for many years was attributed to Ben Wittick now is recognized as the work of John K. Hillers.

The majority of Wittick's photographs are well documented; however, attribution problems surround a number of the portraits. Wittick worked with several partners during his career. From 1881 to 1883 he was in partnership with R. W. Russell, who generally operated the studio whenever Wittick traveled. Wittick frequently traveled with his sons Tom and Archie, both of whom were competent photographers. In the course of his career Wittick traveled and worked with several other photographers; for example, at one time he had an association with J. C. Burge.

The most difficult of the attribution problems focuses on the Apache portraits that bear the copyright mark of A. Frank Randall. Several of the same Apache portrait prints that are mounted on Wittick's studio boards and carry Wittick's copyright can be found on Randall's mounts and carry his copyright stamp. Randall, an itinerant photographer based in Wilcox, Arizona, traveled across the Southwest during the last years of the Apache campaign. Very little is known of the details of Randall's life, and no records have been found to document whether he and Wittick ever had a formal partnership. The Wittick-Randall photographs remain a mystery today.

In the course of my work on Wittick I often have been asked if I finally had solved all problems of attribution. The answer is clear. I do not pretend to have all the answers. Unless records are found that confirm who, over a hundred years ago, actually held a specific camera in a specific place, many of the attribution questions will continue to remain unanswered.

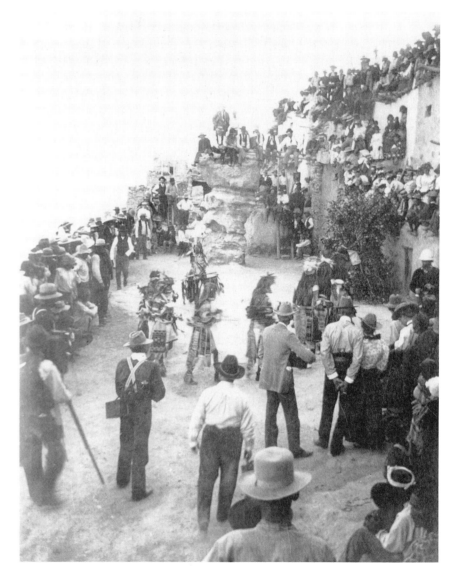

45. *The Beginning of the Snake Dance, Walpi Village, Hopi Mesas, Arizona.* 1897. Note the crowd of photographers in the foreground. Photo: Private Collection

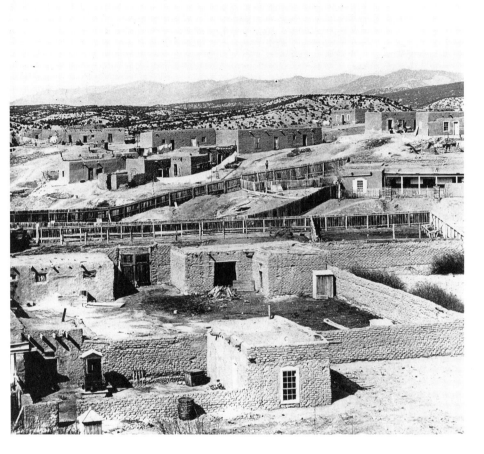

46. *"La Loma" or "The Hill," Montoya Hill, Santa Fe, New Mexico.*
April 1881. Photo: School of American Research Collections in the Museum of
New Mexico, Santa Fe

47. *Plaza, Santa Fe, New Mexico. C. 1881* Photo: School of American Research
Collections in the Museum of New Mexico, Santa Fe

48. *View in Rio Chiquito Street (Water Street), Santa Fe, New Mexico.*
April 1881. Photo: School of American Research Collections in the Museum of
New Mexico, Santa Fe

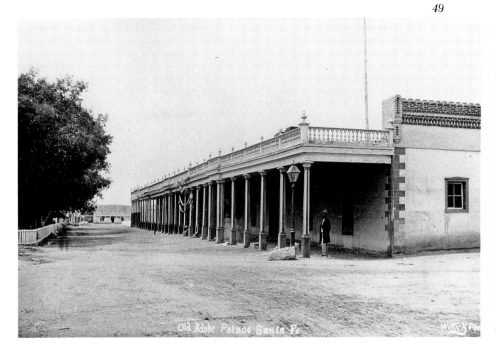

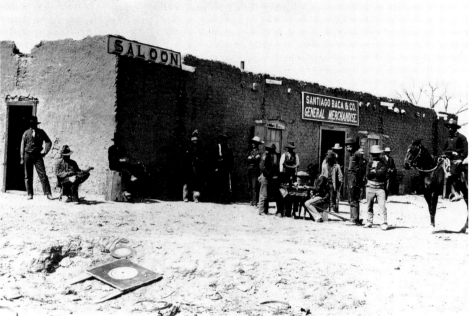

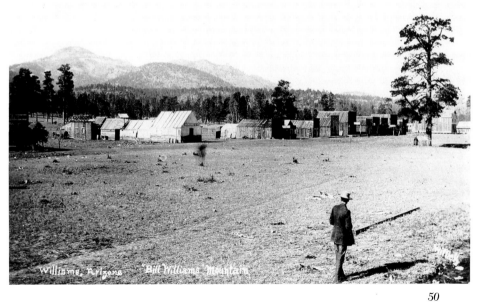

49. *Palace of the Governors, Santa Fe, New Mexico*. C. 1880. Photo: School of
American Research Collections in the Museum of New Mexico, Santa Fe

50. *Williams, Arizona*. 1883. Photo: School of American Research Collections in the
Museum of New Mexico, Santa Fe

51. *Horsehead Crossing of Little Colorado, Holbrook, Arizona*. C. 1883.
Photo: School of American Research Collections in the Museum of New Mexico, Santa Fe

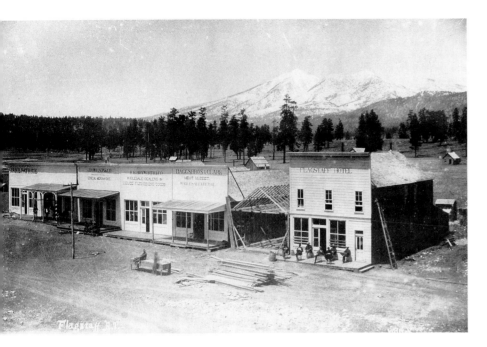

52. *Flagstaff, Arizona.* 1883. Photo: School of American Research Collections in the Museum of New Mexico, Santa Fe

53. *Kingman, Arizona.* 1883. Photo: School of American Research Collections in the Museum of New Mexico, Santa Fe

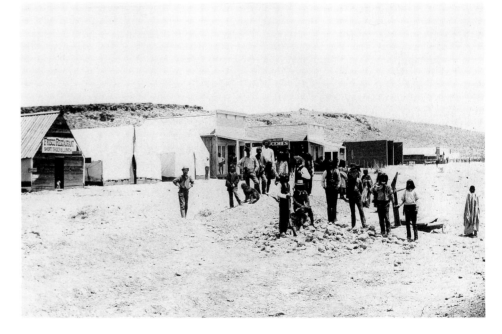

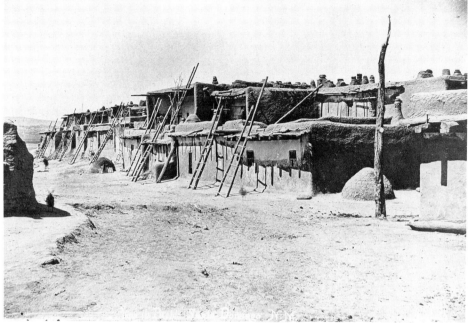

55. *Street Scene, Santo Domingo Pueblo.* C. 1883 Photo: School of American Research Collections in the Museum of New Mexico, Santa Fe

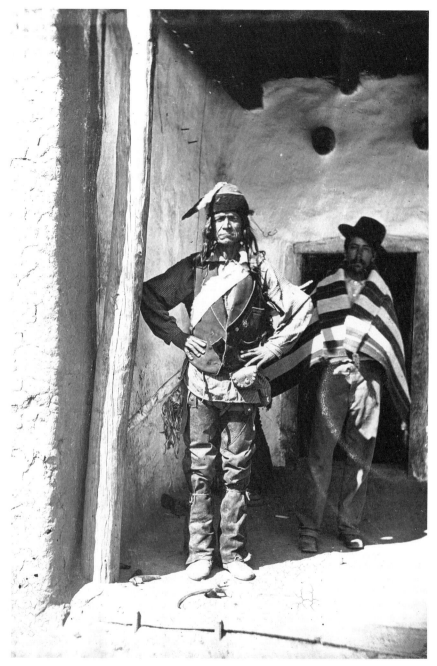

54. *Governor of Santo Domingo Pueblo.* C. 1883. Photo: School of American Research Collections in the Museum of New Mexico, Santa Fe

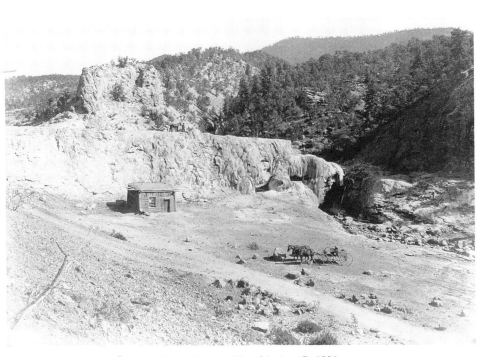

56. *Soda Dam, Jemez Springs, New Mexico.* C. 1882. Photo: Museum of New
Mexico, Santa Fe

57. *Jemez Pueblo.* C. 1882. Photo: School of American Research Collections in the Museum
of New Mexico, Santa Fe

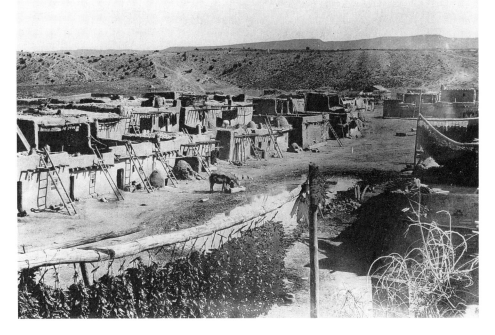

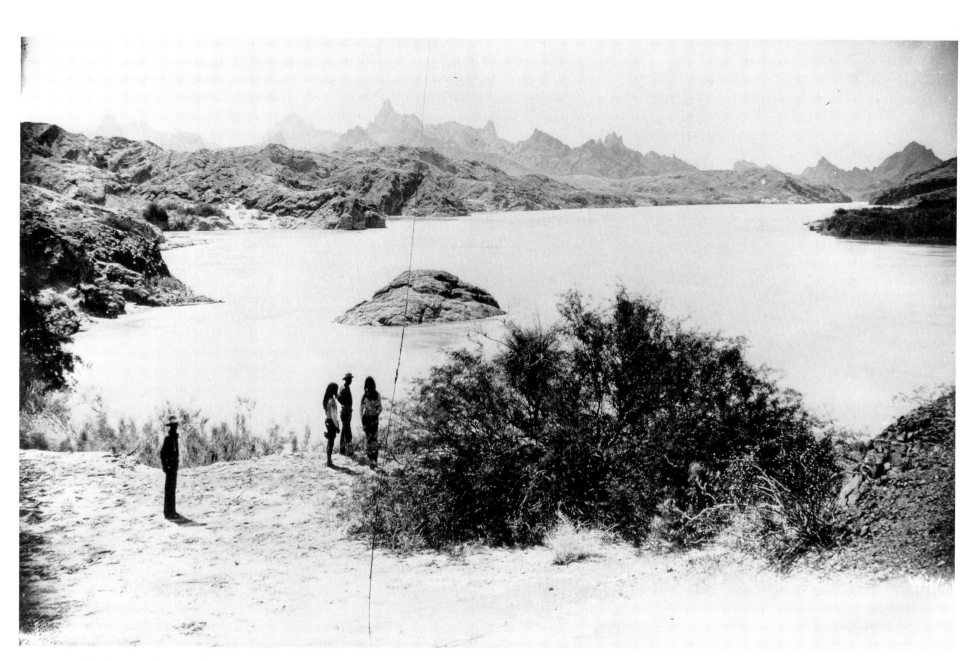

58. *"The Needles," Colorado River, Arizona*. 1883. Photo: School of American
Research Collections in the Museum of New Mexico, Santa Fe

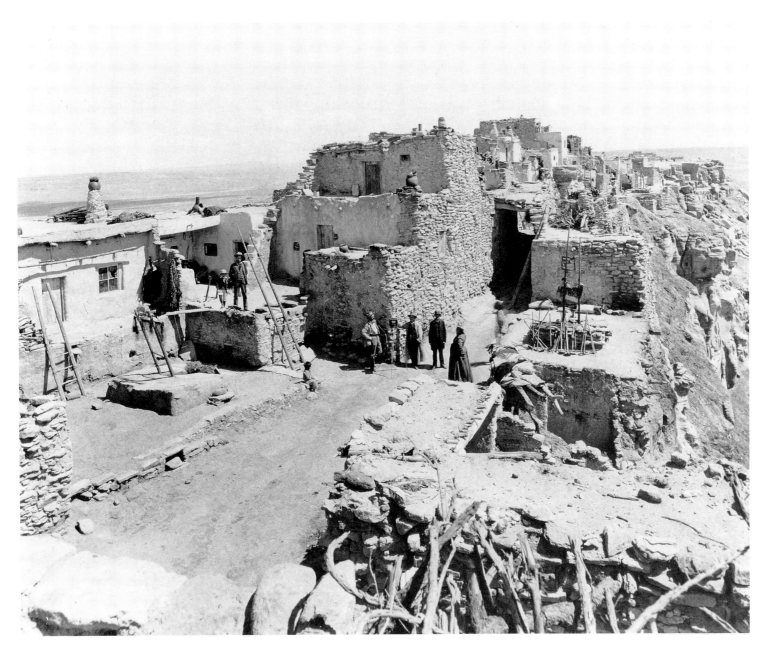

59. *Walpi Pueblo, Hopi Mesas, Arizona.* C. 1895 Photo: School of American Research
Collections in the Museum of New Mexico, Santa Fe

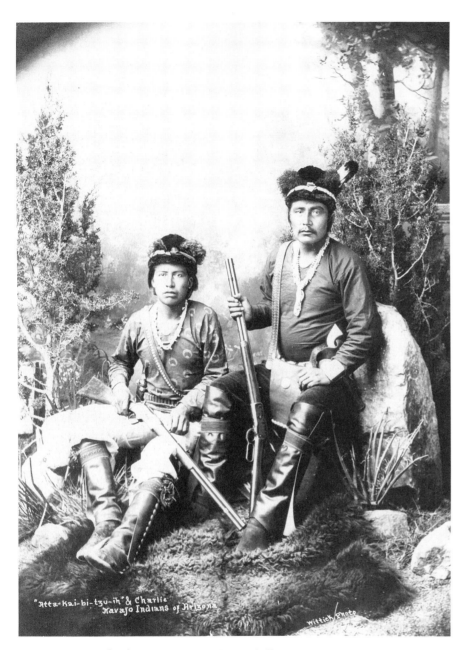

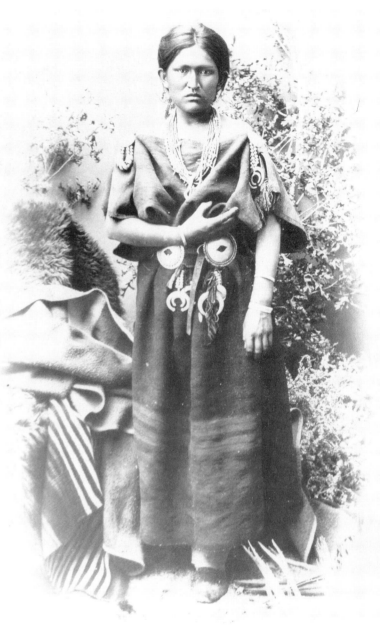

60. *Atta-kai-bi-tzu-ih and Charlie Mitchell, Navajo Scouts.* C. 1885–86.
Photo: School of American Research Collections in the Museum of New Mexico, Santa Fe

61. *Anselina, Navajo Woman.* C. 1885. Photo: Private Collection

66

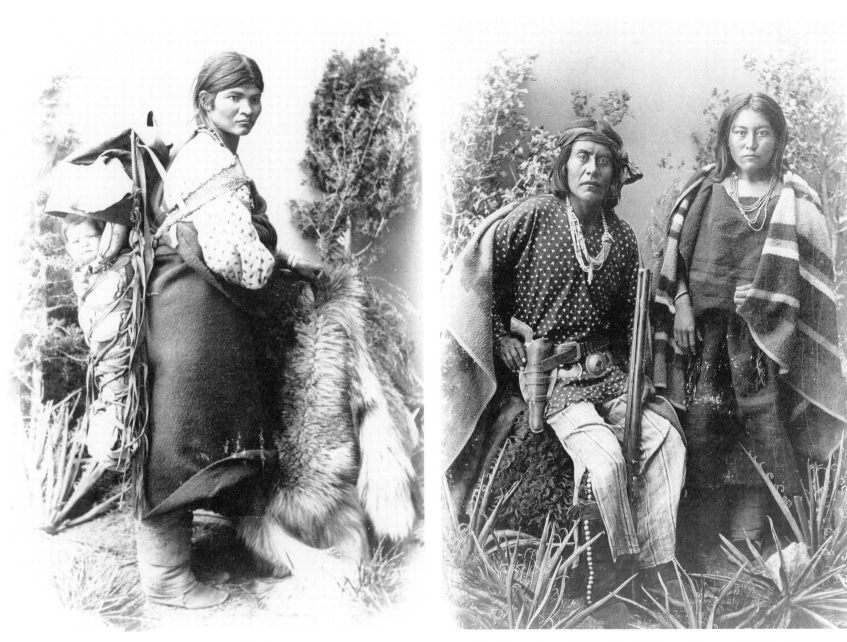

62. *"Chuna and Baby," Navajo Mother and Child.* C. 1885. Photo: Private
Collection

63. *Gayetenito and Malia, Navajo Man and Woman.* C. 1885. Photo: Private
Collection

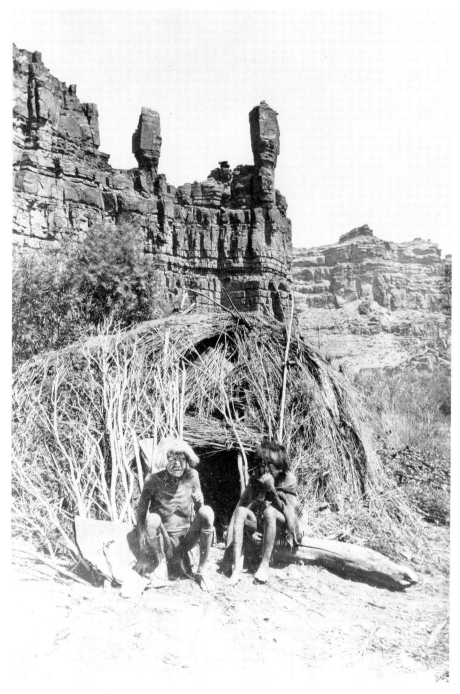

64. *Havasupai Lodge, Wi-kli-iva, The Chief's Rocks, Supai Canyon, Arizona.* 1885.
Photo: School of American Research Collections in the Museum of New Mexico, Santa Fe

3. The Hualapai and the Havasupai

◘

Ben Wittick was one of the pioneer photographers of the Hualapai and Havasupai. His photographs serve as an important visual record of two cultures that have common ethnological roots and that, prior to contact with the Anglo-European world, followed similar economic, social, and governmental patterns. During the 1850s United States' land expansion and mining enterprises began to change the course of both of these tribes and to dictate the diverse directions that would determine the future of their people. Wittick had the opportunity to observe and photograph both the Hualapai and the Havasupai as they approached this cultural crossroads.

The Hualapai and the Havasupai are related culturally and linguistically. They belong to the same ethnic group, "the Pai," which has the ethnocentric meaning of "the people—the only true human beings on earth." The name *Hualapai* translates literally as "Palm Tree People" and *Havasupai* as "Blue-Green Water People." Both the Hualapai and the Havasupai belong to the Yuman linguistic group. Many ethnologists trace the roots of the Hualapai and the Havasupai (and also the Yavapai) to the Cerbat branch of the prehistoric Upland Patayan people, who displaced the Coconino people on the Colorado Plateau around 1150.

Prior to contact with the white man, the Hualapai, or Western Pai, and Havasupai, or Eastern Pai, lived in the area that is now northeastern Arizona. The Hualapai inhabited the land from the Colorado River west to the vicinity of which is now the city of Kingman, Arizona. The Havasupai occupied a part of the Coconino Plateau, which included the canyon drainage area of Cataract Creek, a tributary of the Colorado River. A United States Government publication describes the historic homeland of the Havasupai as extending "from the south bank of the Colorado River within Grand Canyon south to Bill Williams Mountain and the San Francisco Peaks, and from the Aubrey Cliffs east at least to the edge of the Coconino Plateau above the Little Colorado River."[1]

Historically, both tribes lived on the semiarid Coconino Plateau during the winter, a time devoted to hunting and gathering. The men hunted deer, antelope, rabbits, and squirrels in the lower elevations and mountain sheep and birds in the higher elevations, while the women gathered piñon nuts, mescal, cactus, and yucca fruit. In the summer they moved down into the Grand Canyon, where large permanent springs made it possible for them to enjoy the lush vegetation, willows, and cottonwood trees and to grow many of the staples of their diet —corn, beans, squash, and melons. They completed their first planting by April and harvested their crops from June through September. They also planted peach and apricot trees, which had been introduced to the American continent by the Spanish and reached the Pai tribes via trade with the Hopi. Both the Hualapai and the Havasupai collected wild honey and salt from the Grand Canyon. Like the Navajo, however, they followed a prohibition against eating fish.

The Hualapai and the Havasupai were accomplished traders. They traded most frequently with neighboring tribes, particularly the Hopi, the Navajo, and the Mohave, but they even traded with the Rio Grande Pueblo people and the Pacific Coast tribes. They exchanged baskets, buckskins, and food for horses, buffalo hides, jewelry, and cotton cloth. A good example of the complexity of Pai trading is that, during the Hualapai War, Cherum, a Sub-Tribe Chief, exchanged woven goods from the Hopi for Mohave horses, which he then traded to Southern Paiute for guns, which they had obtained from the Utah Mormons.

The traditional Hualapai and Havasupai world was a simple society in which the basic social unit was the family. It was a patriarchal society, patrilineal and patrilocal, except for the first two or three years after marriage, when the young couple would live with the woman's family. The women were the potters and basketmakers; they owned their pottery and baskets and their own personal effects, while the men owned all other property. There were no clans, and leaders were semihereditary, their true status determined by individual merit and skill.

Records of the Spanish explorers of the sixteenth and seventeenth centuries document random encounters with the Pai people; the first direct Spanish contact with the Hualapai and the Havasupai, however, was the 1776 expedition of Father Francisco Garcés, a Franciscan missionary. Garcés, who in 1781 was killed by the Colorado River Yumans, first encountered the Hualapai in the area around present-day Kingman and Peach Springs, Arizona. He then was guided in Cataract Canyon, where he became the first white man to document visiting the summer settlement of the Havasupai people.

Before the Hualapai War and the forced resettlement of the Hualapai on reservations, there were three major branches of the Hualapai: the Middle Mountain People in the north, the Yavapai Fighters in the south, and the Plateau People in the east. Each of these branches or sub-tribes was divided into a number of bands. A band was composed of camps, groups of interrelated families. Many historians believed that the Havasupai were originally a band of the Plateau People, and that the critical separation between the Hualapai and the Havasupai dates back to the 1880s, when the United States Government assigned the two groups to separate reservations.

The Hualapai and Havasupai had little contact with either Spanish or Anglos prior to 1850. During the 1850s the United States Army sponsored expeditions into Pai land in order to determine the best routes for the transcontinental railroad. The first expedition, led in 1851 by Captain Lorenzo Sitgreaves, resulted in open conflict with several bands of Hualapai. In 1857–58 Lieutenant Edward F. Beale led a road-cutting expedition through northern Arizona as a preparatory step in opening first a wagon and then a railroad route to Needles, California. Beale's route cut directly into Hualapai territory.

In 1863 gold was discovered in Prescott, Arizona, and fortune seekers from across the country rushed to northwest Arizona. Many settled in Hualapai territory, increasing friction between the Hualapai and the white man. When, in 1866, a group of prospectors killed Wauba Yuma, a respected Hualapai leader, his followers sought immediate revenge. There followed a series of battles between the Hualapai, a force of about 250 men, and the United States Army regulars under the leadership of Lieutenant Colonel William Redwood Price. The Hualapai people were unable to endure Price's scorched-earth tactics, the burning of their rancherias and the destruction of their crops and supplies. In 1869 Cherum and Leve Leve, the Hualapai leaders, surrendered; the Hualapai War was officially over, and the leaders began a series of peace negotiations.

In 1871 the army imprisoned the Hualapai at Camp Beale Springs, then, three years later, moved them to La Pas, on the Colorado River Indian Reservation, where the half-starved Hualapai were forced to dig ditches and farm hay. Many of the prisoners died from disease in the steaming heat of these lowlands. In 1875 the Hualapai were able to escape from their

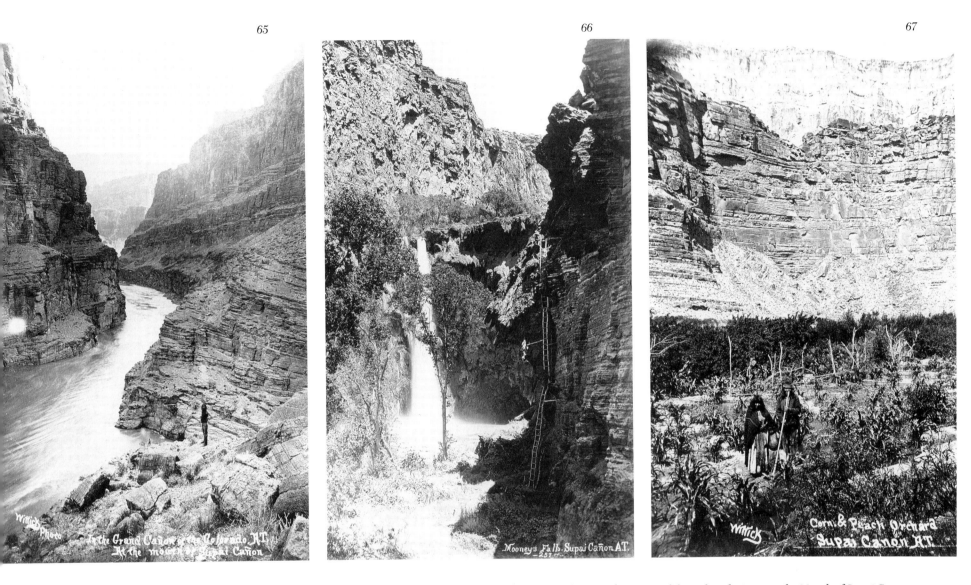

65. *In the Grand Canyon of the Colorado River at the Mouth of Supai Canyon, Arizona.* 1885. Photo: School of American Research Collections in the Museum of New Mexico, Santa Fe

66. *Mooney Falls, Supai Canyon, Arizona.* 1885. Photo: Museum of New Mexico, Santa Fe

67. *Havasupai Corn Field and Peach Orchard, Supai Canyon, Arizona.* 1885. Photo: School of American Research Collections in the Museum of New Mexico, Santa Fe

forced internment and return to their homeland only to discover that in their absence miners and ranchers had taken over their territory and were herding cattle on the grasslands and using the precious water from the springs. Unable to return to their traditional way of life, many of the Hualapai were forced to work as laborers in the mines or on the Anglo ranches.[2]

In 1883, the year of Wittick's visit, a nine-hundred-thousand-acre Hualapai Reservation was established. Not only did this small part of the original Hualapai territory include only the poorest land, but Anglo cattle had destroyed many of the wild plants that were an important part of the Hualapai's daily food supply. Subsequently, epidemic diseases killed a large percentage of the population. It is easy to understand why the Hualapai eagerly grasped the false hope of the Ghost Dance in the years from 1889 to 1891.

The Havasupai, like the Hualapai, also suffered from the advance of the Anglo farmers and miners into the Arizona Territory. The Havasupai not only lost their eastern fields and hunting and grazing land above the canyon, they were threatened with the loss of their holdings within Cataract Canyon when rich copper deposits were discovered there. In 1882, after revoking two previous border agreements, the United States Government set aside an area of 518 acres within Cataract Canyon as the Havasupai Reservation.

Wittick photographed the Hualapai and Havasupai in the critical years immediately after the establishment of these reservations. He photographed the Hualapai in 1883, the very year that this defeated tribe was officially granted the right to an impoverished section of their original territory. He first encountered the Hualapai when he passed through Peach Springs en route to the Grand Canyon. There he met several Hualapai families led by "Captain Jack." Captain Jack had fought in the Hualapai War, been captured, and spent several years as a prisoner of war at Camp Beale Springs. He had a limited knowledge of the English language but wanted no part of the white man's world. The Hualapai recognized that it was impossible to follow the pattern of life that had sustained them in the past, and in Wittick's photographs they appear as a band of displaced nomads, an isolated group of survivors in a world that offered limited sustenance and no hope.

Several days later, on the return trip to the rim of the canyon, the Wittick group camped near a band of Hualapai who traditionally spent the summer months in the canyon. Wittick's son Tom wrote of the experience:

We camped within fifty yards from the Indian camp and while we were cooking and eating supper, we had a large, attentive, and curious audience of squaws, papooses, and old men. Most of the men talk some American, and most of them are in uniform, having been Apache fighters. . . . They live mostly on the root of the mescal, and what rabbits and bighorns they happen to meet. They are too poor to waste ammunition, and several fellows told me that they knock the head off of a jack-rabbit most every shot, at a hundred yards. Most of them have Winchester rifles. . . . A good many of these Indians have died lately, of small-pox and starvation.[3]

The Hualapai had had no prior contact with a photographer and feared that Wittick's images would deprive them of spiritual strength and, ultimately, life. Tom described their response:

In the morning we gave them all the flour we had left, if they would let pap make a picture of them and their "wickeeups." Made eight stereos and two 11 × 14's of them. After we were through, something seemed to strike them. They couldn't understand what that kind of a circus meant, anyhow, unless it was to make harm come to them, and give us a charm over them. One of them acted as spokesman, and came over to us and asked, "All Injins die now?" "That make all Injins go dead, oh, bymeby, mebbe?"[4]

During the 1880s the Hualapai still lived in their traditional shelters. Their summer structures were made of small branches and leaves piled over larger tree branches, in order to afford protection from the sun and the rain. Their winter houses were small dome-shaped structures made of branches and small poles covered with juniper bark or thatched with arrowroot. They preserved their food supplies by drying and used a *mano* and a *matate* to grind corn.

Prior to contact with the Anglos, the Hualapai had made their clothes from buckskins and juniper bark. Women made dresses with a double apron belted at the waist and tied buckskin around their calves for protection when they walked through the brush. Men wore breechclouts, hide shirts, and moccasins. The Hualapai painted and tattooed their faces and sometimes their bodies. The paint was red hematite mined in the territory of the Middle Mountain People, and the tattoos were made with a cactus needle and charcoal. The Hualapai wore neck pendants made of trade shells, which served as ornaments and offered spiritual protection.

The Hualapai bands Wittick encountered wore a combination of traditional and Anglo dress. The men wore Anglo work pants and shirts and buckskin vests, while the women remained in more traditional dress. Several wore Hopi blankets obtained in trade. Wittick's photographs reveal decorative face paint on the women.

In the traditional Hualapai world, basketry was the most highly developed craft art and was one of the most important trade items. Hualapai baskets included decorated plaques made from a coil on three rods and a splint, a technique resembling Apache work, and utilitarian containers made of twined willow shoots, often reinforced with leather. Wittick's photographs showed several traditional Hualapai conical baskets that were used for gathering and carrying seeds.

Two years later, while accompanying the Stevenson expedition to the Grand Canyon, Wittick made a personal detour to visit the Havasupai settlement in Cataract Canyon. In a letter he described this visit to the Havasupai camp and his meeting with tribal leaders:

These Indians are the remnant of the once powerful tribe Cochonino and once roamed over all that country north of the San Francisco Mountains to the Navajo County and to the Grand Canon and it is to their wars with the Navajos that they owe their decline as a tribe. They are hospitable people and just revere Genl. Crook.

The Hava-Supais live in "shacks" built of cottonwood posts and beams covered with brush and thatched with brush and grass, raise splendid corn, melons squashes and beans—and they have in the Canon the largest peach orchards I've found in the Indian Country. The old chief brought us a flour sack filled with apricots on the 20th offered 85 perfectly ripe, simply asking that we save and return to him the stones, as he wanted to plant them.[5]

Traditional Havasupai dress was similar to that of the Hualapai, and Wittick's photographs illustrate the use of facial paint. One of Wittick's photographs shows a group of men wearing remnants of military uniforms and carrying rifles. It is interesting to contrast these assimilated Havasupai who served as guides for General Crook with the tribal elders who still remained faithful to the traditional world.

Wittick's Havasupai photographs show rectangular summer houses, thatched lean-tos, and winter houses, domed structures made of dirt and thatch covering a log-and-pole foundation. Basketry was the most highly developed Havasupai craft art, and several of Wittick's photographs include pitch-smeared water bottles, burden baskets, boiling containers, and parching trays.

The 1880s were critical years for both the Havasupai and Hualapai people. During the years that followed, many of the Hualapai left the Reservation, moved to railroad towns, and worked in the mines or on nearby ranches. Traditional Huala-

pai life belonged to the past. Oliver Gates, superintendent of the reservation in 1905, described the area as "730,880 acres of the most valueless land on earth for agricultural purposes. It is unsurveyed and unallotted. Scarcely a dozen families live on the reservation."[6]

The Havasupai, in contrast, were able to continue to maintain a variation of traditional tribal life within Cataract Canyon. Nevertheless, their hunting and gathering were increasingly restricted by their loss of land, and in time the Anglo world brought an unending series of irreversible changes to every aspect of Havasupai culture—clothing, housing, education, even religion. Today a few hundred Havasupai still strive to maintain their tribal identity in their historic homeland, a land in which tourism is their primary source of income.

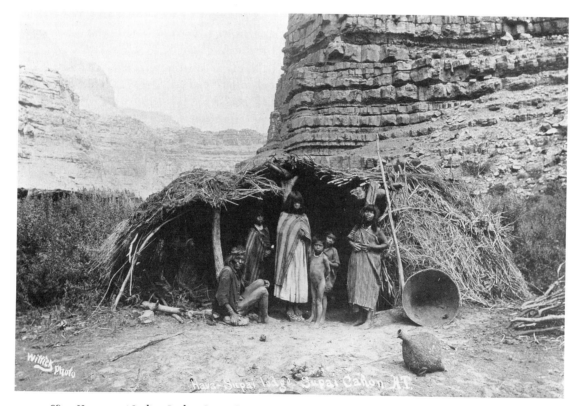

68. *Havasupai Indian Lodge, Supai Canyon, Arizona. 1885.* Photo: School of American Research Collections in the Museum of New Mexico, Santa Fe

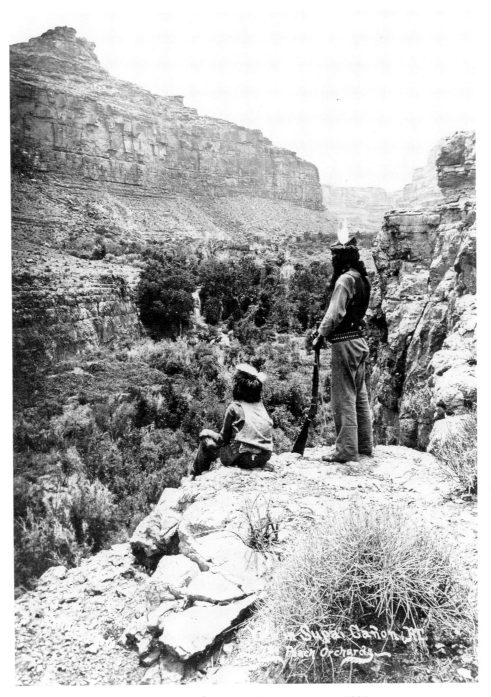

69. *Havasupai Peach Orchards in Supai Canyon, Arizona.* 1885. Photo: School of
American Research Collections in the Museum of New Mexico, Santa Fe

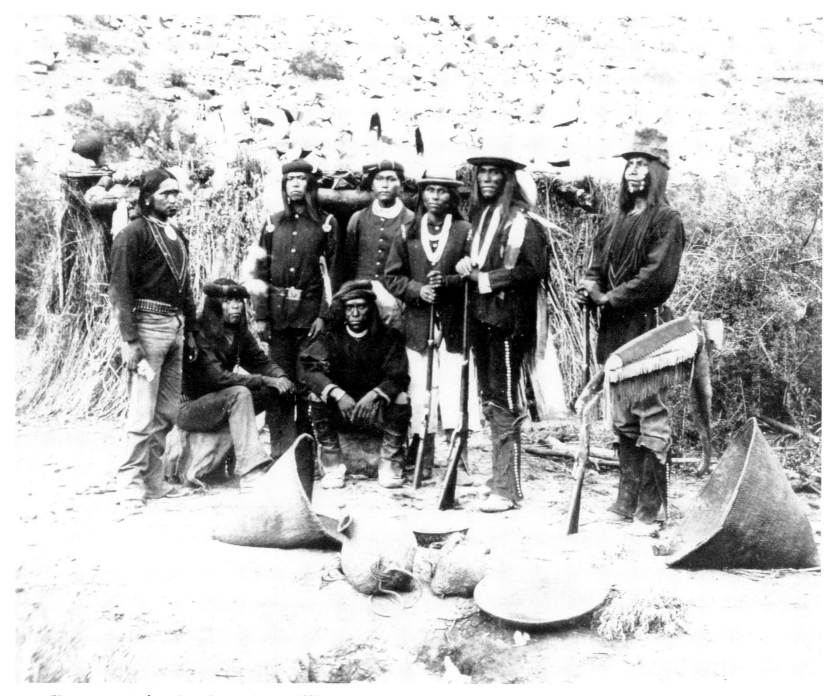

70. *Havasupai Indians, Supai Canyon, Arizona.* 1885. Photo: School of American
Research Collections in the Museum of New Mexico, Santa Fe

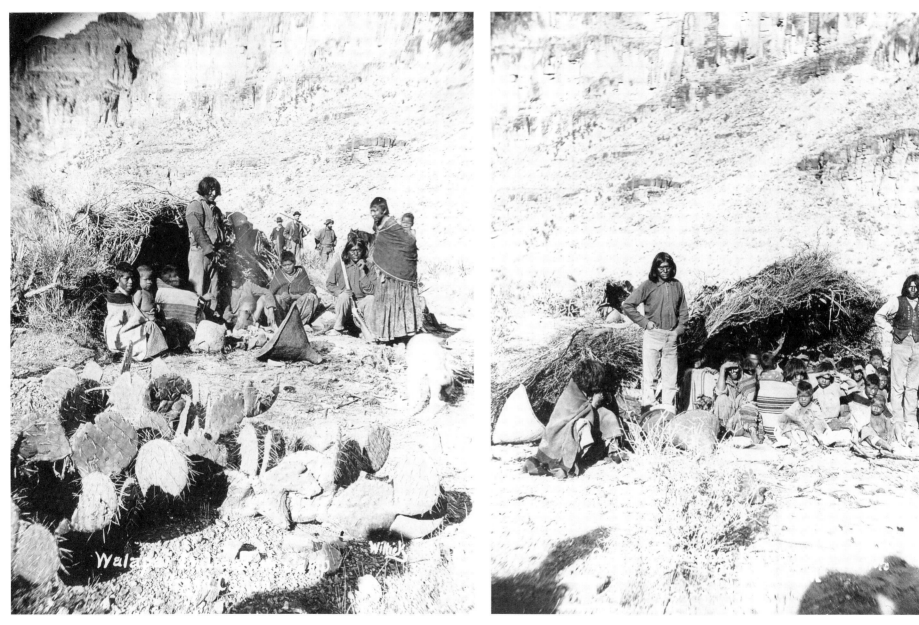

71. *Group of Hualapai Indians, Grand Canyon, Arizona.* 1883. Photo: School of American Research Collections in the Museum of New Mexico, Santa Fe

72. *Group of Hualapai Indians, Grand Canyon, Arizona.* 1883. Photo: School of American Research Collections in the Museum of New Mexico, Santa Fe

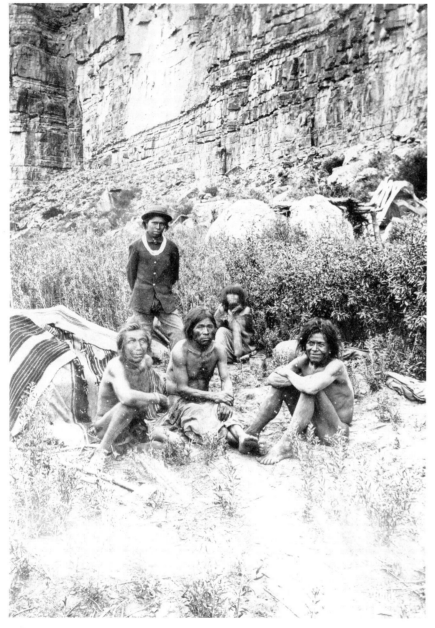

73. *Havasupai Group, Supai Canyon, Arizona.* 1885. Photo: School of American
Research Collections in the Museum of New Mexico, Santa Fe

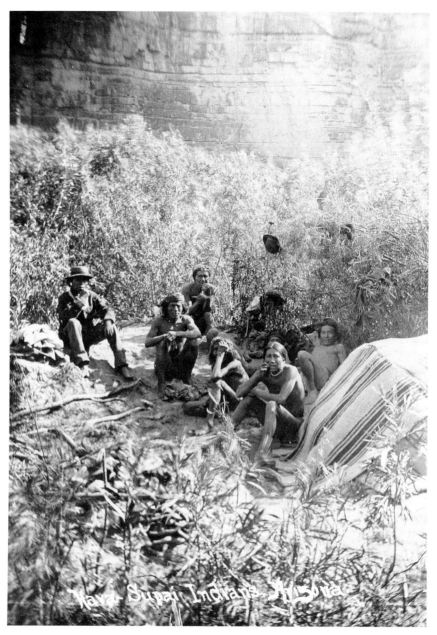

74. *Havasupai Indians, Supai Canyon, Arizona.* 1885. Photo: School of American
Research Collections in the Museum of New Mexico, Santa Fe

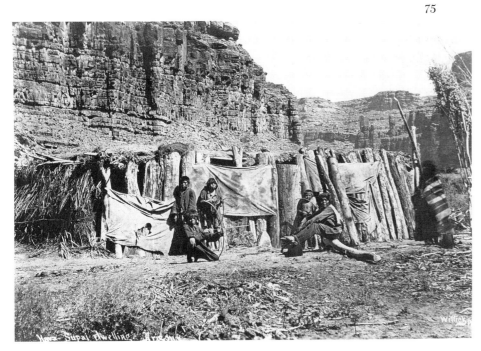

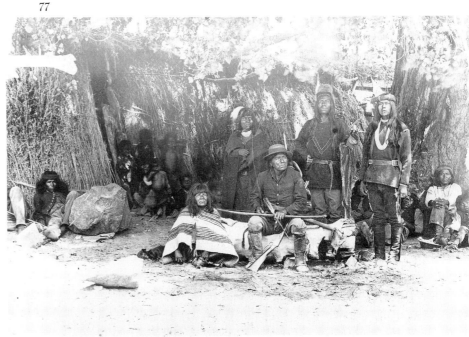

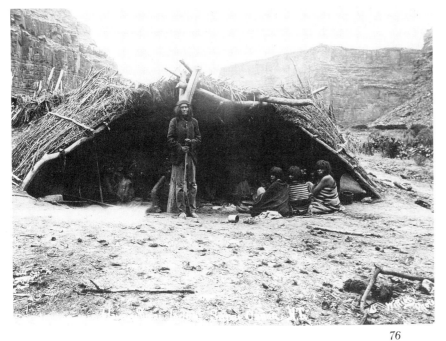

75. *Havasupai Dwelling, Supai Canyon, Arizona.* 1885. Photo: Private Collection

76. *Havasupai Lodge, Supai Canyon, Arizona.* 1885. Photo: School of American Research Collections in the Museum of New Mexico, Santa Fe

77. *Captain Jack and Wife with Group of Havasupai Indians, Supai Canyon, Arizona.* 1885. Photo: School of American Research Collections in the Museum of New Mexico, Santa Fe

76

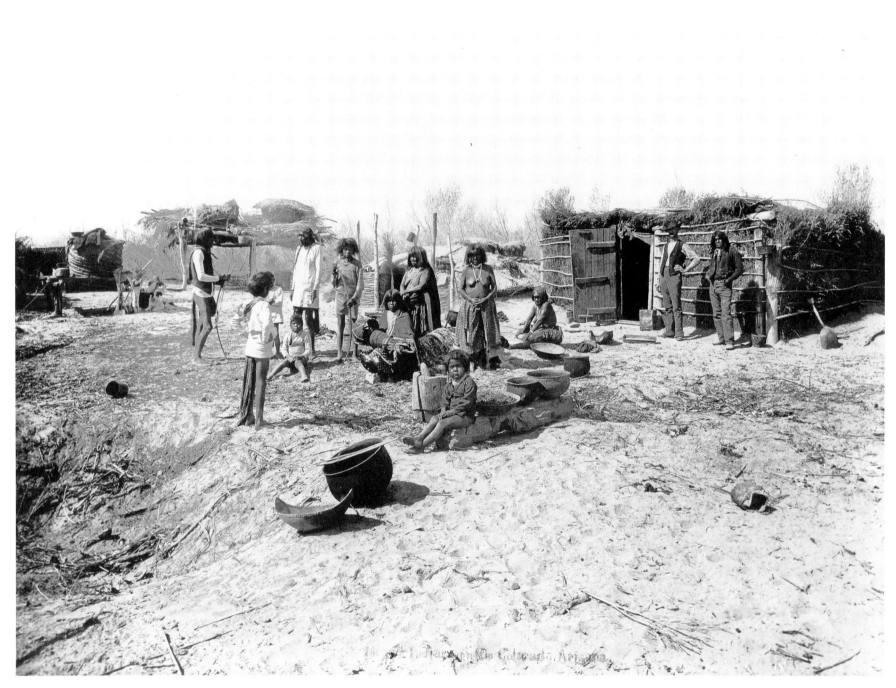

78. *Mohave Indians on Rio Colorado, Arizona.* 1883. Photo: School of American
Research Collections in the Museum of New Mexico, Santa Fe

4. The Mohave

◘

Ben Wittick traveled to the newly created Mohave Reservation in July 1883. Mohave country was the westernmost point of his travels for the Atlantic & Pacific Railroad, because at the time the Atlantic & Pacific offered passenger service only as far as Peach Springs, the departure point for expeditions to the Grand Canyon. As Peach Springs was more than a hundred miles from their destination, Wittick and his son Tom had to transfer to a freight train, which brought them to within twenty miles of the Colorado River, and then take a construction train for the last leg of their journey. The terminal point of the track was about six miles from Powell or Needles City, a Mohave settlement on the Colorado River.

The Mohave Reservation was a combination of desert and swampland, a semiarid world of mesquite, cactus, and chaparral rising about four hundred feet above sea level and a watery lowland where cane and arrowroot grew along the riverbank. Groves of cottonwood and willows flourished on the surrounding flood plain. Confronted with the sweltering heat of summer in Mohave country, Tom described his initial reaction:

The country around has an unnatural appearance. From what the railroaders say of it, "it isn't a white mans country."... Yuma, near the mouth of the river, ranks among the five or six hottest places of the world. There is a story to the effect that a soldier dying at Fort Yuma, and having been a pretty tough cuss generally, he went to "Brimstone Gulch," but came back the next night after blankets. That's why there are so many bad men in this country. If they can stand it here, they can stand it as easy in the "sweet subsequently."

The average, in July and August, is about 125° in the shade. But it is frequently way above that, as a contractor told us lately, that it has been 136°—and the superlative is rendered thusly: positive, hot; comparative, hotter; superlative, hot as h--l!! The superlative is most generally applied. The altitude of the country around the Needles is only a few hundred feet, but the air is very dry. If the air was as moist as it is in Illinois, the country would be uninhabitable.[1]

The Fort Mohave Reservation, established by Executive Order in September 1880, was a sub-agency of the Colorado River Indian Reservation, created by an act of Congress in March 1865. Although the Mohave land was owned in undivided shares by tribal members, the Reservation was held in trust for them by the United States Government.

The Fort Mohave Reservation encompassed land in present-day Mohave County, Arizona, San Bernardino County, California, and Claude County, Nevada. The Mohave lived in loose settlements on both sides of the Colorado River and often shifted locations during the year. Tom estimated that six hundred to eight hundred Mohave lived in Needles City in traditional mud-and-stick houses and in tents. Fifty miles south, along the Colorado River, was another Mohave community.

Traditional Mohave life included gathering, trapping, hunting, farming, and fishing. The Mohave were successful in growing maize (white flower corn), melon, tepary beans, and pumpkins on the rich flood plain.

As Wittick planned to publish a book on his life's work and adventures, both he and his son kept detailed records of their travels, including descriptions of Mohave dress, household utensils, and weapons, and elaborate reports on the basic activities of Mohave daily life. Tom wrote the following description of Mohave and milling techniques:

These Indians raise corn, wheat and melons on some parts of the river bottom. Their corn only grows two or three feet high. They grow it in holes in the ground, each bunch planted in a hole about a foot wide and eight or ten inches deep. The roots keep cooler and absorb more moisture in this way, than if the corn was cultivated in hills.

The wheat is planted in bunches, to facilitate pulling. They don't cut it. We saw it in all stages of growth, and some patches were "pulled." One day we saw the whole operation of converting the raw material into bread. Saw an old squaw go out into the wheat patch, pull a few bunches, head it, mash it in the "Nah-mah-kay", grind it fine on the "ahch-pay", make a wad of dough by mixing water with it, and bake it in the hot ashes. They live partly on their corn and wheat and partly by hunting. Some families also keep goats, sheep and chickens. Every house has a lot of meat hanging along a pole, drying in the sun. Their extra provisions they keep in a store-house, a huge basket mounted on a square framework of poles.

They have two kinds of grain-mills in which they grind corn and wheat. One is similar to the "mitata" used by the Mexicans and the Pueblo Indians, a large, smooth, slightly hollowed or dished rock, on which the grain is placed, and a smaller stone to grind with. The other is a mortar and pestle. The mortars are of different sizes, but are generally about fifteen inches in depth by seven or eight inches in diameter, inside. They are

shaped from a hard, solid volcanic rock, called "mal-pais," and you may bet that "mucho trabajo" is spent on them. The pestle is also of "mal-pais," round, and about eighteen inches in length.[2]

The Mohave ate fish and beaver but had a taboo against eating turtle, lizard, and snake. The hunters traded deer and rabbit meat, for it was believed to be bad luck to eat one's own kill.

At the time of Wittick's arrival, most of the ancient Mohave ceremonies had been abandoned, and tribal spiritual life focused on dream power and dream interpretation. The Mohave were still a society of hereditary chiefs and shamans, and their most important religious ceremonies were death rituals, which focused on the sacred funeral pyre.

Most Mohave craft arts were relatively unsophisticated, for they believed that all the property of an individual must be destroyed at death. Most Mohave pottery was made by a coiling technique, then decorated with a yellow ocher pigment that turned red when fired. The Mohave used gourds for carrying water and storing seeds, and utilized their basketry skills for such utilitarian products as flat trays made of willow twigs and head rings of willow bark. Tom wrote of Mohave basketry and pottery:

They have as great a variety of domestic utensils as the Pueblo Indians, and excel the Pueblos in the manufacture of some of them. Their pottery is strong and symmetrical, and some of it very large. Their baskets, which hold water, are very fine, and intricately woven into beautifully colored patterns. Most of them are made from the yucca. Five dollars is the price of a good basket.[3]

Wittick's photographs document several types of traditional Mohave structures. For centuries the Mohave had built log houses on the low rises above the flood plain. The Mohave

79, 84

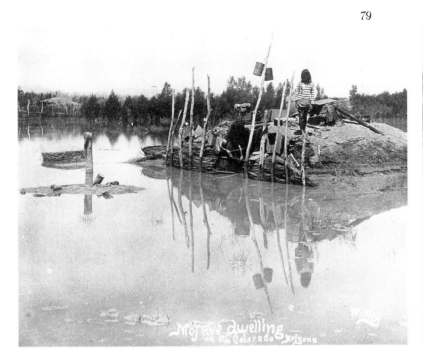

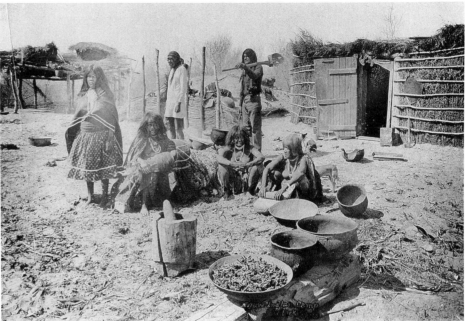

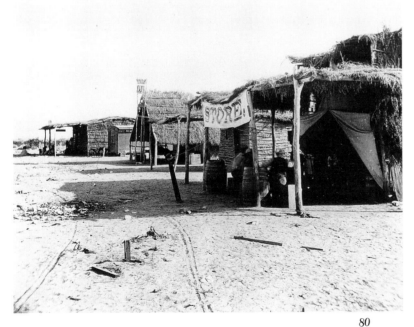

79. *Floating Mohave Indian Dwelling on Rio Colorado.* 1883. Photo: School of American Research Collections in the Museum of New Mexico, Santa Fe

80. *Needles City, Arizona.* 1883. Photo: School of American Research Collections in the Museum of New Mexico, Santa Fe

81. *Mojave Indian Home, Arizona.* 1883. Photo: School of American Research Collections in the Museum of New Mexico, Santa Fe

thatched the roofs with arrowroot and covered the exterior of the houses with sand and dirt. The doors of their houses faced south, in anticipation of the cold north winds in winter. During the summer the Mohave slept in open-sided ramadas. Tom described the Mohave dwellings: "The Mohave builds a good house, has all kinds of domestic utensils, and knows something about cultivation of the ground. They build their houses both square and round, and well proportioned. The framework is of poles, and the roof and sides are wattles and willows, thatched in. The whole is sometimes covered with dirt, giving it the appearance of a cave, or dugout."[5]

Ancestors of the nineteenth-century Mohave were thought to have first settled in the Colorado River area in about A.D. 1150. The Mohave were the largest of the Yuman-speaking group in the Colorado River area. Many ethnologists believe that the word *Mohave* comes from the native word *Hamok aui*, meaning "three mountains," the name referring to the Needles, the outstanding geological feature of the area. The traditional friends of the Mohave were the Yavapai, the Yuma, the Chemehuevi, and the Western Apache, while their traditional enemies were the Pima, the Cocopah, the Papago, and the Maricopa.

Although the Spanish conquistador Juan de Onate recorded an encounter with the Mohave in his travels of 1604–1605, and Father Francisco Garcés paid a visit to Mohave country in 1775–76, the Spanish conquest of the Southwest had little impact on Mohave life. Under Spanish rule, Anglos were forbidden into the entire Southwest Territory, and it was not until after 1821, when the area became part of an independent Mexico, that Anglo fur traders and trappers ventured into Mohave country. Jedediah Smith in 1826 and James Ohio Pattie in 1827 were among the first Anglo visitors.

Life in the Mohave world continued relatively undisturbed until the United States took control of the area with the signing of the Treaty of Guadalupe Hidalgo in 1848. During the 1850s Congress authorized several expeditions to the area in order to determine the most favorable route for the transcontinental railroad. The first was Lorenzo Sitgreaves's 1851 expedition, followed three years later by Amiel W. Whipple's 1854 expedition. In 1858 Joseph C. Ives, a well-known explorer and steamboat captain, traveled to Mohave territory to determine the navigability of the Colorado River. (Historically, the Mohave did not use boats, but rather swam across the river or rode astride logs on their occasional journeys downstream.)

As more and more Anglos ventured into Mohave territory, tensions between the Mohave and the white man steadily increased. In 1858 a Mohave attack on a wagon train bound for California precipitated the establishment of a military post, later named Fort Mohave, in the Mohave Valley. The following year, a great number of Mohave met death in an encounter with United States military forces. This battle, the last major Mohave resistance, stands as the turning point in Anglo-Mohave history. From this time on, the Mohave were a defeated people, forced to follow the path toward assimilation. As their traditional culture deteriorated, the Mohave were plagued by disease and condemned to face a meaningless life of abject poverty.

In 1883, the year Wittick visited the Needles, the Mohave people were living in a vacuum, suspended between two cultures. The men and women still wore long hair, which they cleaned with a mixture of mud and boiled mesquite bark; the women's hair hung loose, while the men's hair was rolled into ropelike strands. Most of the Mohave men and women went barefoot and bareheaded, and covered the upper part of their bodies only in the cold. Both men and women continued the tradition of painting their torsos, arms, and legs, and a few still tattooed their skin.

By the time of Wittick's arrival, acculturation was well under way. Many of the Mohave women wore long full skirts of brightly colored calico and shawls, while a number of Mohave men had begun to dress in Western-style trousers, shirts and hats. Tom recalled:

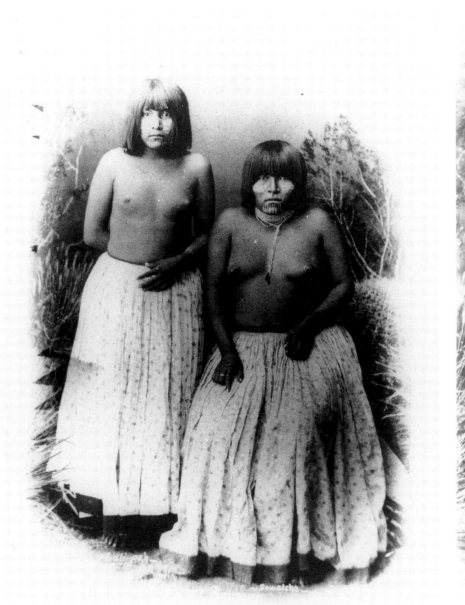

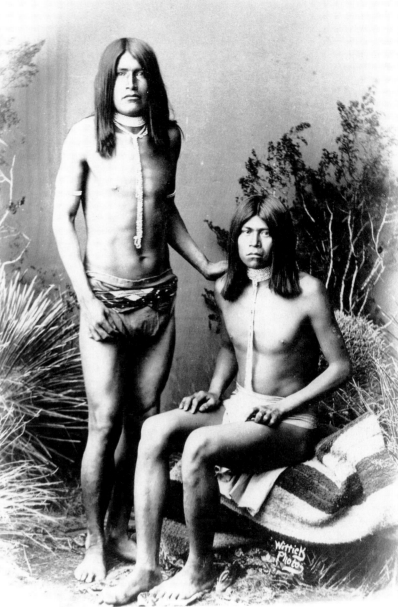

82. *Luli-pah and Sowatch, Mohave Women.* This photograph was published as fig. 7 in Robert Shufeldt, *Indian Types of Beauty* (Washington, D.C., 1891). Photo: Smithsonian Institution, National Anthropological Archives, Bureau of American Ethnology Collection, Washington, D.C.

83. *Mohave Runners, San Carlos Reservation, Arizona.* C. 1885. Photo: Private Collection

The Mohave dress, before they got cloth from the whites, was simple. The railroaders say that when the road struck the Mohave country, most of the Indians were naked. Even now, about half the men wear nothing but a breech clout and ornaments.

The women wear a sort of an apron, and a something which is on the same principle as a white woman's bustle—though it is original—made out of cottonwood-bark, which they call a "tum-scootch-ee." They also have a mantle made of rabbit-skins, called "to-ho-mah," but it is only worn in winter.

The young-ones, up to the age of eight or nine years, wear nothing but paint and ornaments. The papooses are strapped onto a strong, well made cradle, which is ornamented with feathers, and has little buckskin bags, filled with different colors of pigments, dangling about the hood. Father bought one of these cradles, a "toho inah," and a "tumscootchee," and had to pay big prices for them.

The only weapon I saw the Mohaves have, of their own manufacture, was the bow. Their bow is a holy terror. It is strong, sometimes sinew-backed, and six feet in length. The arrows are three feet in length. These bows, in their hands, are as good as a rifle at any reasonable distance, as they are wonderfully good shots. Father tried to buy one, but "no sell um."

The Mohaves have very long hair, on the average reaching to the waist, though the hair of some men reaches as low as the knees. Sometimes you meet a Mohave with his hair in a pyramid, on top of his head, plastered with mud. That's to "kill um bugs."

Most of the Mohaves speak some English, which is to their credit for smartness, having yet had but little intercourse with the whites. A few speak Mexican. [6]

Although Tom wrote that the Mohave children ran naked, the children in the majority of Wittick's photographs have covered their bodies, perhaps in compliance with the photogra-

pher's request, anticipating the response of his potential customers.

Wittick made many field studies; it is apparent, however, that he carefully posed the people in the field studies and attempted to include numerous examples of Mohave artifacts and craft arts—basketry, pottery, planting sticks, and cradle boards, as well as the Mohave bows and arrows.

Wittick did not carry his portrait equipment on his first trip to the Grand Canyon, since he did not anticipate his encounter with Hualapai, and in any case it would not have been possible for him to be lowered into Supai Canyon with the props and backdrops necessary for formal portraiture. It is doubtful that he carried any portrait paraphernalia into Mohave country, although in the course of his career he made several formal portraits of the Mohave people. These portraits are master-pieces of cultural incongruity, featuring store-bought fabrics, traditional jewelry, body painting and chin tattoos. Most of Wittick's Mohave portrait subjects, in contrast to the people in the field studies, have carefully arranged their hair and assumed stereotypical nineteenth-century poses. [82, 83]

After Wittick photographed the Mohave settlement on the east bank of the Colorado River, he and his son crossed the river to explore the California side. They returned to Powell, then traveled four miles south to make landscape photographs of the Needles formation before starting on the hot, dusty journey home. [58]

Although Wittick was not the first to photograph the Mohave, today his work stands as a valuable record of Mohave culture. [7] In addition to their ethnological importance, Wittick's photographs capture the human dimension of people confused by the imposition of a foreign culture and an accelerated pace of change. During the last quarter of the nineteenth century, Mohave men and women continued to live in their traditional homes, to farm, fish, care for their children, and respect their elders. Above all, they tried to retain their dignity and cultural identity. Nevertheless, there is a sadness in

the facial expressions of the elders, who alone were forced to reconcile the differences between their memory of life in pre-reservation days and the reality of life with an Anglo military presence. Wittick's portraits and field studies capture the psy-chological as well as the physical dimensions of the life of a defeated people who must learn to accept the presence of strangers and have agreed to serve as subjects for a commercial image maker.

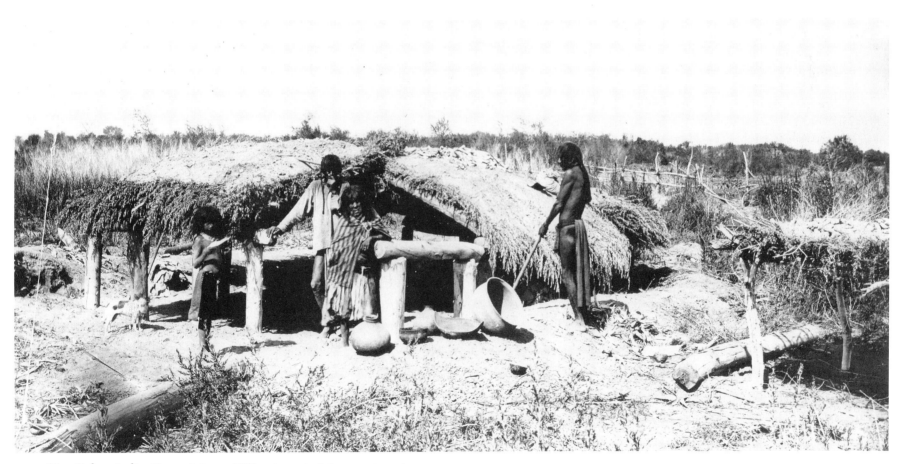

84. *Mohave Indian Home, Arizona.* 1883. Photo: School of American Research
Collections in the Museum of New Mexico, Santa Fe

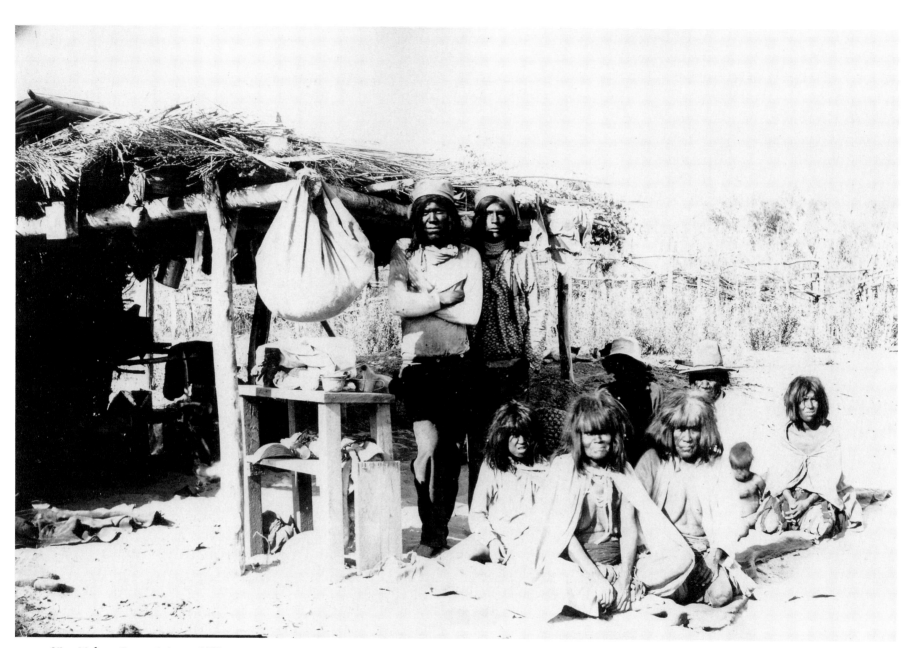

85. *Mohave Camp, Arizona.* 1883. Photo: School of American Research Collections in the
Museum of New Mexico, Santa Fe

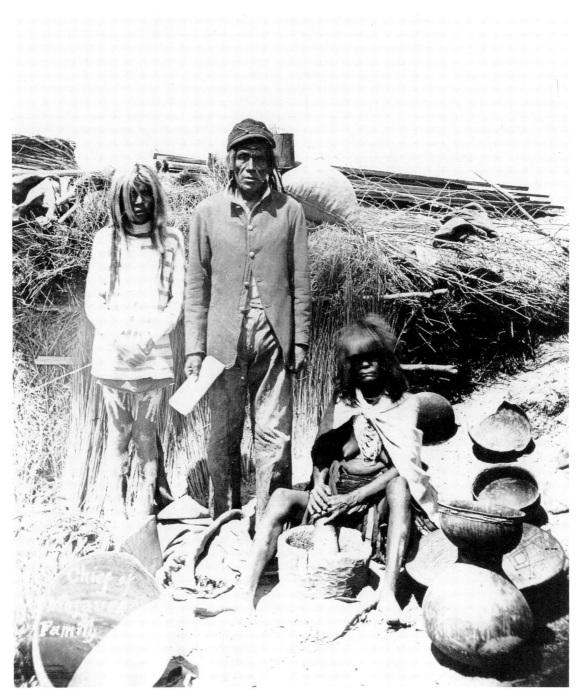

86. *Que-sa-tapka, Mohave Chief, and Family, Arizona.* 1883. Mrs. Que is grinding screwbeans in the mortar.　Photo: School of American Research Collections in the Museum of New Mexico, Santa Fe

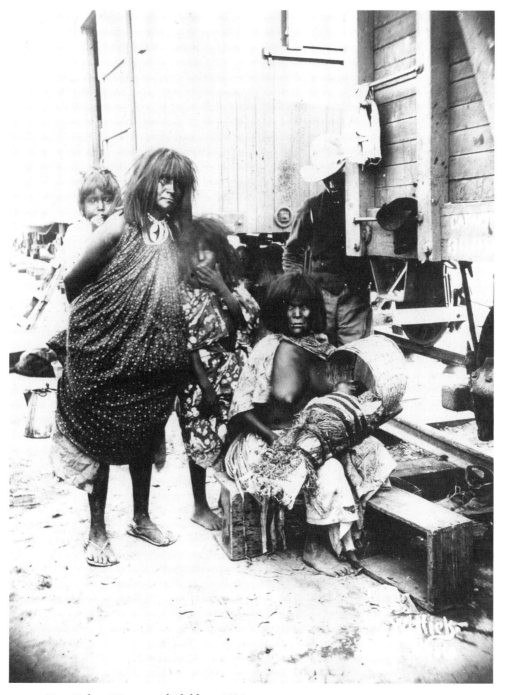

87. *Mohave Women and Children.* 1883. Photo: School of American Research
Collections in the Museum of New Mexico, Santa Fe

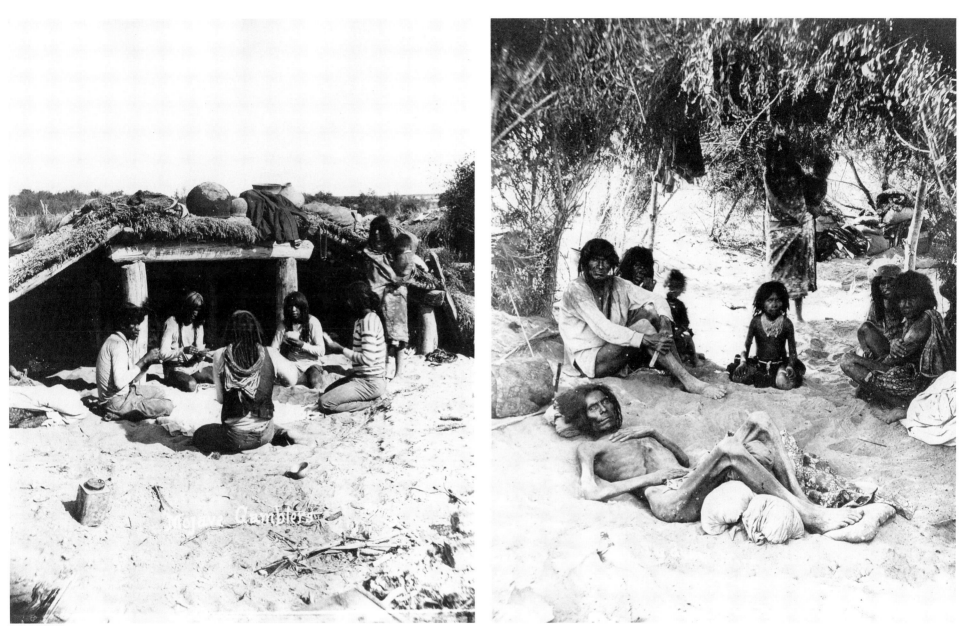

88. *Mohave Indian Gamblers, Arizona.* 1883. Photo: School of American Research Collections in the Museum of New Mexico, Santa Fe

89. *Mojave Man Dying, Arizona.* 1883. Photo: School of American Research Collections in the Museum of New Mexico, Santa Fe

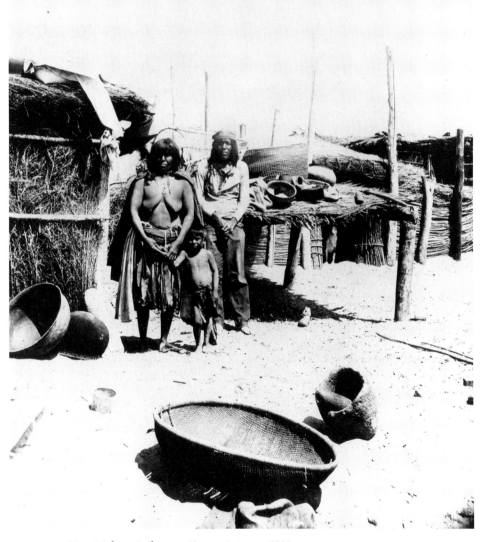

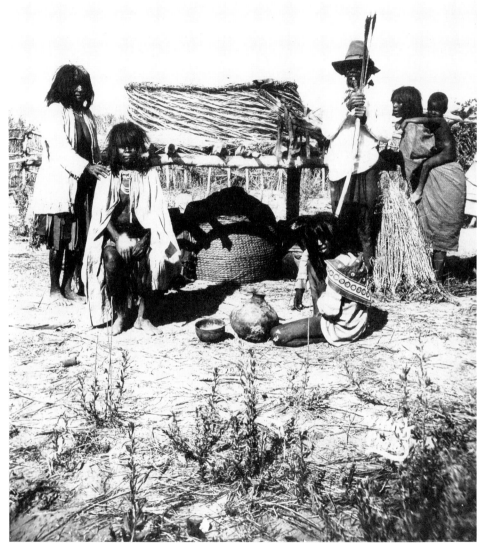

90. *Mohave Indians at Home, Arizona.* 1883. Photo: School of American Research
Collections in the Museum of New Mexico, Santa Fe

91. *Mohave Family.* C. 1885. Photo: School of American Research Collections in the
Museum of New Mexico, Santa Fe

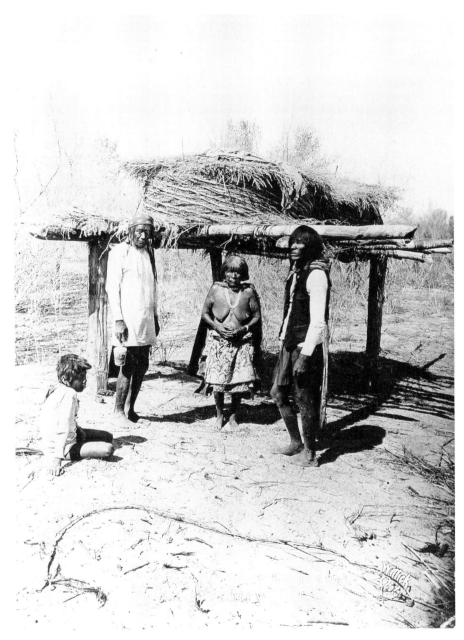

92. *Mohave Ramada, Arizona.* 1883. Photo: School of American Research Collections in the Museum of New Mexico, Santa Fe

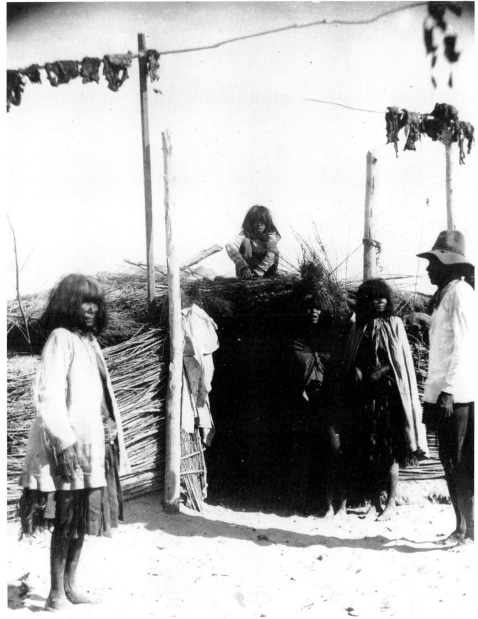

93. *Mohave Granary, Arizona.* 1883. Photo: School of American Research Collections in the Museum of New Mexico, Santa Fe

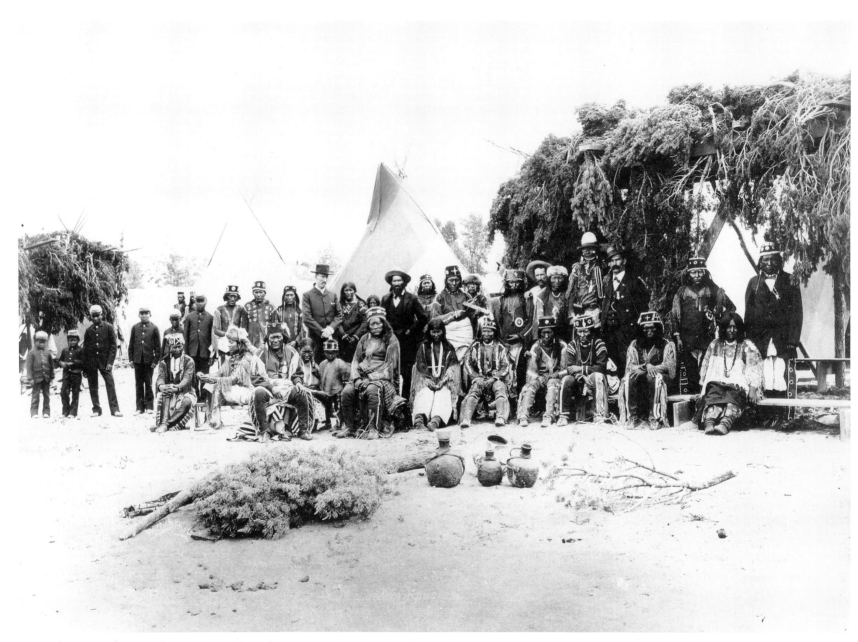

94. *Mescalero Apache at Tertio-Millennial Exposition, Santa Fe, New Mexico.*
1883. Photo: School of American Research Collections in the Museum of New Mexico,
Santa Fe

5. The Apache

◘

During his lifetime, Ben Wittick's Apache portraits brought him fame and financial reward as true images of the Apache, the fiercest and most infamous Indians in the Southwest. For over a hundred years, they have remained among his best-known photographs. Today, these images offer insight into a crucial period of American history, a period of conquest and assimilation. The forced submission of the Apache marked the end of an era. The Mescalero Apache, who had been forcibly relocated in the barren desert, Chiricahua Apache, who were the last renegade Indians in the Southwest, and White Mountain Apache, who served as scouts for the United States military, all faced the necessity of reconciling the political, social, and economic realities of two worlds—the traditional and the modern.

In 1883 Wittick attended the Tertio-Millennial Celebration in Santa Fe and photographed the Mescalero Apache delegation. Between 1883 and 1886 Wittick completed a series of portraits of the Apache Chiefs and Sub-Chiefs, including those leaders whose willingness to travel with the United States military in pursuit of their own tribesmen made possible the final submission of the Chiricahua. During this critical period of Apache history, Wittick photographed Nachez (Nai-chi-ti), Bonito, Got-chi-eh, Kla-esh, Chatto, Mangas, Loco, Zele (Tze-le), and Nana.[1] During these years there continued to be considerable dissent among the Chiricahua leaders. Chatto, Zele, and Loco were among those who believed it would be

7 / 106 / 99 / 100 / 4 / 114 / 113 / 109

23

futile to resist the United States, that the only way to avoid starvation and ultimate genocide was to remain on the sanctioned Reservation land and obey their captors. Despite promises made and broken, evidence of cruelties and injustices, and military and political corruption, they remained faithful to their agreement of submission and were willing to serve their captors. In contrast, leaders like Nachez, Geronimo, and Nana refused to accept terms of absolute surrender and confinement, believing that it was impossible to uphold their honor and tradition and submit to military and political regulations they saw as injustices and humiliations, or to sanction actions they perceived as treachery and betrayal. These leaders periodically broke out of camp, vainly trying to grasp a last few days of freedom.

In 1883 Wittick had the opportunity to photograph many of the Chiricahua leaders who had surrendered to General Crook and were negotiating terms for the resettlement of their people. That year he also photographed several White Mountain Apache scouts who had served General Crook by trailing Geronimo and his followers to their hideout in the Sierra Madre Mountains of Sonora, Mexico.

During 1885 and 1886 Wittick traveled with Captain Ben Rogers and his troop of Navajo and Apache scouts. It is easily understandable that the Navajo, wards of the United States for almost twenty years, should help the United States military capture the Apache, their traditional enemy, in return for gen-

erous wages, opportunities for leadership, and special privileges and honors. The White Mountain Apache had suffered far less than the Chiricahua from the trauma of resettlement, and by the 1880s were almost self-supporting. Having lived in more agricultural society than the Chiricahuas, they were willing and able to raise grain and cut and sell wood and hay. By 1885 those who remained in Camp Apache and even those who had been moved to the San Carlos Reservation had learned the benefits of cooperating with the Anglos.

In addition to portraits, Wittick made numerous field studies of Apache life. His work includes views of traditional Apache encampments taken in the years just prior to surrender and views of Apache settlements taken during their first years on the San Carlos Reservation.

The years of the Apache wars were fraught with conflicts between tribal leaders and misunderstandings between Indian leaders and United States Government officials. In an era marred by individual and institutional corruption, ambition, and greed, the situation was further confused by competition between the members of the military and political arms of the United States Government. Wittick's camera captured the psychological as well as the historical realities of these years. To fully appreciate Wittick's Apache portraits and field studies, it is important to understand the precontact history of these people, the predominant characteristics of traditional life, the values of their society, and the events that marked the transition from Spanish to Mexican to Anglo dominance in the Southwest—events leading to the final conquest of the Apache.

The ancestors of the Apache are thought to have crossed the Bering Strait from Asia to the American continent and, over a period of more than a thousand years, moved southward down the eastern flank of the Rocky Mountains to the area known today as the American Southwest. Estimates as to the time of their arrival range from the thirteenth century to the sixteenth.[2]

Throughout the centuries the Apache lived in bands composed of a loose union of groups. (A group was a confederation of local extended families.) Primarily a political unit, each band had a nonhereditary leader or Chief, chosen for such personal abilities as success in negotiation and eloquence of speech. Although during the years of their southern migration the Apache way of life was similar to that of the Navajo in the Gobinador phase, in the course of their migrations the Apache acquired many of the characteristics that distinguished Plains Indian life, such as housing, clothing styles, and hair styles. In time the Apache bands that migrated to the Southwest began to settle in more permanent communities and learned sufficient agricultural skills to raise corn, which became one of the primary staples of their diet. Meat, however, remained their favorite food, and mescal, in those areas where it was available, served as an important part of the Apache diet.

The Apache who lived in the desert built tepees, whereas those who lived in the wooded mountains above the desert built wicki-ups, shelters made of poles covered with grass and brush. Although some were tepee-shaped, the true wicki-up was dome-shaped. Like the Navajo, the Apache built their houses with the door facing east, to greet the rising sun.

Apache society was matrilineal and matrilocal; a typical extended family included mother and father, married daughters and their husbands, and unmarried sons. Each nuclear family lived in a separate residence, but the entire extended family shared food and supplies and worked and hunted as a team. Men entered the family through marriage and were bound by honor to contribute to the support and defense of its members.

The Apache women were the center of the family. Renowned for their skills in basketry, they were respected as important members of the community. By the third quarter of the nineteenth century, many of the women had abandoned

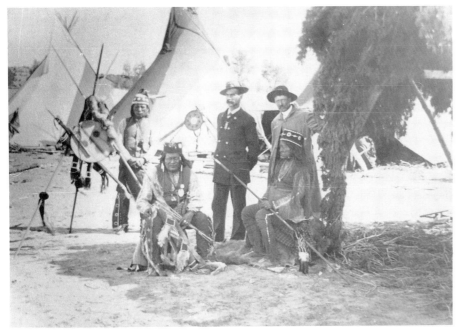

95. *San Juan and Nodzilla, Mescalero Apache Chiefs, Tertio-Millennial Celebration, Santa Fe*. 1883. Photo: Private Collection

96. *Ignacio and Son, Mescalero Apache*. C. 1883. Photo: School of American Research Collections in the Museum of New Mexico, Santa Fe

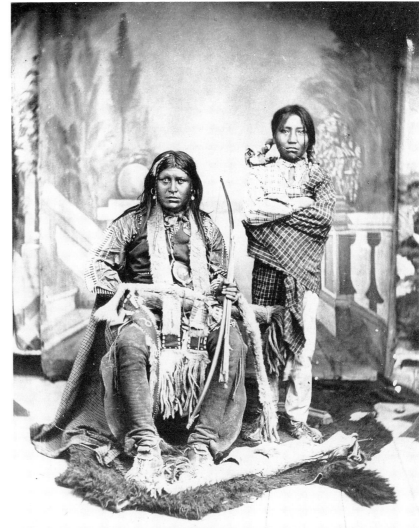

traditional clothing and wore two-piece calico dresses with long full skirts, while the Apache men favored calico shirts, muslin breechclouts, and moccasins. During these years of Apache resistance, women as well as men wore ammunition belts and carried knives and rifles.

The Apache recognized a supreme deity, the Giver of Life, and a deity, White Painted Woman, who was comparable to the Navajo deity Changing Woman. The Gahen or Mountain Spirits, a major source of supernatural powers, were thought to inhabit the mountains and were associated with the primary colors and directions. In the Mountain Spirit Dance, the ceremony that marks the rite of passage from youth to womanhood, Apache shamans represent the Mountain Spirits. The majority of traditional Apache ceremonies are similar to those of the Navajo and include sand painting, fire dancing, and blessings with sacred pollen.

The records of the Coronado expedition document the presence of the Apache in eastern New Mexico upon the Spaniards' arrival in 1540.[3] The Spaniards made little attempt to colonize or convert the Apache, but, by introducing horses, cattle, grain, and guns to the American continent, they changed every aspect of traditional Southwestern life. As the Apache became dependent on the Spanish material possessions and food supplies, raiding became an established way of life. Although there was never a direct confrontation between the Apache and the Spaniards, Spanish settlements throughout the Southwest were faced with a growing number of Apache raids in the years after the Pueblo Revolt and Reconquest. Intermittent warfare between the Apache and neighboring tribes also disturbed the missionary and colonization efforts of the Spanish. Horses, guns, and ammunition so completely changed the Apache way of fighting that by the end of the seventeenth century the frequency and intensity of Apache raids posed a serious threat to Spanish military control of the area. Although the Spanish built presidios, or forts, by the mid-eighteenth century they were plagued by constant raids.

To understand the problem of Apache raids, it is important to distinguish between raids and warfare. A raid was a mission of acquisition, a sanctioned response to a shortage of horses or supplies for the community. Raids were secretive and fast, and the raiders hoped to escape without revealing their identity. In contrast, revenge, not booty, was the goal of war, for only the death of an enemy could avenge a kinsman slain in battle. Because the honor of the family or band was at stake, Apache warriors sought full recognition for their deeds.

In a desperate attempt to control Apache raids, the Spanish, under the direction of Viceroy Bernardo de Galvez, sanctioned a system of bribes, offered in hopes of forcing the Apache into dependency. The Spanish furnished the Apache with food rations, firearms adequate for hunting, and liquor, given with the hope that the consumers might become addicted and thus become less functional as warriors. This expensive program helped to lessen Apache hostility, and by the early nineteenth century several newly dependent Apache bands were willing to negotiate peace.

In 1821 Mexico took control of Apache territory, but the Mexican Government lacked the funds to continue the "peace though dependency" policy of the Spanish. When raids resumed with greater intensity than ever before, the Mexican Government mounted a campaign to exterminate the Apache and went so far as to offer a bounty of $100 for every captured Apache.

With the signing of the Treaty of Guadalupe Hidalgo in 1848 and the Gadsden Purchase in 1853, the United States Government became heir to Mexico's Apache problem. Neither Spanish nor Mexican rule had seriously affected Apache religious or political life, but the United States military occupation of the Southwest brought a series of critical changes to the Apache world. Whereas the goal of the Spanish had been to

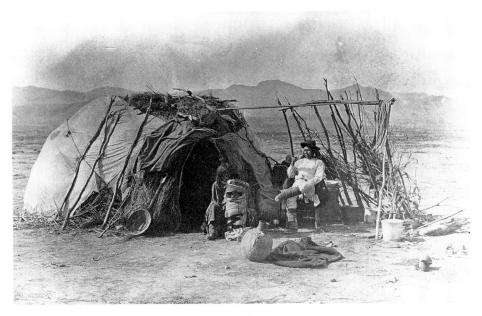

97. *Apache Playing "Chus."* C. 1885 Photo: School of American Research Collections in the Museum of New Mexico, Santa Fe

98. *Chiricahua Apache Camp, San Carlos River, Arizona.* C. 1885. Photo: School of American Research Collections in the Museum of New Mexico, Santa Fe

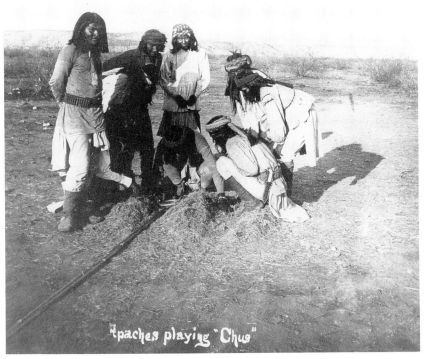

99

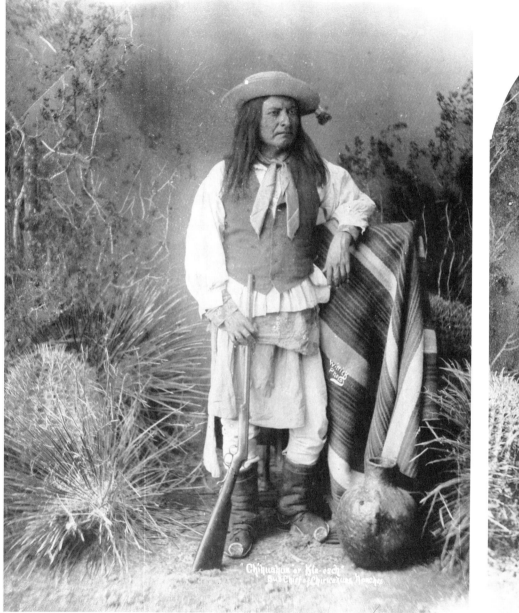

99. *Kla-esh or Chihuahua, Sub-Chief of Chiricahua Apache.* C. 1885.
Photo: School of American Research Collections in the Museum of New Mexico, Santa Fe

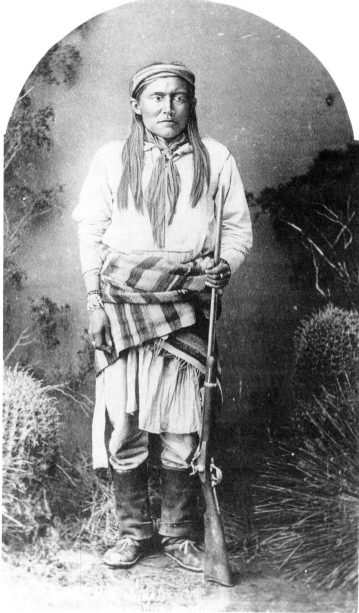

100. *Chatto, Sub-Chief of the Chiricahua Apache.* C. 1884. In the spring of 1882, Chatto, Nachez, and Penaltish and their bands fled the San Carlos Reservation and escaped to Mexico. In May 1883 General Crook, led by his Indian scouts, located Chatto's camp, captured the renegade Apaches, and returned them to the San Carlos Reservation. Chatto later became a sergeant in Crook's regiment of Indian scouts. Photo: School of American Research Collections in the Museum of New Mexico, Santa Fe

integrate the Indians into the mainstream of society, the basic policy of United States was to isolate them, to place them on reservations where they would be forced to live as wards of the government.

For hundreds of years the Apache had lived on the American continent, defending their territory against other tribes (particularly the Comanche, Ute, and Pawnee) and against the Spanish and the Mexicans. To the Apache, it was inconceivable that the Americans could claim all rights to Apache land simply because they had won a war against Mexico. During the Mexican War the United States had taken the side of the Apache in their struggle against Mexico, and the Apache expected the United States Government to continue this alliance. The Apache were shocked to learn that one provision of the Treaty of Guadalupe Hidalgo was a United States promise to force the Apache to cease all raids on Mexico. Initially, the majority of Apache bands refused to relinquish their rights to their ancestral land and continued to pursue a policy of raids and retaliatory wars.

It took more than three decades for Washington to gain full control over Apache land. These years were characterized by military and political corruption, treaties signed and broken, battles, raids, ambushes, the pillaging of white settlements, and the humiliation and killing of Apache leaders.

Between 1846 and 1855, the United States built a series of forts intended to impose military control on the area and bring an end to all Apache resistance. During the 1850s gold deposits were discovered in New Mexico, and waves of Anglo miners were followed by eastern farmers, eager to claim all rights to Apache land. The interests of the United States were in direct conflict with those of the Apache.

During the first years of the Civil War, the United States military concentrated on recovering New Mexico from the Confederacy. In 1863 gold was discovered in the area of Prescott, Arizona, and General James H. Carleton, justifying his actions as the most effective means of protecting East-West communications, initiated a major campaign to exterminate the Apache.[4] He ordered the construction of a series of forts all across the area of potential mineral wealth and authorized the relocation of all Apache and Navajo on government reservations. Although the Chiricahua firmly refused to relinquish their land and move onto a reservation, Carleton succeeded in confining 450 Mescalero Apache to Fort Sumner (Bosque Redondo) in southeastern New Mexico.

The Mescalero Apache first had been recognized as a separate tribe during the early seventeenth century by Father Alonso de Benavides as he journeyed through the region east of the Rio Grande.[5] Although there are no specific records of the date of their arrival in the Southwest, most ethnologists believe that the Mescalero and the Chiricahua journeyed southward along the eastern slope of the Rocky Mountains during the same period. Mescalero territory extended from central and southeast New Mexico and western Texas south into the northern Mexico states of Coahuila and Chihuahua.

Because of the rugged terrain and extremes of temperature in the harsh lands of the Mescalero—mountains that reached over twelve thousand feet and great stretches of burning desert—the Mescalero had little opportunity for agriculture and became primarily a hunting and gathering people.[6] The Mescalero hunted over a territory that included the Sacramento, Guadalupe, and Sierra Blanc Mountains, the Big Bend country, and northern Chihuahua.

The history of the relation between the Spanish and the Mescalero is one of mutual hostility—Spanish slave raids followed by Mescalero retaliation, and Mescalero horse, cattle, and food raids followed by Spanish punitive missions and military campaigns. During the years of the Pueblo Revolt and Reconquest, the Mescalero offered constant harassment to the Spanish. Mescalero raids continued to grow in frequency and intensity until 1810, when the Spanish negotiated a reasonably successful treaty in which the tribe was granted rations and the right to a large section of their traditional land. In 1832 the

Mexican government reaffirmed this treaty, which, despite some raiding action, remained in effect until the United States took control over the Texas–New Mexico territory.

During the Texas-Mexico dispute the Mescalero sided with the Texans, and during the Mexican-American War they supported the United States. Despite this alliance, when the United States took control of the area that was the northern territory of the Mescalero, Washington refused to recognize any Mescalero claim to their homeland and devoted the next forty years to carrying out an official policy of tribal relocation or extermination. Mescalero land was given to mining interests and settlers, and even before the Mescalero were confined to the reservation, the occupation of their land by these newcomers severely limited their food supply.

The fortunes of the Mescalero changed with each turn of the United States' Indian policy. In 1863 the Mescalero were sent to the Bosque Redondo Reservation, but in 1865, faced with a smallpox epidemic, they managed to escape. In 1869 the army was given control of the Indians of New Mexico, but in 1870 military control was abolished and a church-related Indian agency was established. In 1873 the United States established an official Mescalero Reservation, a small area in the vicinity of the White and Sacramento Mountains.[7] There, the Apache came into direct conflict with the settlers, a problem intensified by the Desert Land Act of 1877, which was passed in response to pressure from prospective miners and settlers to further confine the Southwest Indians.

Wittick's first Apache photographs were the portraits and group photographs of the Mescalero delegation at the Tertio-Millennial Celebration of 1883 in Santa Fe. Mescalero willingness to participate in the fair, this first public display of the Mescalero as submissive, cooperative participants in the white man's world, stands as a turning point in United States–Apache relations.

By 1883 the life of these delegates bore little resemblance to that of their ancestors. Since 1874, barbed wire had severely limited the mobility of their people and their horses and cattle across much of their territory. The Atlantic & Pacific Railroad had divided the territory of the Mescalero and had provided the necessary transportation for scores of buffalo hunters. For centuries the buffalo had been an important part of the food supply and the economic base of the Mescalero, but by the 1880s the great herds had been massacred by the thousands.

By the time of the Tertio-Millennial Celebration, the United States Government had begun to make fundamental changes in the Mescalero way of life. The first day school for Mescalero children was opened in 1877, and in 1884 the United States established a boarding school on the Mescalero Reservation with the express purpose of "civilizing" the next generation of Mescalero by separating the children from their families and teaching them to reject the traditions of their people and accept the values and standards of the white man.

The Tertio-Millennial Celebration was truly a landmark in Anglo-Apache relations, for the members of Mescalero delegation were willing participants in ceremonies dedicated to celebrating the white man's occupation of their ancestral land. Displaying examples of traditional handicrafts, the Mescalero openly sought the approval of the citizens of New Mexico and the United States officials who attended the celebration. The tide had turned, and within a year after the fair the first Roman Catholic priest on the Mescalero Reservation baptized 173 tribal members. (Ultimately, the majority of the tribe would become Roman Catholics.) In 1885 the government set up a Court of Indian Offenses, which was under the final authority of Reservation officials.

By 1883 the Mescalero had abandoned all hopes of resistance to the dictates of the United States Government. They had been transformed into a showcase example of peaceful Apaches. Having pitched their tepees, the delegates to the fair willingly posed with United States military officials. The Chiefs, San Juan and Nodzilla, were cooperative portrait sub-

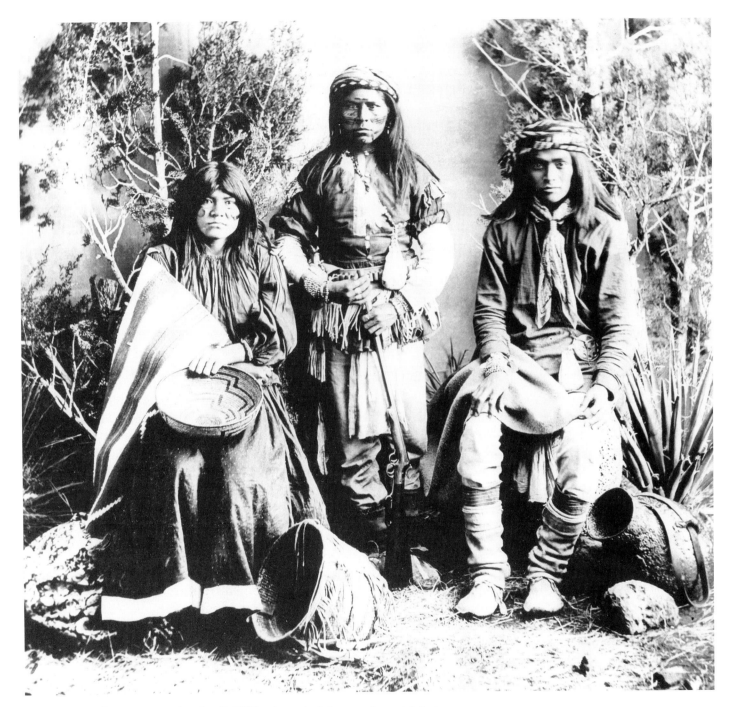

101. White Mountain Apache. C. 1885. Photo: School of American Research Collections
in the Museum of New Mexico, Santa Fe

jects, willing to pose in front of the most preposterous false backdrops. Only the facial expressions of these Mescalero leaders, who appear in white man's dress with a few traditional ornaments and artifacts, suggest their lives of futility and despair. The Wittick group photograph of the Chiefs, Sub-Chiefs, and United States military officials posed in front of Apache tepees at the fair, with a few examples of Apache basketry in the foreground, expresses the fundamental reality of these defeated Mescalero who faced a future of Reservation life.

94, 95, 96

In the course of the struggle between the United States military and the Apache, the Chiricahua suffered the greatest hardship and losses of all of the Apache tribes. Ancestors of the nineteenth-century Chiricahua had traveled south to the Rio Grande Valley during the sixteenth and seventeenth centuries, establishing their territorial homes in southwest New Mexico, southeastern Arizona, and adjacent parts of Mexico. The majority of Chiricahua were unwilling to change their way of life and yield to the demands of the United States Government.

In 1861 an ambitious cavalry lieutenant, George Bascomb, arrived in the West. Straight from West Point, he was convinced that all Indians were a threat to the American people. That year he helped bring an end to all hope of peace with the Chiricahua when, in a dispute over cattle and the return of some Mexican captives, he arrested Cochise, who at that time was one of the most cooperative Chiricahua Chiefs, along with his brother, two nephews, and several followers. When Cochise escaped, Bascomb murdered his followers; the Chiricahua vowed revenge, and war between the United States and the Chiricahua was inevitable.

In 1865 Mangas Colorado, a greatly respected Chiricahua Chief, entered the United States camp in response to an offer of peace and was murdered. His son, Mangas, sworn to avenge his father's death and the dishonor to his family, band, and people, became one of the most devoted leaders of the Apache resistance to United States military control.

In 1871 Congress appointed Vincent Colyer, Secretary of the Board of Indian Commissioners, Chief Executor of the Official Peace Policies and authorized him to spend ten million dollars "to collect the Apache Indians of Arizona and New Mexico upon reservations…and to promote peace and civilization among them…."[8] General George W. Crook, who had achieved distinction by confining many of the Plains Indians to reservations, was chosen to lead the campaign. Crook announced that all Apache must be assigned to reservations by February 1872 or be hunted down by the military. Although initially he achieved only limited success, by the end of the year he had formulated his most successful policy—his policy of using Apache to hunt Apache.

Crook envisioned a successful reservation system in which the Apaches would learn to farm and build dams. He believed that Apache should be treated as "children in ignorance, not in innocence."[9] An advocate of a paternalistic approach to justice, he attempted to establish a policy of native police and trial by native jury.

In 1875 the government moved about half of the Chiricahua to a desolate region in the White Mountains of Arizona that became known as the San Carlos Reservation. There the Apache were housed in an abandoned military camp, Camp Goodwin, in a desolate desert where the summer temperature often reached 140 degrees. "There was no game, no food except the occasional meager and unfit stuff issued to them. The insects swarmed about them and almost devoured the babies."[10] Many of the Apache died of malaria.

Soon after the establishment of the San Carlos Reservation, the discovery of gold and coal brought prospectors and miners into the area, along with cattle ranchers and land-hungry Mormon farmers. Washington sanctioned this seizure of Apache land by reducing the size of the Reservation from 7,200 to 2,600 square miles and giving the water rights of the Gila River to the white settlers. The Chiricahua were left with only the poorest land and no means of irrigation. Although they had

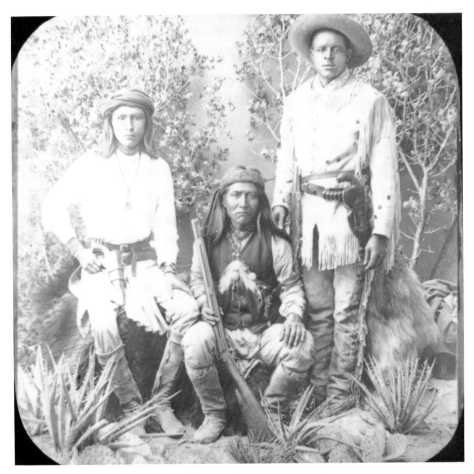

102. *Sergeant Jim, Bonito, and Renegade Negro. C. 1885.* Photo: Private Collection

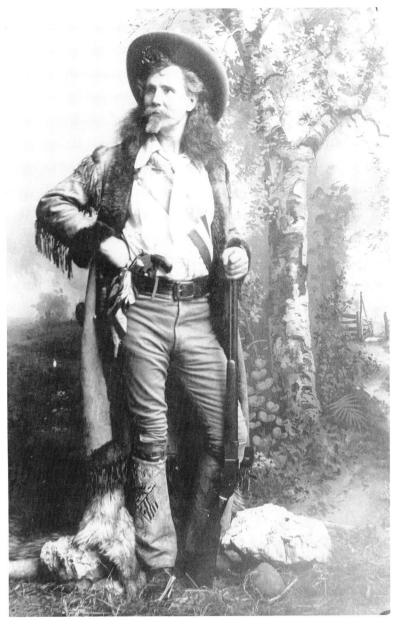

103. *Portrait of Jack Crawford, Indian Scout.* C. 1883–85. Crawford was known as "The Poet Scout." Photo: Private Collection

been promised protection for their horses and cattle, they were forced to give up their livestock and work as farmers on an unyielding land. By 1878 more than five thousand Apache were concentrated on the San Carlos Reservation.

In 1879, however, the government reversed its policy and authorized the decentralization of the Apache. Geronimo and about 500 Apache were permitted to return to the mountain country of the Fort Apache area, and for a short time peace appeared to have been restored. Then, in May 1885, Geronimo and Mangas, in response to a rumor that they were about to be arrested for the murder of a Lieutenant Davis (they did not know that the attempt had failed), broke from Fort Apache and headed for Mexico with 142 followers.[11] For almost ten months Crook unsuccessfully pursued Geronimo; then, in March 1886, he resigned, leaving his unfulfilled mission to General Nelson A. Miles. Using a troop of about 5,000 soldiers and almost 500 Navajo and Apache scouts, Miles located Geronimo and his band, who, faced with starvation and exhausted from years of fighting and being hunted, surrendered on September 3, 1886. Geronimo and his followers, as well as the Apache scouts who had discovered and delivered them to Miles, were loaded into boxcars and sent to prison in Florida. Although Crook had promised that those who surrendered would remain prisoners no longer than two years, President Grover Cleveland repudiated Crook's offers and demanded unconditional surrender.

The first group of Chiricahua men, women, and children arrived at Fort Marion in St. Augustine, Florida, in March 1886. The second group, composed of the "loyal Chiricahua" leaders who had served as scouts for the army, first went to Washington, D.C., where they requested and were refused a separate reservation for their people. In Washington, the members of this official delegation, led by Chatto, a warrior of the Warm Springs band, were greeted by President Cleveland, presented with peace medals, and then sent on their way to St. Augustine by way of Leavenworth, Kansas. The army

had promised to return this group to Arizona but, midway through the return trip, changed its plans. The third group, which included Geronimo, was imprisoned at Fort Pickins on Santa Rose Island, off the coast of Pensacola, Florida. The men remained alone on this island prison, despite the promise that they would be housed with their wives and children.

Because of the lack of sanitary facilities, the difference in climate, inadequate food, and salty water, scores of Chiricahua died during the first year in Florida. In March 1887 the Chiricahua were moved to Mount Vernon, Alabama, a slightly less humid area just north of Mobile. There the death rate climbed so rapidly that in 1894 all surviving Apache were moved to Fort Sill, Oklahoma. The Apache, above all, wished to return to their homeland in the West, but the fears and protests of Arizona citizens were heeded by the authorities in Washington. The citizens of New Mexico even had opposed the choice of Fort Sill, insisting that the Apache were only five hundred miles from their original land and were still too close for comfort. When the Chiricahua were finally released from Fort Sill in 1913, they had been prisoners of the United States Government for twenty-seven years.

Wittick's portraits of the Chiricahua Chiefs, Sub-Chiefs, and scouts were taken when the final fate of this tribe had not yet been determined. Why were these men willing to cooperate with an Anglo photographer during the very time that they were fighting for the survival of their people? Why did they agree to pose, weapons in hand, wearing part traditional Apache, part European clothing, in front of a background of Indian blankets, cacti, and woodland foliage? Were they not already captives of the Anglo-European world? Had they not already accepted their role as living exotic specimens, fierce Apache in a white man's world?

The majority of the portraits of the Chiricahua leaders were taken in 1883, three years before their final capitulation, yet there can be no doubt that these men would ultimately yield to

the economic, military, and political realities of a changed world. They wore the symbols and were decorated with the amulets and medals of the white man's world. Loco wore a calico shirt and star; Nana and Chatto wore store-bought hats, jackets, and vests and traditional loincloths. Only the faces of such leaders as Loco, Nana, and Got-chi-eh suggest the hardships they had experienced and the compromises they had been forced to accept. Nachez, the youngest son of Cochise and one of the last Apache to be captured, posed for two formal portraits. In the first, he carried a blanket as he posed as a traditional Chiricahua leader. In the second, a seated portrait, he wore white man's clothes, a participant in the modern world.

The Chiricahua were a ragged crew compared with Rogers's White Mountain Apache scouts, who for almost a decade had worked for wages for the United States military. The White Mountain scouts dressed carefully for their portraits and combed their hair. They proudly displayed their favorite Indian jewelry. Two scouts even agreed to stage a scene of applying war paint. An Apache policeman, displaying the photographer's standard props, willingly posed in front of an architectural backdrop that suggested the grandeur of the white man's civilization. Na-buash-i-ta, a Medicine Man, posed like Napoleon Bonaparte in his splendid costume and headdress. Peaches (Penaltish, or Tzoch), Crook's most distinguished scout, posed with rifle and pistol in an elaborate outfit suitable for a Hollywood stage set. There is no question as to his identification with the white man.

Wittick's photographs offered the American public a chance to see true Apache chiefs and scouts, the hunters and the hunted. These photographs gave prospective tourists a glimpse of the fiercest inhabitants of the American West. Just as Geronimo later sold and resold the buttons on his coat as souvenirs and Chief Wolf Robe and Chief Ironsides starred as Wild West Show Indians, many of Wittick's portrait subjects were willing participants in the consumer West. Wittick's Apache subjects were heroes of the past, living reminders of a way of life that had been destroyed. Their photographs were shadows on glass, and they would spend the rest of their lives as shadows of the past.

107

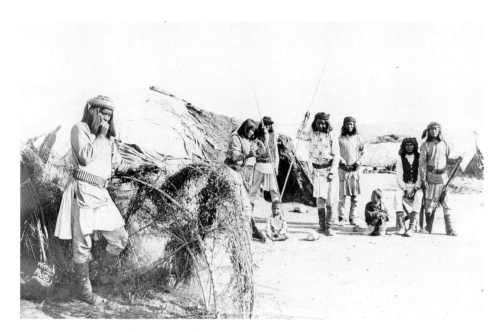

104. *Chiricahua Apache Camp on the San Carlos River, Arizona.*
C. 1885. Photo: Museum of New Mexico, Santa Fe

105. *Chiricahua Apache Camp on the San Carlos River, Arizona.*
C. 1885. Photo: Museum of New Mexico, Santa Fe

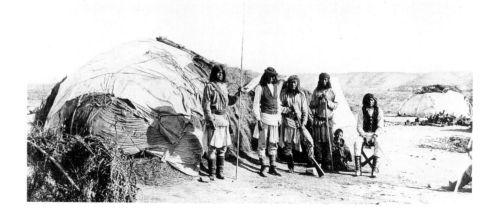

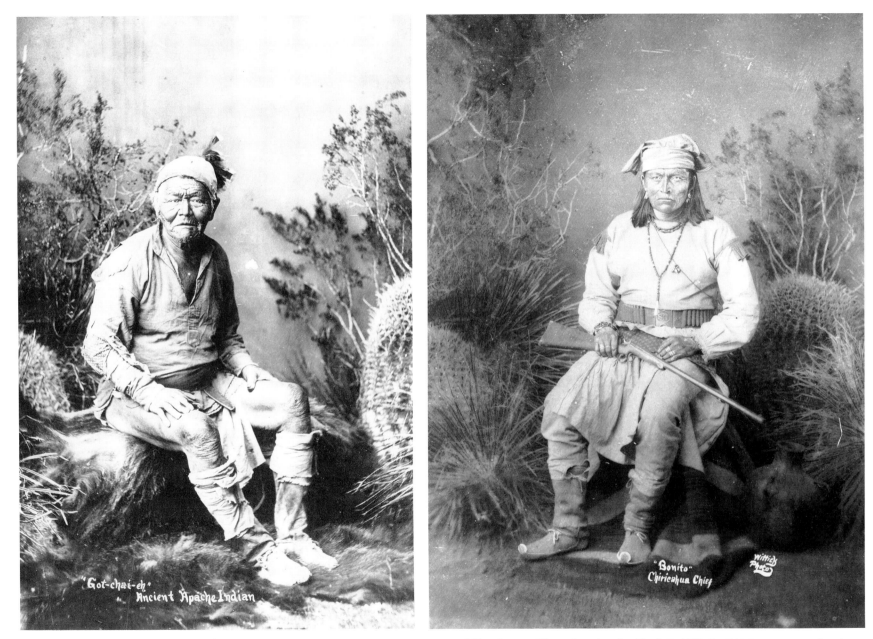

106. *Got-chi-eh, Ancient Warm Springs Apache.* C. 1883. Photo: School of American
Research Collections in the Museum of New Mexico, Santa Fe

107. *Bonito, Chiricahua Apache Chief.* C. 1883. In 1883 Bonito surrendered to
General Crook. Photo: School of American Research Collections in the Museum of New
Mexico, Santa Fe

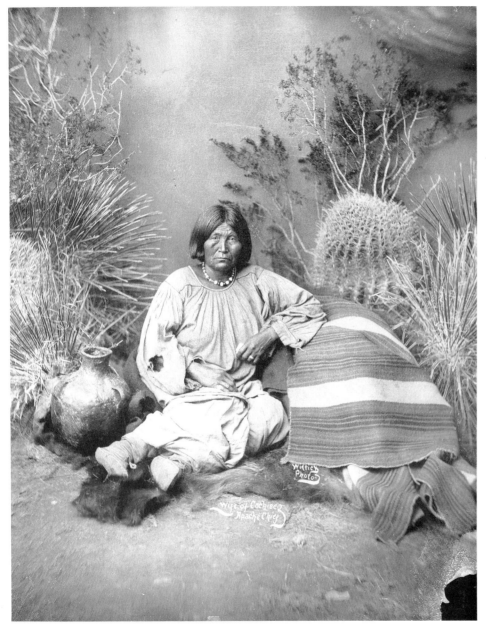

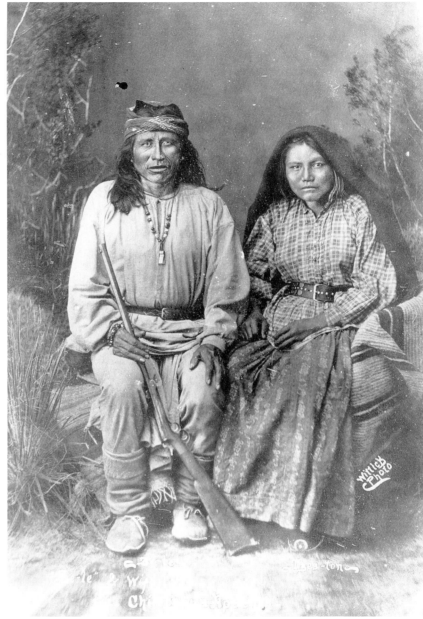

108. *Toos-day-say, Apache, Wife of Cochise and Mother of Nachez.*
C. 1885. Photo: School of American Research Collections in the Museum of New Mexico, Santa Fe

109. *Tze-le and Wife, Chiricahua Apache. C. 1883.* Photo: School of American Research Collections in the Museum of New Mexico, Santa Fe

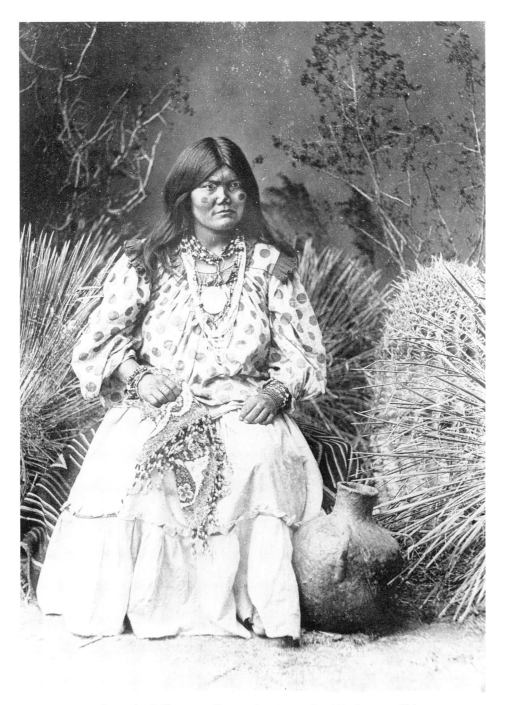

110. *Nal-Tzuck-ich ("Cut Nose"), Apache Woman.* C. 1883. Cutting off the
fleshy part of a woman's nose was a traditional Apache punishment for
infidelity. Photo: School of American Research Collections in the Museum of New Mexico,
Santa Fe

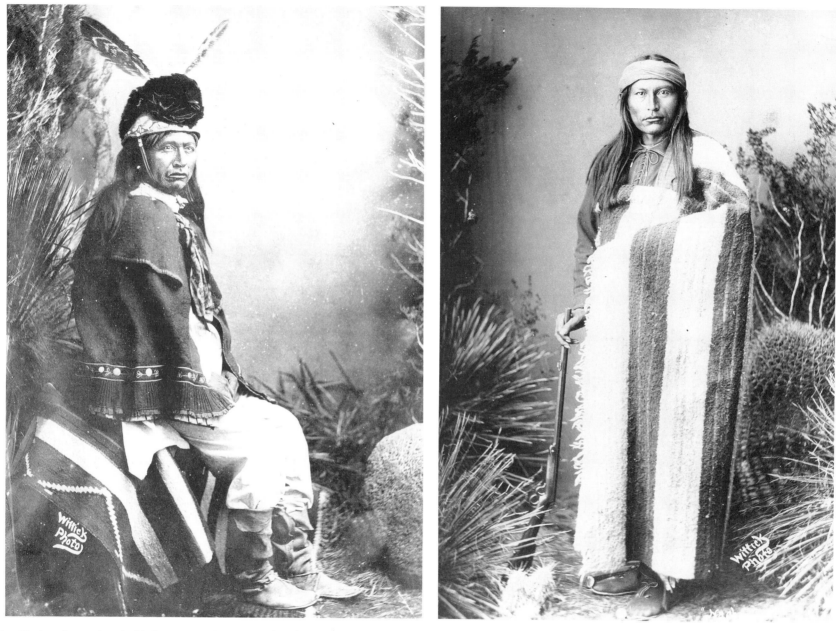

111. *Na-buash-i-ta, Apache Medicine Man.* C. 1884. Na-buash-i-ta wore a
medicine hat to protect him from bullets and arrows. Photo: School of American
Research Collections in the Museum of New Mexico, Santa Fe

112. *Nai-chi-ti (Nachez), Chiricahua Apache, Son of Cochise.* C. 1883.
Photo: School of American Research Collections in the Museum of New Mexico, Santa Fe

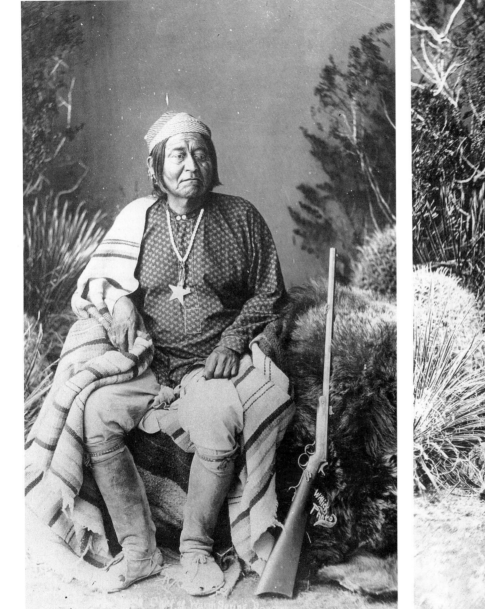

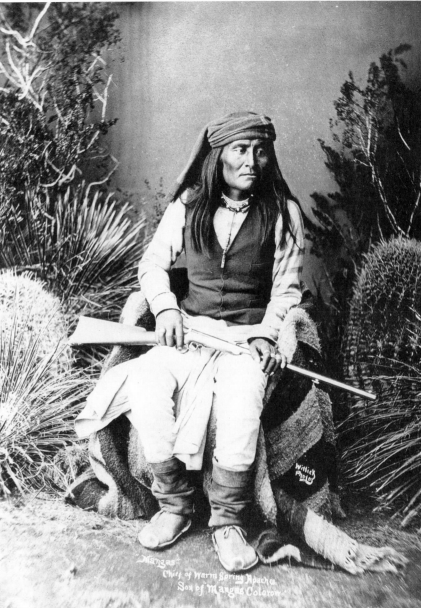

113. *"Old Loco" (or "One Eye Lost"), Chief of Warm Springs Apache.* C. 1883. Loco was Chief of a band of Warm Springs Apaches who fled from the San Carlos Reservation in 1882. They were captured at Horse Shoe Canyon and returned to the Reservation. Photo: School of American Research Collections in the Museum of New Mexico, Santa Fe

114. *Mangas, Chief of the Warm Springs Apache.* C. 1885. Mangas was the only important Apache leader to be captured in the 1886 campaign. Photo: School of American Research Collections in the Museum of New Mexico, Santa Fe

115. *Chai-si-to with Mescal Fiddle.* C. 1883. Chai-si-to was the son of **Bonito.** Photo: School of American Research Collections in the Museum of New Mexico, Santa Fe

116. *Na-tu-ende, Apache Woman.* C. 1884. Photo: Museum of New Mexico, Santa Fe

114

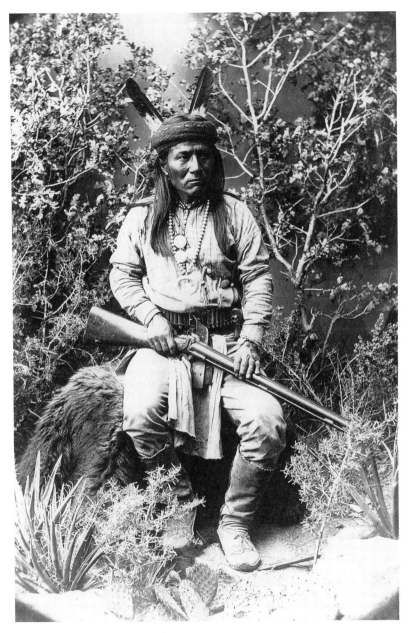

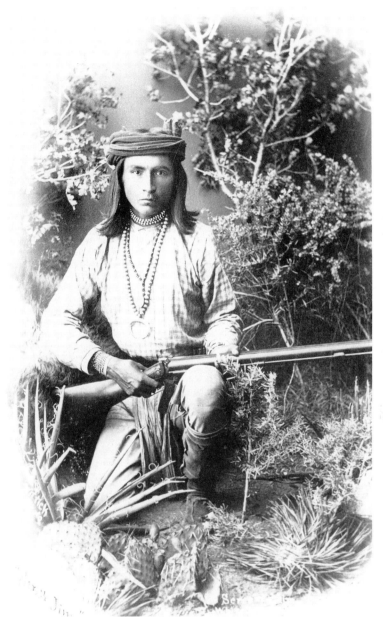

117. *Bonito, White Mountain Apache.* C. 1883. Photo: School of American Research
Collections in the Museum of New Mexico, Santa Fe

118. *Sergeant Jim, White Mountain Apache Scout Who Served in Captain Emmett Crawford's Campaign of 1885 and 1886.* C. 1885.
Photo: Private Collection

119. *Navajo Scouts in the Apache Campaign.* C. 1885. Photo: School of American
Research Collections in the Museum of New Mexico, Santa Fe

6. The Navajo

◘

Ben Wittick first traveled into Navajoland in 1878, the year he first arrived in the Southwest. The incredible land forms of the desert, fantastically shaped sandstone mesas and granite monoliths, and the awe-inspiring panoramas—vistas that seemed to encompass hundreds of miles in every direction—inspired the newcomer to devote his first years in the area to landscape photography.

Wittick never had the opportunity to photograph either sacred Navajo ceremonies or intimate moments of Navajo family life, because it was impossible to establish a network of close personal contacts in the Navajo world similar to that which he had built in the Pueblo world. Unlike the Pueblo people, who are village dwellers, the Navajo live in small family groups, often separated from each other by miles. During the years that Wittick worked in this area, few Navajo spoke English and very few had any interest in friendship with an itinerant Anglo photographer. Despite these limitations, his photographs document one of the most important periods of Navajo history, a period distinguished by social changes that would determine the future of the Navajo people.

Wittick's images of Navajo life include field studies of Navajo encampments, interior and exterior views of the first Reservation trading posts, and portraits of the Navajo people. Wittick photographed Navajo jewelers and weavers, federally appointed Navajo policemen, and Navajo hired as United States Army scouts to track the renegade Apache. In 1885 and 1886 he had the opportunity to travel with an army regiment on one of the last Apache campaigns and make portrait studies of those Navajo men, who, although they still remembered the days when they had been hunted, captured, and imprisoned as enemies of the American nation, agreed to serve as army scouts. During his years in the Southwest, Wittick photographed almost all of the important Chiefs and Sub-Chiefs chosen to lead the Navajo people. His portrait subjects included Manuelito, the famous leader of the Navajo resistance, and his successor, Henry Chee Dodge, the man who became the first Chairman of the Navajo Tribal Council.

Wittick arrived in Navajo country only a decade after the Navajo had returned from the Long Walk, the forced march and four-year imprisonment of the Navajo people at Fort Sumner (Bosque Redondo) in southeastern New Mexico. In 1868 the Navajo returned to a section of their ancestral homeland, the newly established Navajo Reservation, where they were forced to live in accordance with the limitations and regulations of the dominant American society. The Navajo were a people whose world had been destroyed and who were willing to accept the only available condition for survival, the beneficence and sustenance of the United States Government.

The Long Walk, a critical milestone in Navajo history, has become a symbol of the Navajo ability to survive as a people. The Navajo returned to their ancestral land determined to

protect their heritage. For the first time they experienced a tribal identity, an understanding of the importance of the Navajo Way. Every aspect of Navajo life was recognized as part of a tradition that must be preserved. Wittick arrived in Navajoland just in time to document a world defined by this new awareness. The men and women whom Wittick photographed understood the importance of tradition as they tried to find a way of life that would honor fundamental Navajo values, despite the compromises necessary for survival in the contemporary world.

The land and life of the Navajo—Navajo dress, Navajo religion, Navajo family structure, and the activities of daily life— have changed only very gradually since Wittick first visited the Reservation, because the Navajo in many ways have succeeded in preserving their culture. It is, nevertheless, ironic that what today is viewed as traditional Navajo life is the way of life established during the last quarter of the nineteenth century. This way of life was the product of three hundred years of relatively peaceful coexistence with the Spanish crown and just over thirty years of conflict with the United States Government.

Since about the fourteenth century, the Navajo people have lived in the heart of the American Southwest in a land surrounded by four sacred mountains. To the east is Mount Blaca (Sisnaajiní), to the north Mount Hesperus (Dibénitsaa) in the La Plata Mountains, to the south Mount Taylor (Tsoodzil), and to the west the San Francisco Peaks (Doko' ooslííd). There are also three sacred mountains, Huerfano Mesa (Dzilnáoodilíí), Goberna Dor Knob (Ch' óól'i''i') and Navajo Mountain (Naatsi s áán), southeast of the Reservation, in the center of the historic Navajo homeland. The Navajo believe that they were brought into the present world, the Glittering World, from the Underworld, their spiritual home. According to Navajo legend, these mountains, all other forms of land, all forms of water, all varieties of vegetation, all animals, and all people were

brought through a series of underworlds to the surface of this world by supernatural beings, the Navajo Holy People. The holy site of emergence, Xajíínai, is believed to be a hole in the La Plata Mountains. Following emergence, the people wandered for centuries in many directions until they reached the land that the Holy People had chosen to be the sacred Navajo homeland.

Most anthropologists and ethnologists believe that about three thousand years ago the ancestors of the Navajo came from Asia across the Bering Strait to the North American continent. The Navajo are related linguistically to the Athapascan people, who during the 1400s traveled south along the eastern slope of the Rocky Mountains until they reached the area that today is the southern border of Colorado. These migratory Athapascans then splintered into several groups, which pursued different directions. Those who would later be known as the Navajo traveled southwest to northern New Mexico, where they settled in the upper San Juan Valley, an area carved by the Governador and Largo tributaries of the San Juan River.

The original homeland of the Navajo in the American Southwest is known as the Dinétah, which means "among the people."[1] The canyons of the Dinétah are filled with examples of ancient rock art—petroglyphs and pictographs—that offer visual testimony to the beliefs and rituals of the past and serve as a chronicle of the pageant of Navajo history. For centuries this area has had the greatest cultural and spiritual significance to the Navajo people: The Dinétah is the Navajo holy land, and contemporary Navajo spiritual leaders readily explain the importance of the term: "Dinétah is not some place that exists only in our stories, some place that no one has seen. Dinétah is a place, a beautiful place, where the Navajo lived and where much of the relationship between the Navajo and the Holy People took place. It isn't too far away. It is a place which has canyons and rocks and bushes and plants and trees. It is a place where our stories began."[2]

121. *Indian School at Fort Defiance Indian Agency, Arizona.* C. 1886.
Photo: Private Collection

120. *Navajo Church Rock, Famous Landmark on Prescott Trail, View from Southeast.* C. 1883. Photo: School of American Research Collections in the Museum of New Mexico, Santa Fe

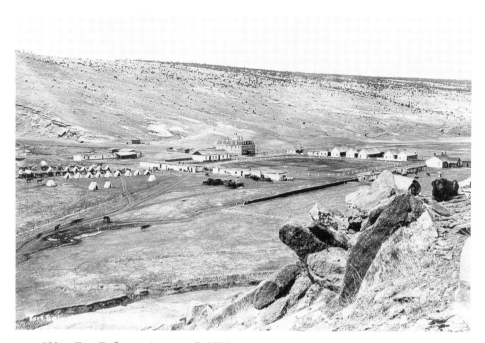

122. *Fort Defiance, Arizona.* C. 1890. Photo: School of American Research Collections in the Museum of New Mexico, Santa Fe

123. *Group of Navajo Indians and Simon Bibo* (kneeling), *Manuelito* (on right). C. 1883. Photo: School of American Research Collections in the Museum of New Mexico, Santa Fe

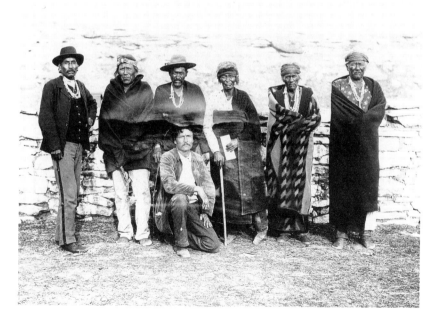

Before the arrival of the Navajo, the Dinétah was inhabited by ancestors of the Pueblo people who, during a long period of drought, abandoned the area to move nearer to a more dependable source of water. Because the ancient Navajo lived in small bands as hunters and gatherers, they had greater mobility than the Pueblo people, who lived in large agricultural communities.

The Navajo of the Dinétah hunted deer, antelope, Rocky Mountain sheep, and a variety of small animals. The men planted and harvested corn, beans, melons, squash, cotton, tobacco, gourds, and pumpkins, while the women gathered grasses, seeds, roots, and herbs. The men offered protection to the group while the women cared for the children, prepared and cooked the food, and made all clothing. They made most of their clothing and blankets from skins, but they also wove blankets from cedar bark and fibers. The ancient Navajo wove watertight baskets and occasionally made some crude utilitarian pottery. From the time of their arrival on the American continent, the Navajo lived in conical dwellings called hogans, which are traceable to the Asian world. Then as now, when a new hogan was built, the Navajo sprinkled cornmeal and corn pollen in four directions in the structure to bring blessings to the new home.

Throughout history, spiritual harmony, a sense of personal and communal well-being, has been the focus of the Navajo world. The Navajo believe that it is possible to achieve and maintain a harmonious world by sustaining the good will of the supernatural beings, the Holy People or Yeii, who control the destiny and well-being of the human inhabitants of earth. The most important rituals of the Navajo are song ceremonies, chants performed to attract and influence these Holy People. Navajo Medicine Men perform these sacred chants, provide herbal cures, and create special sand paintings, which must be destroyed as soon as the ceremony has been completed.

In the modern world, as in the Dinétah, the Navajo have a great fear of death and ghosts because they believe that the spirits of the dead who return to earth have the potential to harm the living by bringing sickness, death, and a wide range of afflictions. Each critical human problem has an elaborate ritual that, if properly directed and performed, will exorcise angry spirits, appease any offended natural or supernatural forces, restore harmony to the individual, and bring blessings to all of the Navajo people. For centuries Navajo peace leaders have performed the Blessingway, the most important Navajo ceremony, to ensure a world with plentiful food, a world in which the inhabitants enjoy good health and protection from their enemies. Other Navajo chant ceremonials, which last several days and include a variety of social events, are the Warway, the Nightway (Yeiibichi), the Mountainway, and the Holyway.

The Spaniards arrived in the Southwest in the sixteenth century, but they paid little attention to the Navajo until the early eighteenth century. They held little hope of finding gold or other forms of material wealth in Navajoland and recognized that the Navajo people had few resources to offer in tribute. Not only were the Navajo not included in Juan de Onate's plan for colonization, they escaped the missionary zeal of the Spaniards. The Franciscan Fathers believed that these seminomadic people had little formal religious life, and saw greater potential for conversions among the Pueblo Indians.

One of the first Spanish references to the Navajo was the report in 1626, by Father Zárate-Salmerón, that the *Apache de Nabajú* lived north of the Jemez Pueblo in the region between the Chama and San Juan rivers.[3] In 1627 Father Alonso de Benavides, the Custodian of Missions of New Mexico, founded a mission at the Tewa village of Santa Clara, but the Franciscan failed to make a single Navajo convert.[4]

Although after the Pueblo Revolt, Spain was determined to reestablish political and religious control over the Pueblo people, the Navajo were never part of De Vargas's mandate for reconquest. Nevertheless, the events of these years had a ma-

jor impact on the social and economic life of the Navajo people. During the Pueblo Revolt the Navajo allied with the Jemez and the Cochiti in their fight against the Spaniards, and in the years immediately following the Navajo gave sanctuary to many of the people who sought refuge from impending Spanish reprisals. A major exception were the Navajo in the vicinity of the Acoma and Laguna Pueblos, who, although they rejected all Spanish attempts at missionary conversion, became friendly with the Spanish and formed an independent group that became known as the Enemy Navajo.

After De Vargas's successful reconquest of the Pueblos, many of the Jemez, Keres, and Tewa people fled from their Rio Grande homes to Navajo territory. A number of these Pueblo people remained with the Navajo, and subsequent intermarriages resulted in several new Navajo clans.[5] Pueblo culture brought many important social and economic changes to the Navajo world, and the Pueblo people made several major contributions to Navajo ceremonial life. The Pueblo people brought new pottery skills to the Navajo, and although weaving had been part of Navajo culture for many centuries, the skills of the Pueblo refugees helped to transform weaving into one of the primary craft arts of the Navajo people. Many ethnologists believe that Navajo ritual sand painting developed during these years of contact with the Pueblos.

During the early eighteenth century the Navajo, searching for grassy plains and fertile valleys, migrated southwest to an area that includes the present-day Navajo Reservation. By the mid–eighteenth century, the Spanish referred to the region between the Rio Grande Pueblos and the Hopi Mesas and from the vicinity of Zuni north to the San Juan River as the Province of Navajo. The center of the province was the Canyon de Chelly area. There the Navajo followed a way of life that differed in many ways from what is seen today as traditional Navajo life. The Navajo lived in small communities of ten to forty families, each in its own clearly defined area. Their primary activities included hunting, gathering, agriculture, and grazing. Each group was an independent agricultural unit, and each band, led by a regional War Chief, made independent raids.

Neither the Spaniards nor the Mexicans, their successors in the Southwest, ever established military, political, or ecclesiastical control over the Navajo, but the arrival of the Spaniards on the American continent completely transformed almost every aspect of Navajo life. Although they never forced the Navajo to live under a missionary system or to live in concentrated settlements, they introduced horses, cattle, goats, and sheep to the Navajo world and thereby brought a major transformation to all of Navajo life. By the late seventeenth century these animals had been fully integrated into Navajo daily life and had completely changed the Navajo diet and their performance of daily chores, methods of transportation, and craft arts.

In the course of the eighteenth and nineteenth centuries the Navajo acquired thousands of horses and sheep raised on Spanish settlements. By 1846, the year the United States Government took control over the Arizona—New Mexico territory, raiding had become a basic means of economic subsistence for the Navajo bands in the area. Among the terms of the Treaty of Guadalupe Hidalgo, signed in 1848, was a United States pledge to bring an end to all Navajo and Apache raids.

Relations between the United States Government and the Navajo were doomed to failure from the start, because United States political and military leaders had several basic misconceptions about Navajo life.[6] The primary objective of the Navajo raids were food, animals, material goods, and Pueblo or Mexican slaves. These raids were under the independent authority of the War Chief of each band. When General Stephen Watts Kearny established his headquarters at Santa Fe in 1846, he thought of the Navajo as a united people with a central government, not as independent bands, and authorized his

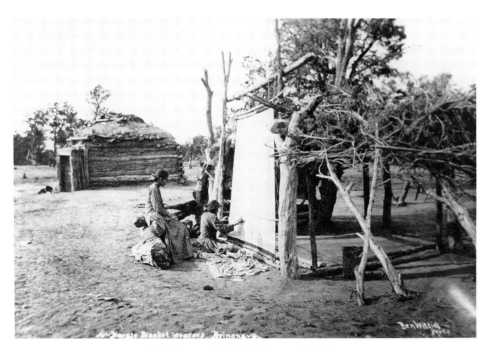

124. *Navajo Blanket Weaver.* C. 1885. Photo: Private Collection

125. *Tze-he-lih Trading Post, Arizona.* C. 1890. Photo: School of American Research
Collections in the Museum of New Mexico, Santa Fe

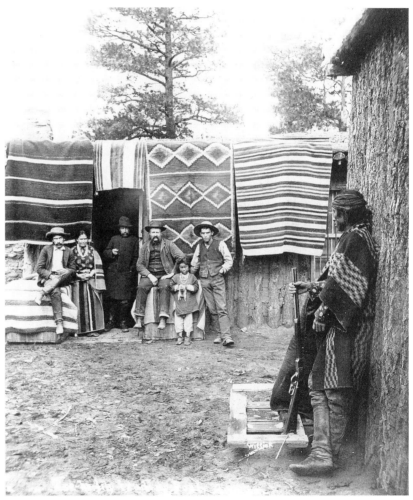

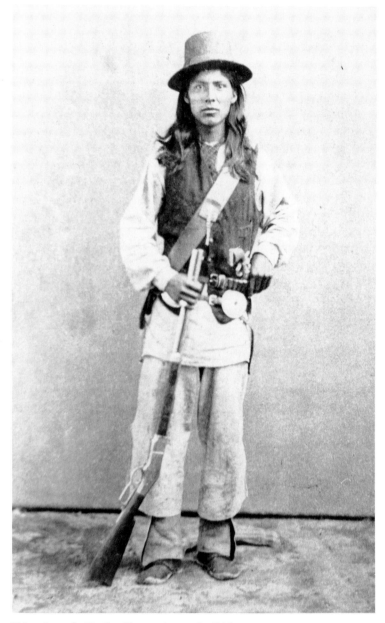

126. *Juan the Trailer, Navajo Scout.* C. 1885. Photo: Private Collection

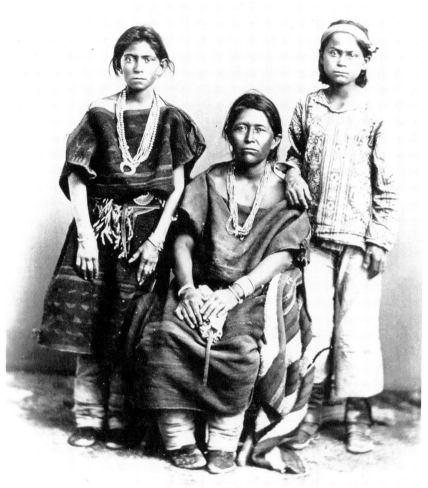

127. *Navajo Wife and Children of Jesus Arviso.* C. 1885. Mexican man captured by the Apaches and sold to the Navajo, Arviso worked as an interpreter for the U.S. Army and U.S. Indian Agency. Photo: Private Collection

officers to negotiate peace treaties with those Navajo Chiefs who he believed spoke for all of the tribes. For five years Navajo leaders such as Narbona, Largo, and Zarcilla, who in reality spoke only for a regional band, signed peace treaties that the majority of Navajo bands completely ignored. United States Government officials became convinced that a Navajo pledge was meaningless and that Navajo treaties were signed only to be broken.[7]

Recognizing that peace treaties would never solve the issue of Navajo raids, the War Department, in an act that the Navajo regarded as invasion of their territory, established a permanent military post (later called Fort Defiance) with an artillery company, two infantry companies, and four cavalry companies. The Department of Interior sent into Indian country an Indian Agent, Henry Linn Dodge, who, determined to maintain peaceful relations with the Navajo, was reasonably successful in communicating with Navajo leaders.[8] Unfortunately, after he was killed by an Apache party in 1856, military leaders pursued a policy of expansion and carried out a series of reforms that ran into direct conflict with Navajo interests. Utes, Zuni, Hopi, even the Enemy Navajo, all sided with the army in the conflict with the Navajo.

In September 1858 Colonel Dixon Miles of the War Department issued a formal declaration of war against the Navajo, proclaiming the Navajo the official enemy of the United States Government. Navajo leaders grew determined to drive the hated Anglos from their land. In April 1860 Manuelito and Barboncito, against the advice of Ganado Mucho, a leader in the area near Fort Defiance, mounted an attack on the fort that had become a symbol of the Anglo invasion of their territory. They completely underestimated the strength of the army troops, and within two hours army guns proved their superiority over Navajo bows and arrows. After this defeat the Navajo renewed their raids on New Mexican villages in an area that stretched from Santa Fe to Zuni, and the New Mexicans retaliated with raids on the Navajo. Among their prisoners were

women and children who were sold to the local inhabitants as slaves.[9]

With the start of the Civil War, the Army turned its attention away from the Navajo, but by 1862, with the New Mexican territory firmly under Union control, Brigadier General James H. Carleton, the newly appointed military commander of New Mexico, mounted a campaign to destroy the Navajo and gain complete United States control over Navajoland and its resources. Carleton's stated purpose was to protect the Union's line of communication with the West; however, letters written in 1863 make it clear that his primary motive in removing the Navajo from their homes was his belief that the Navajo land had deposits of gold far richer than those discovered in California. In June 1863, determined to claim his share of Navajo mineral treasures, he issued a general order against the Navajo, commanding Colonel Christopher "Kit" Carson to force all of the Navajo to surrender and accept relocation by the United States Government. Carson was authorized to kill any Navajo men who offered resistance and to take prisoner all Navajo women and children. Carleton's plan, which now stands in history as the Long Walk, was for the Navajo prisoners to travel on foot to a reservation at Fort Sumner, where about four hundred Mescalero Apache and four hundred Enemy Navajo were already living as wards of the United States Government.

When Barboncito, the War Chief of the Canyon de Chelly Navajo, and several other Navajo leaders openly defied Carleton's order and refused to leave their homeland to live as prisoners on land that belonged to the Comanche, Carson carried out a scorched-earth campaign. Carson, with seven hundred New Mexican volunteers, tore up cornfields, destroyed orchards, slaughtered Navajo sheep, and burned Navajo homes. He then authorized the payment of a bounty for captured Navajo sheep, mules, and horses. Starving and homeless, the Navajo began to surrender at Fort Defiance.

Unlike Carleton, who wished to see the Navajo extermi-

122

nated as a race, Carson's goal simply was to obey orders and force the Navajo to surrender. In his 1864 campaign at Canyon de Chelly he offered those who surrendered food and the possibility of survival. When the majority of Navajo accepted his offer, he used this technique in the remainder of his Navajo confrontations.

Carson eventually captured over eight thousand Navajo who made the tragic three-hundred-mile journey to Fort Sumner. (Between fifteen hundred and two thousand Navajo remained free). One survivor of the Long Walk recalled: "There were a few wagons to haul some personal belongings, but the trip was made on foot (over a distance of 300 miles). People were shot down on the spot if they complained about being tired or sick, or if they stopped to help someone. If a woman became in labor with a baby, she was killed. There was absolutely no mercy."[10]

The Fort Sumner plan proved a failure from the start. Carleton's master plan was founded on the assumption that he could transform the Navajo into village dwellers and farm workers. He envisioned teaching the Navajo to irrigate the desert and raise a variety of crops that would make them self-sufficient. He planned the division of the Navajo community into twelve small villages, each governed by a Head Chief and Sub-Chief, who would be granted such special privileges as uniforms and superior lodging. Each head chief would form a court presided over by a military authority. A Navajo council would help to maintain peace and order on the Reservation, but the council's authority was subject to the approval of the United States military. The proceedings of a Board of Officers, which met in April 1865 at Fort Sumner, clearly reveal the attitude of the military to their Navajo captives:

It may appear unjust to punish people for a violation of laws which they do not only not understand, but have heretofore been taught to regard as the highest virtue to break. But it must be recollected that these Indians have got to be made to respect the bonds which unite civilized society, and the only practical way of doing this is by inflicting a punishment, however light, for the first offense, and increasing the punishment in proportion to the increase of knowledge, until its severity would prevent further repetition. This is the only possible mode of instructing them on the subject.

Article 6 exemplifies the Army's paternalistic orders:

Any adult Indian who shall be found absent from his or her village between the hours of 7 o'clock p.m. and 5 o'clock a.m. in winter, and 8 o'clock p.m. and 4 o'clock a.m. in summer, shall be imprisoned as in article 3.[12]

Carleton expected the Navajo to make wigwams, in which they would live while they built the rectangular adobe houses of their pueblo town. He also believed that before long they would make their own clothing and send their children to a Catholic school, the first steps in their transformation into civilized inhabitants of this planned community.

The Navajo had no interest in complying with Carleton's orders. They lived in holes in the earth covered with brush and insisted on devoting all efforts to finding forage for the few sheep they had managed to bring with them. They paid little attention to learning irrigation or planting skills.

Until the Navajo were self-sustaining, Carleton ordered that they be issued rations and counted daily, but he underestimated by more than three thousand the number of Navajo to be sent to Fort Sumner. Corruption was rampant at the Indian Agency, and the meager supply of food, blankets, and supplies did not even begin to cover minimal necessities. In 1865 a smallpox epidemic killed over twenty-three hundred Navajo. Each year the crops failed or were not even planted, and it soon became clear that Carleton's relocation plan would never succeed.

As public opposition to the Fort Sumner project grew and livestock interests began to press for the release of the Bosque

Redondo land, government officials began to question the mounting expenses of this failing project. In 1866 Carleton was released of his command, and the following year the Bureau of Indian Affairs replaced the army as the government agency in control of the Navajo. When, in May 1868, Colonel Samuel F. Tappan and General William T. Sherman arrived at Fort Sumner to negotiate a peace treaty with the Navajo, Barboncito spoke on behalf of the Navajo people: "I hope to God you will not ask me to go to any other country except my own....We do not want to go to the right or left, but straight back to our own country."[13] The Peace Treaty ratified by Congress in July 1868 permitted the Navajo to return to an area less than one-quarter the size of their former homeland.[14]

After the signing of the treaty, the survivors of the Bosque Redondo ordeal began the long journey back to their homeland. They returned to the newly created Navajo Reservation a changed people. The Long Walk had given them a sense of unity and tribal identity. The government-enforced tribal council at Fort Sumner, the first unified Navajo governing body, had served as a precedent in uniting Navajo leaders. The Long Walk had made an indelible mark on the memory of all who survived this journey of misery, fear, and death and gave them a deep determination to preserve their tribal heritage and retain their spiritual independence. The Navajo would never again live as groups of independent bands.

The Navajo returned to a land that had been ravished by Carson and his men. With their homes burned, their fields scorched or overgrown, their sheep dead or vanished, the Navajo now were totally dependent upon the United States Government for food and the rebuilding of their herds and crops. The treaty of 1868 provided that each Navajo be issued two sheep and a goat and, if necessary, rations for a period of ten years. The government would provide aid to Navajo agriculture, build schools, and provide teachers. The treaty required that the government establish schools on the Navajo Reservation and provide one teacher for every thirty children between the ages of six and sixteen. The stated purpose of the government schools was to teach English and encourage the Indians to forget their "uncivilized ways" and recognize the cultural superiority of the dominant Anglo society. The government program for Indian education was based upon off-reservation boarding schools. Far from the influence of family and tribal leaders, the government leaders believed, they could transform the children into civilized American citizens. All children were given haircuts and uniforms and were forbidden to speak their native tongues or to observe any traditional sacred or secular rituals.

The Navajo refused to send their children to government schools, for they feared cultural genocide.[15] In 1887 the Indian Bureau passed a compulsory school order that resulted in direct confrontation between the Navajo and government officials. Often it was necessary for government troops to go from community to community to capture its prospective students. Although for centuries traditional education had ensured the passing of Navajo culture from generation to generation, no effort was made in the government schools to teach the children an appreciation of Navajo history, culture, or language. For almost a century those who completed this educational process often lost sight of the importance of their native heritage.

During the years after the Long Walk, the Navajo, with government encouragement, turned to stock raising rather than agriculture. As the number of sheep and horses increased on the Reservation, the search for adequate grazing land became a major problem (sheep deplete grazing land because they eat the roots of the grass), and by 1880 it was necessary for many Navajo families to lead an increasingly nomadic life. Although the Navajo paid little attention to the terms of the 1868 treaty and permitted their herds to feed on non-Reservation land, a land they believed belonged to them, the majority of these

121

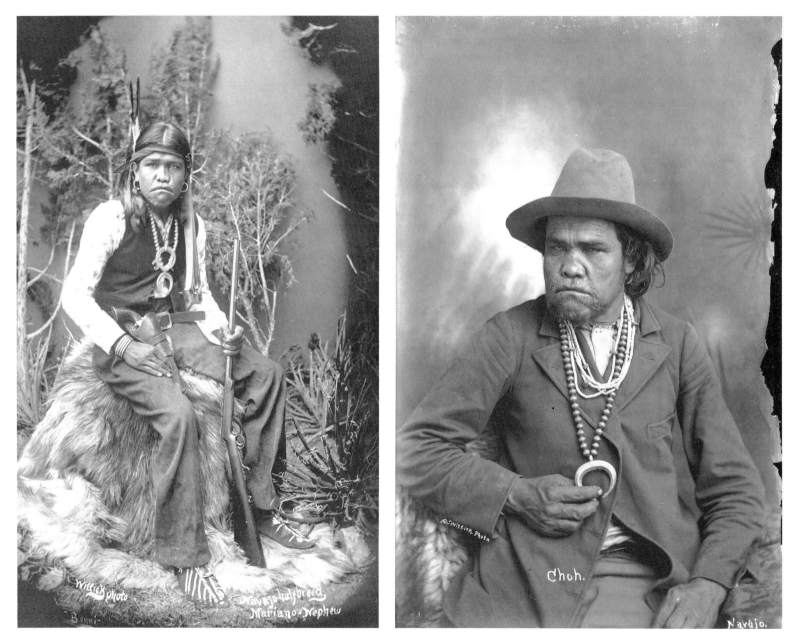

128. *"Choh, Navajo Half-breed," Nephew of Mariano.* C. 1882. Photo: El Paso
Centennial Museum, El Paso, Texas

129. *"Choh, Navajo Half-breed," Nephew of Mariano.* C. 1886. Photo: El Paso
Centennial Museum, El Paso, Texas

families continued to suffer severe economic hardship and had to rely on government subsidy for their survival.

The railroad brought many changes to the Navajo world. In 1876, upon completion of the survey for the Atlantic & Pacific Railroad's route across the Southwest, the Navajo learned that large sections of Navajo land promised in the 1868 treaty would be given to the railroad or opened for settlement. Manuelito, the government-appointed Sub-Chief for the eastern section of the Reservation, traveled to Washington to protest this action. His trip was in vain. The government insisted that both Anglos and Indians could homestead the land, but refused to recognize the building of a hogan as establishing residency or improving the land. There is no record of an established Navajo homestead between 1875 and 1905.

Like the Pueblo people, the Navajo gradually made the transition from a subsistence to a cash economy. During the 1870s the construction of the railroad provided wage work for those Navajo who turned to the railroad for economic survival. Thanks to the railroad, scrap iron and railroad ties became available on the Reservation. Shortly after the arrival of the first train in 1881, the first coal mine was opened in Gallup, and within a few years Gallup had become a thriving mining and railroad center. Whiskey from the local bars and liquor stores brought endless problems for the Navajo.

The opening of the railroad brought hordes of tourists to the border of the Navajo Reservation. The Navajo Reservation, unlike the Pueblo Reservations, offered the tourists almost no opportunity to attend tribal ceremonies or witness Navajo communal life, but they were rewarded with picturesque vignettes of Navajo life set against the towering red walls or the incredible sandstone formations of the area that became known as Monument Valley. The chance to see a Navajo hogan and catch a glimpse of an occasional weaver working at her loom and sheep herders tending their flocks made a tour of the Navajo Reservation an experience to be remembered and treasured.

During the 1870s and 1880s trading posts were established on the Reservation, which, as the years passed, became the focal point of Navajo economic life.[16] The trading post served as an information, communication, and business center on the Reservation. The trading post's operator was banker, local authority on government policy, and medical counselor. Often the only white man in the area, the trader wrote letters and, theoretically, served as friend and advisor to the people of the area.

The success of the paternalistic trading post system resulted in a way of life that is best described as debt peonage. The trader, in return for sheep, craft arts, or cash, would provide the Navajo with the material necessities on which they had become dependent. If an individual had no funds, the trader accepted Navajo blankets, jewelry, baskets, or any other items of Navajo clothing or sacred paraphernalia as pawn to be redeemed at a later date. If the pawn remained unclaimed for longer than the date on the pawn contract, it was sold or traded. This system resulted in a lifetime of debt for thousands of Navajo.

In addition to food supplies like sugar and coffee, the trader supplied the Navajo commercial cloth—satin, calico, and velveteen for clothing. Although historically Navajo women wore two-piece hand-woven dresses, during the years after the Long Walk they continued to wear long-sleeved blouses and full skirts that were based on patterns supplied by the government at Fort Sumner. Today this costume is considered to be traditional Navajo dress.

The Navajo women Wittick photographed wore both traditional hand-woven dresses and the Fort Sumner costume made of store-bought fabrics. Like most Indian women, they retained traditional dress longer than the men. By the time Wittick arrived in the Southwest, the majority of Navajo men wore a wide variety of white man's clothing, including store-bought shirts, vests, wide Spanish-type

127
122
123

trousers, and every conceivable form of white man's hat.

As the trading posts, with their rich stock of newly made or pawn jewelry and crafts, became tourist centers, the tourist market for souvenirs and curios effectively transformed Navajo crafts from utilitarian creations to trade items. The newly established trading posts offered the tourists Navajo weaving and jewelry to satisfy their desire to own authentic Indian souvenirs. Many traders specialized in Indian weaving, and some, like Lorenzo Hubbel, who had opened a trading post in Ganado in 1874, influenced both the color and the design of the completed trade blankets in accordance with their perception of what would be seen as truly Indian.

Despite major economic changes in the Navajo world, the Navajo family retained its traditional structure. The grandmother remained the center of the family, and several generations continued to live together. Navajo women owned and cared for their homes, their crops, and their livestock, but men and women owned their own property, including silver and other craft work they had made. (In the Hopi culture men are the weavers; in the Navajo culture women are the weavers and men are the jewelers.)

Wittick's photographs of Navajo women seated at their looms and Navajo men displaying their silverware have become classic images of the traditional Navajo world, and his views of the spectacular land forms and vistas of Navajoland and his picturesque vignettes of Navajo men and women on the newly established Reservation have inspired generations of tourists to make the long journey to the American Southwest. However, the Wittick photographs that offer the greatest insight into the transformations in the Navajo world during the years following the Long Walk are his portrait studies of Navajo leaders and Navajo scouts—men who tried to reconcile the realities of two cultures and two periods of history. Wittick had the opportunity to make portrait studies of two generations of Navajo leaders—the old Navajo Chiefs, who retained a memory of the days

of economic and political independence, and the young leaders, who were willing participants in the bureaucracy of Reservation life.

The Navajo Chiefs and Sub-Chiefs who returned with their people to their ravaged homeland, the newly created Navajo Reservation, knew they would never be able to regain the power and independence of the past. After years of being hunted like animals, then captured and forced to endure the Long Walk and imprisonment at Fort Sumner, they had little will to rebel or resist government authority. The Navajo were a defeated people, wards of the United States Government; cooperation with military officials offered the only hope for ensuring the security and economic survival of their people. Many of the leaders who at Fort Sumner had agreed to serve as divisional chiefs, positions of authority and privilege, on returning to the Reservation accepted the job of Head Chief or regional leader. All Reservation appointments were made by the Indian Agent, and the tribal leaders' authority was enforced by the troops at Fort Wingate. In the 1880s, less than two decades after they had been hunted by Carson and his men, several of the most influential Navajo Chiefs, Sub-Chiefs, and their supporters agreed to work as scouts for General George Crook, Captain Emmet Crawford, and Captain Ben Rogers. In 1885 and 1886 Wittick traveled with a troop from Fort Wingate commanded by Captain Rogers.

The Navajo scouts who served on the final campaigns against the Chiricahua Apache wore the clothing of the white man and the jewelry of the Indian, multiple strands of turquoise beads and magnificent examples of Navajo silverwork. They willingly posed in front of woodland and cacti backdrops and proudly displayed badges of merit, rifles, and ammunition belts. Their headgear varied from felt and fur hats to headbands and feathers. On one occasion, several Navajo posed for a formal portrait as "Indian Hunters." Wittick's costumes and settings belonged to a world of make-believe, but it is clear that the greatest fantasy was in the minds of the subjects.

By the time Ben Wittick arrived in the Southwest, almost every aspect of Navajo life bore the indelible stamp of contact with two foreign cultures, the Spanish and the Anglo. Nevertheless, this world today is thought of as the bastion of Navajo tradition. For the remainder of the nineteenth century and through the twentieth century, the Navajo have fought to retain all that remained of their historic culture. The Wittick photographs, taken over a century ago, testify to their success. His Navajo subjects are the embodiment of defiance and conquest, tradition and change, cultural integrity and acculturation. Shadows of a heroic past, they held the key to Navajo survival.

130. *"Navajo Indians at Home."* C. 1885. Photo: School of American Research Collections in the Museum of New Mexico, Santa Fe

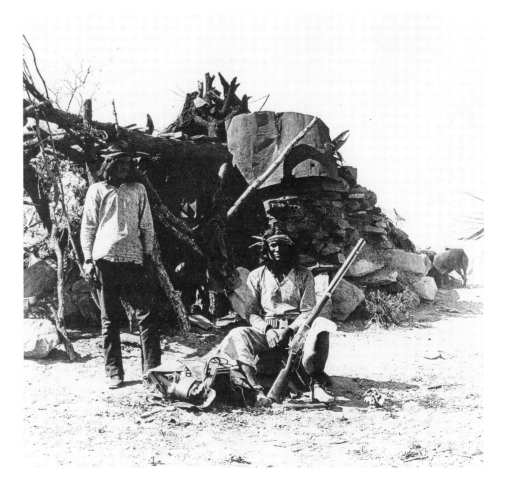

131

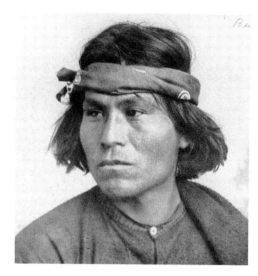

131. *Navajo Boy.* C. 1890. Photo: Private Collection

132. *Waterhole in the Arizona Desert.* C. 1890. Photo: School of American Research
Collections in the Museum of New Mexico, Santa Fe

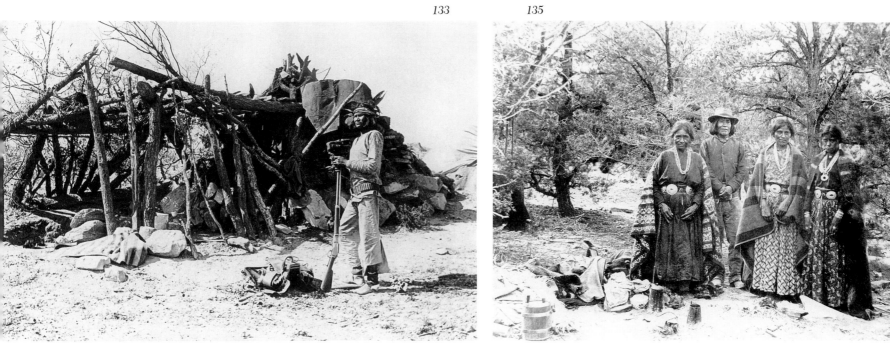

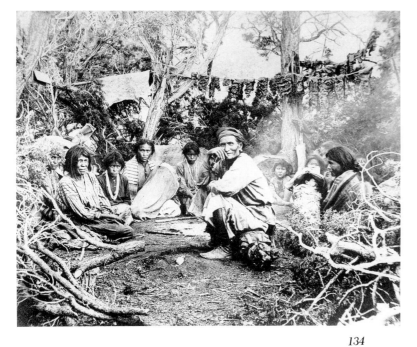

133. *"Navajo Man at Home."* C. 1885. Photo: School of American Research Collections in the Museum of New Mexico, Santa Fe

134. *Navajo Indian Camp Scene, New Mexico.* C. 1898. Photo: The Science Museum, Saint Paul, Minnesota

135. *Navajo Women in Camp.* C. 1885. Photo: Private Collection

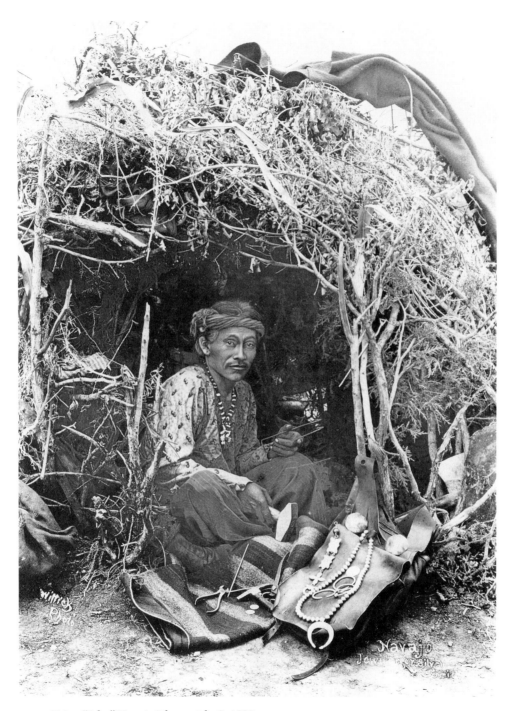

136. *"Jake," Navajo Silversmith*. C. 1886. Photo: School of American Research Collections
in the Museum of New Mexico, Santa Fe

137. *Sam E. Day's Trading Post, Chinle, Arizona. C. 1890.* Photo: School of
American Research Collections in the Museum of New Mexico, Santa Fe

138. *Hubbell Trading Post, Ganado, Arizona.* C. 1900. Photo: School of American Research Collections in the Museum of New Mexico, Santa Fe

139. *Warehouse Interior, Hubbell's Trading Post, Ganado, Arizona.* C. 1900. Photo: School of American Research Collections in the Museum of New Mexico, Santa Fe

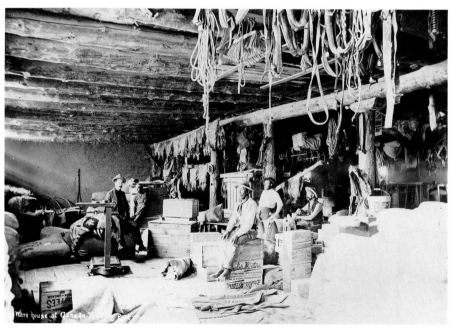

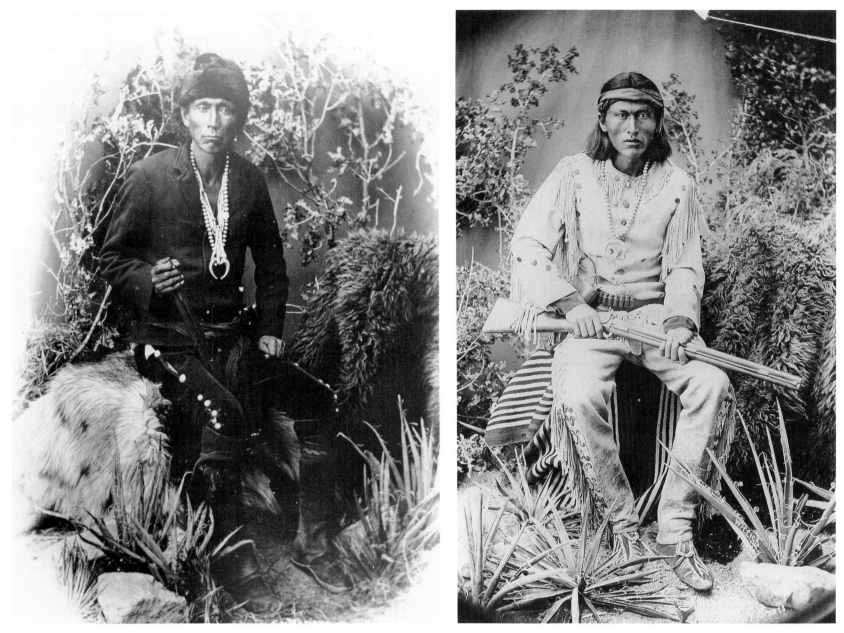

140. **Mariano, Chief of the Navajo, New Mexico.** C. 1885–86. Photo: Private
Collection

141. **Chich-is-nez, Sub-Chief of Navajo Scouts.** C. 1885. Photo: School of American
Research Collections in the Museum of New Mexico, Santa Fe

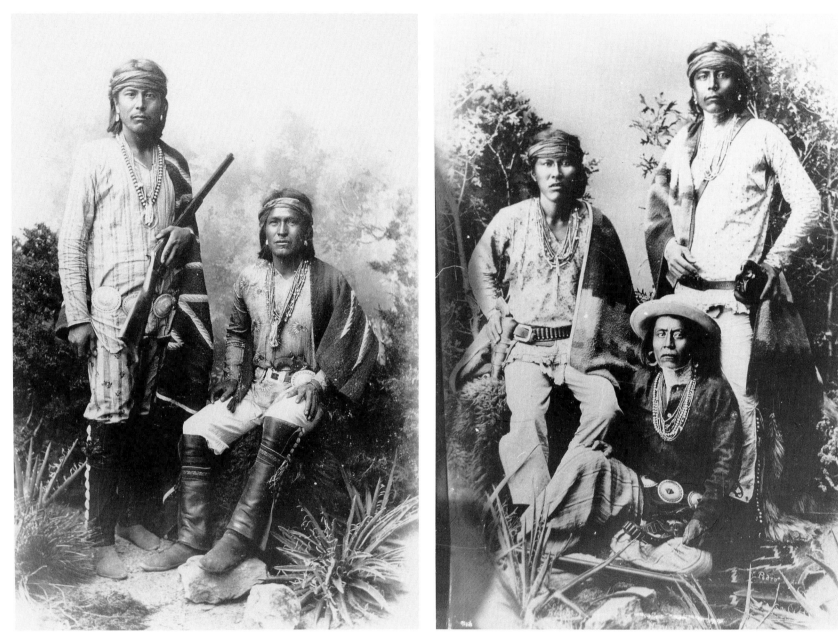

142. *Navajo Scouts.* C. 1885. Photo: Private Collection

143. *Pedro, Gayetenito, and Biziz, Navajo Scouts.* C. 1886. Photo: Private Collection

138

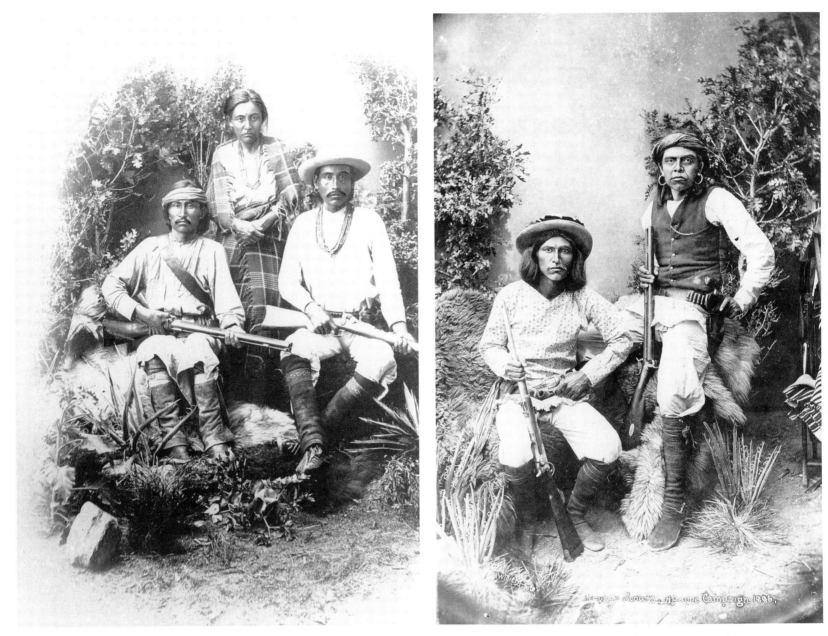

144. *Vicente, Pitacio, and Juan, Navajo Scouts.* C. 1885. Photo: Private Collection

145. *Navajo Scouts in 1886 Apache Campaign.* C. 1886. Photo: School of American Research Collections in the Museum of New Mexico, Santa Fe

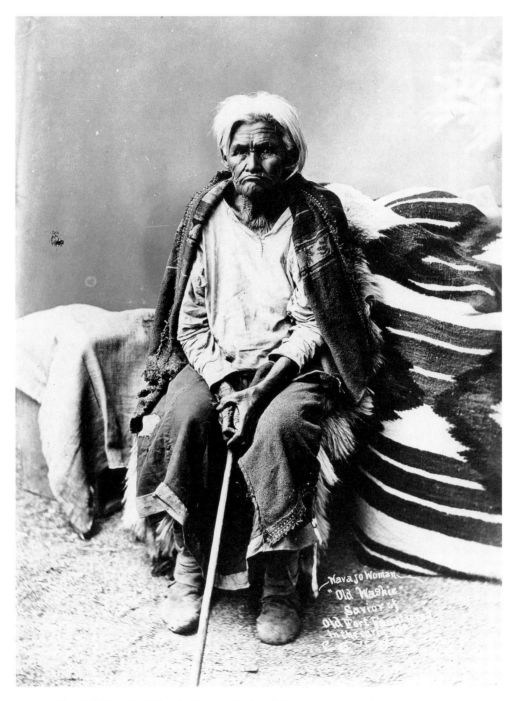

146. *"Old Washie," Navajo Woman. Savior of Ft. Fauntleroy in the 1860s.*
C. 1885. Photo: School of American Research Collections in the Museum of New Mexico,
Santa Fe.

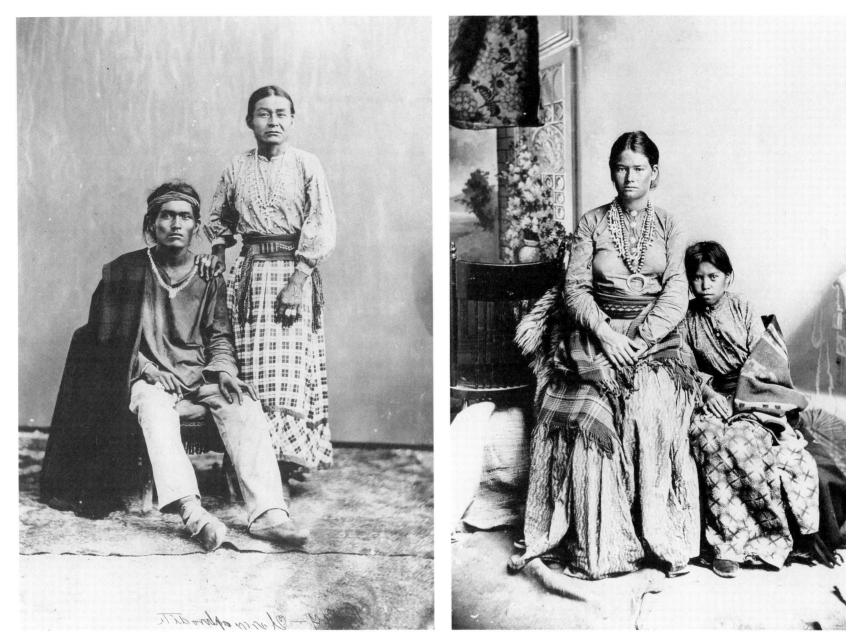

147. *Peggy and Young Man, Navajo Man and Woman.* C. 1885. Photo: School of
American Research Collections in the Museum of New Mexico, Santa Fe

148. *Navajo Mother and Daughter.* C. 1885. Photo: School of American Research
Collections in the Museum of New Mexico, Santa Fe

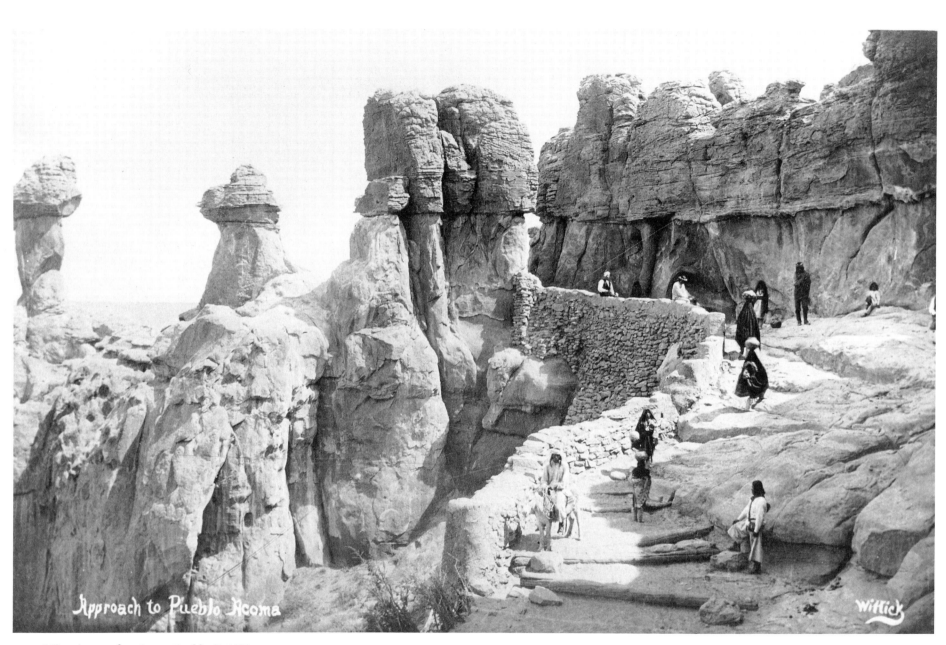

Approach to Pueblo Acoma

Wittick

149. *Approach to Acoma Pueblo.* C. 1883. Photo: Museum of New Mexico, Santa Fe

7. The Pueblos of Acoma, Isleta, Laguna

◘

During his twenty-five years in the Southwest, Ben Wittick visited and photographed almost all of the Rio Grande and Western pueblos. On his first visit to the pueblos, he concentrated on photographing the physical environments of each community—the surrounding landscape, the mission church, the plazas, and the streets lined with multiple-story adobe buildings. Throughout his career he remained fascinated with Indian ceremonial life and seized every opportunity to photograph the colorful rituals of the Pueblo people.

During the 1880s Wittick concentrated on portrait and field studies of the Pueblo people, which he copyrighted and sold as authentic images of the exotic inhabitants of the American desert. Although he completed several single-lens images and stereo views of the buildings, streets, and landscape of the San Felipe, Santo Domingo, Tesuque, Taos, and Jemez Pueblos, he made the majority of his Pueblo portraits and field studies at the Pueblos of Acoma, Isleta, Laguna, and Zuni and in the villages of the Hopi Mesas. (Separate chapters will be devoted to Wittick's Zuni and Hopi photographs.) A comparison of the cultural background and the postcontact histories of the Acoma, Isleta, and Laguna people helps to explain the vast differences in Wittick's images of these pueblos.

In 1540 Francisco Vasquez de Coronado arrived in the land of the Pueblo people with about three hundred soldiers and some Christianized Mexican-Indian servants, intent on finding the Seven Cities of Cibola. Disappointed with the Zuni, the first Pueblo community he encountered, Coronado ordered Captain Hernando de Alvarado to lead an exploratory expedition, in the hope that he might find in one of the northern Pueblos the fabled riches of the Southwest. Alvarado's expedition first traveled north to the Acoma Pueblo, then turned east to the Rio Grande River, and ultimately traveled north as far as Taos, the northernmost Pueblo. Alvarado was the first of a series of conquistadors who journeyed across the Southwest in search of the legendary riches of the New World.

In 1595 Juan de Onate was given royal approval to conquer in the name of Spain all the Indian settlements in the Spanish provinces. Three years later Onate, accompanied by four hundred potential colonists, a party of Penitente Brothers, Franciscan priests, lay brothers, and friars, set out to colonize New Mexico and begin a missionary program to claim the souls of the Indians for the Catholic Church.

The Spaniards gave the name *Pueblo*, a Spanish word meaning village, to the complex Indian societies that followed a communal life of farming rather than a nomadic or semi-nomadic life of hunting and gathering. At the time of the arrival of the conquistadors, the Pueblo people lived in multistoried structures built around a central plaza. The majority of these settlements were situated near running water or permanent springs. It is believed that prior to the great drought of 1276–99, when it became necessary to move closer to a de-

143

pendable source of water, the majority of the Pueblo people lived in the mesa and canyon country of the Southwest.

Every aspect of life in the Pueblo world was focused on survival in the harsh land of the high desert. Most Pueblo rituals offer prayers for water, the source of life, and prayers for the germination of seeds, a successful harvest, and the survival of the people. The routine activities of daily existence and the sacred rituals of the Pueblo ceremonial year all have the same basic goals—universal harmony, fertility, and regeneration. Because in the traditional Pueblo world there was no real distinction between the sacred and the secular, it was not possible to separate the rituals of daily life, religious observance, and artistic creation. Over the years the Pueblo people developed a high level of permanent arts and crafts, which included weaving, basketry, pottery, and ritual painting. They had a knowledge of irrigation and dry farming techniques, and their principal crops, prior to contact with the Spanish, were beans, corn, squash, melon, and cotton.

The Pueblos believed that there was a fixed order in both the natural and supernatural world. The only way to survive and prosper in this world and to contribute to universal progress was to recognize and maintain this order. For centuries each of the Pueblos had a well-organized communal government and a network of spiritual societies.

The Spaniards gave the Pueblos the names of Spanish saints and divided the country into districts, assigning a Catholic priest to each district. The Indians were forced to swear obedience to the Spanish government and pay homage to the Spanish Church and crown. After the Spanish conquest, religious rituals at most Pueblos became a combination of Saint's Days and native rituals; for example, Christmas was both the time of the winter solstice and a sacred Christian holiday. Although in 1620 the Spanish crown introduced a system of Pueblo governors and governors' assistants and presented metal-topped canes as the official badges of authority (a practice continued by the Mexican and United States governments), the Pueblo

people found it impossible to separate religious and secular government, and the Pueblos remained a theocracy.[1]

By the mid-seventeenth century, the Spaniards believed that they had made great progress in completing their mission in the New World; nevertheless, in the years that followed the Pueblo people continued to observe their native religion and follow the dictates of their traditional government. In 1661 the Franciscans, in an attempt to stamp out pagan idolatry, began a campaign to prohibit masked dances and rounded Kivas (ceremonial chambers) and confiscated and destroyed all of the sacred ceremonial paraphernalia they could find. In 1675 the Spanish governor, Juan Francisco de Trevino, offered his support to the missionaries in their attempt to end all superstitious practices by authorizing the whipping and imprisonment of twenty-three Pueblo religious leaders who were accused of idolatry and sorcery. Three were hanged.

Popé, a Medicine Man from the San Juan Pueblo and one of the released leaders, formulated a plan to kill the missionaries and drive out the Spaniards. Popé's plan developed into the Pueblo Revolt of 1680 (see page 16). From 1680 until 1692, when Don Diego de Vargas recaptured New Mexico for Spain and the Catholic Church, Pueblo leaders ruled New Mexico from the Governor's Palace in Santa Fe.

Following Reconquest, the Spanish government devised a land-grant system, allotting to each Pueblo the land within a two-and-a-half-mile radius from the central point of the Pueblo church. Only the Hopi were able to prevent reconquest by the Spanish crown and Spanish Church.

The years of Spanish domination left a strong imprint on the Pueblo world. The Spaniards brought cattle, horses, and sheep to the Southwest and taught the Pueblo people to grow wheat and fruit trees. They encouraged a method of building based on bricks of adobe, rather than mud poured within a confined area, and introduced indoor fireplaces and beehive ovens (*hornos*), which today are still a familiar sight at most Pueblos. The years of Spanish domination brought hardship

150. *Acoma Pueblo.* C. 1890. Photo: School of American Research Collections in the Museum
of New Mexico, Santa Fe

151. *Acoma Pueblo.* C. 1883. Photo: School of American Research Collections in the Museum
of New Mexico, Santa Fe

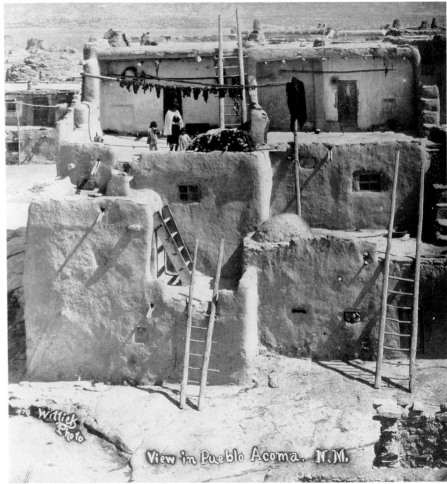

and decline to many of the Pueblos as disease and attacks by Utes, Comanches, and Apaches took their toll on the Pueblo world. Of the sixty-six Rio Grande villages encountered by the Spaniards, only nineteen remained in existence by 1800. Of these, only the villages of Isleta, Taos, and Picuris were in their original location.

Spain ruled New Mexico until 1821, when, at the end of the Mexican War for Independence and the signing of the Treaty of Cordova, New Mexico became part of the new Mexican nation. The only major change during the years of Mexican rule was that the Mexican Government abandoned the Spanish policy of excluding foreign traders. The opening of the Santa Fe Trail and the arrival of the first Anglo-European traders marked the beginning of a new era for the Pueblo world.

With the signing of the Treaty of Guadalupe Hidalgo in 1848, Mexico ceded all of the territory east of the Rio Grande and the territories of New Mexico and California to the United States in return for fifteen million dollars. Although the previous three centuries had brought a series of gradual changes, the next hundred years, years of the American nation's urbanization and industrial growth, completely transformed the Pueblo world. Ben Wittick's photographs of the Pueblos of Acoma, Isleta, and Laguna illustrate the different responses of the Pueblo people to a new era of Protestant Anglo settlements and industrial expansion.

Although Ben Wittick did not visit the Pueblo of Acoma until 1883, he achieved the distinction of being the first to successfully photograph this ancient Pueblo, which lies about 60 miles southwest of the Rio Grande River in a land of mesas, buttes, arroyos, rolling hills, and valleys.[2] This high desert country has an altitude of between 6,000 and 8,000 feet and the historic village of Acoma stands atop a sheer cliff rising 357 feet above the plains.

The Acoma people trace their ancestry to several basic roots to those who have inhabited the area since prehistoric days and to the ancient people of the Mesa Verde area who migrated to the site following a prolonged drought in about 1300. The inhabitants of Acoma, like the inhabitants of Oraibi, the oldest village on the Hopi Mesas, claim that their village is the oldest continually inhabited site in the Southwest.

The Acoma people have inhabited this area since approximately A.D. 900 and have lived in the village on the mesa since 1075. The village consists of rows of terraced adobe houses, some three stories high. For centuries the mud for the Acoma adobe houses has been made from earth carried up the cliffs from the desert below. The streets run east-west, and all the buildings face south. Incorporated into the house blocks are rectangular kivas with rooftop ladder entrances. In the traditional world, the primary occupations of the Acoma men were dry farming and herding.[3] The village leader was the Cacique, who watched progress of the sun across the sky. As representative of the supreme deity, he determined the solstices and dates for all sacred ceremonies.

The first mention of the Acoma Pueblo in Spanish history dates back to 1539, when Fray Marcos de Niza wrote a report to the viceroy of New Spain referring to the "Kingdom of Hacus."[4] Fray Marcos based his report on a message from Estevan de Dorante, a black servant, who was believed to be the first non-Indian to enter the ancient village. Estevan called the Acoma people *encacoñados*, a term that describes them as having turquoise hanging down from their ears and noses.

In 1854 Coronado dispatched Captain Hernando de Alvarado on a northeast expedition. His report describes a town called *Acuco*.

There was only one entrance by a stairway built by hand.... There was a broad stairway of about 200 steps, then a stretch of about 110 narrower steps and at the top they had to go up about three times as high as a man by means of holes in the rock, in which they put the points of their feet, holding on at

160

150

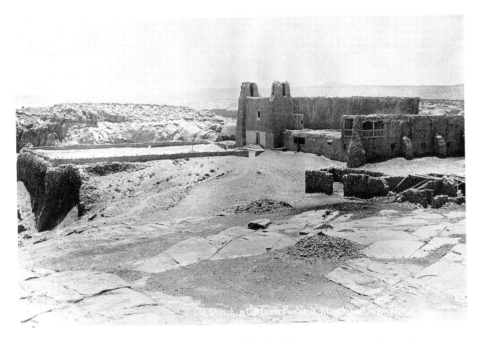

152. *Mission Church, Acoma Pueblo.* C. 1883. Photo: Museum of New Mexico, Santa Fe

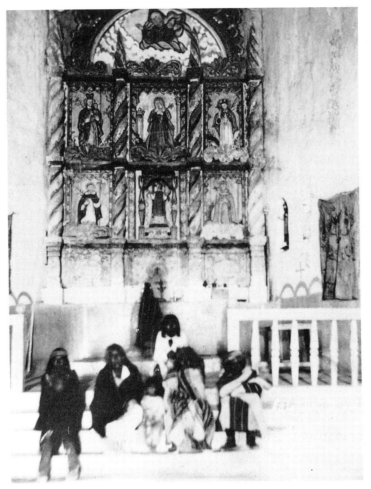

153. *Interior of Acoma Mission Church.* C. 1883. Photo: Photograph courtesy Kramer Gallery, Inc., Saint Paul, Minnesota

the same time by their hands. There was a wall of large and small stones at the top, which they could roll down without showing themselves, so that no army could possibly be strong enough to capture the village. On the top they had room to sow and store a large amount of corn, and cisterns to collect snow and water.[5]

In 1581 a Spanish missionary party visited the Pueblo and, in 1582 Antonio de Espejo, a Spanish explorer, military leader, and prospector, who arrived at the Pueblo with his entourage, had the opportunity to witness several ceremonial dances.

Trouble between the inhabitants of the Acoma Pueblo and the Spanish did not begin until 1598, when Juan de Onate, after taking formal possession of the New Mexico territory, arrived in Acoma and demanded formal surrender to the crown of Spain. The village leaders vowed token submission but remained unwilling to accept Spanish domination. Zutacapan, one of the Acoma leaders, pretended friendship and permitted Juan de Zaldivar, Onate's nephew, and his men to enter the village. Although the Spanish later said that Zutacapan was planning to kill Onate and his men, while the Acoma inhabitants explained that Zaldivar and his men entered the homes of the Acoma people and attacked several women, it is indisputable that a battle broke out and that Onate's aide and five soldiers were killed.

Onate mounted a punitive expedition, sending Vincente de Zaldivar, brother of the slain leader, and seventy soldiers to seize and burn the village. In a fight lasting three days, Onate's men killed over eight hundred of the Acoma men and captured five hundred men, who were sentenced according to Spanish law: "All Acoma males over 25 years of age were condemned to have one foot cut off and to give 20 years of personal service; all males between the ages of 12 and 25 were to give 20 years of personal service. All females above the age of 12 were to give 20 years of personal service."[6] What the Spanish defined as "personal service" was slavery, and the Indian prisoners were given to government missions and to government officials.

This defeat divided the Acoma people into two groups. Those who remained determined to defy the Spanish rebuilt their village on the mesa and returned to their historic homes, while those were willing to yield to the Spanish settled in farming villages at the foot of the mesa. For centuries the Acoma people had used the land surrounding the mesa for farming and herding and as the sites of seasonal homes, but in the years after Onate's revenge, the villages of Acomita and Ticiyama (renamed McCartys by the Atlantic & Pacific Railroad) became permanent residential communities.[7]

In 1680 the Acoma people participated in the Pueblo Revolt and in 1692 they accepted a token reconciliation with the Spanish crown. The majority of the people, however, remained hostile to the Spanish and, whenever possible, gave refuge and support to any Pueblo group that opposed the Spanish. In 1696 the Acoma people gave sanctuary to a group of refugees from five Rio Grande Pueblos who had killed their resident priests. It was not until 1699, when these refugees left Acoma and established the Pueblo of Laguna, that the Acoma Pueblo fully submitted to the Spanish and permitted the reestablishment of the mission and the Church.

Spanish conquest had brought destruction, bloodshed, and suffering to the Acoma people, and they held little hope that a change of rulers would improve life in the Pueblo world. They accepted the United States' acquisition of the New Mexico territory with the same grim stoicism that had enabled them to endure years of Spanish rule.

In 1877 the United States officially sanctioned an Acoma Reservation, composed of ninety-four thousand acres of the original Spanish land grant. During 1881 and 1882 the Atlantic & Pacific Railroad laid track on land that ran directly through the villages of Acomita and McCartys.[8] Only ten miles from two major thoroughfares across the Southwest, the railroad and the wagon route (which ultimately became a superhighway), Acoma was destined to become a tourist attraction

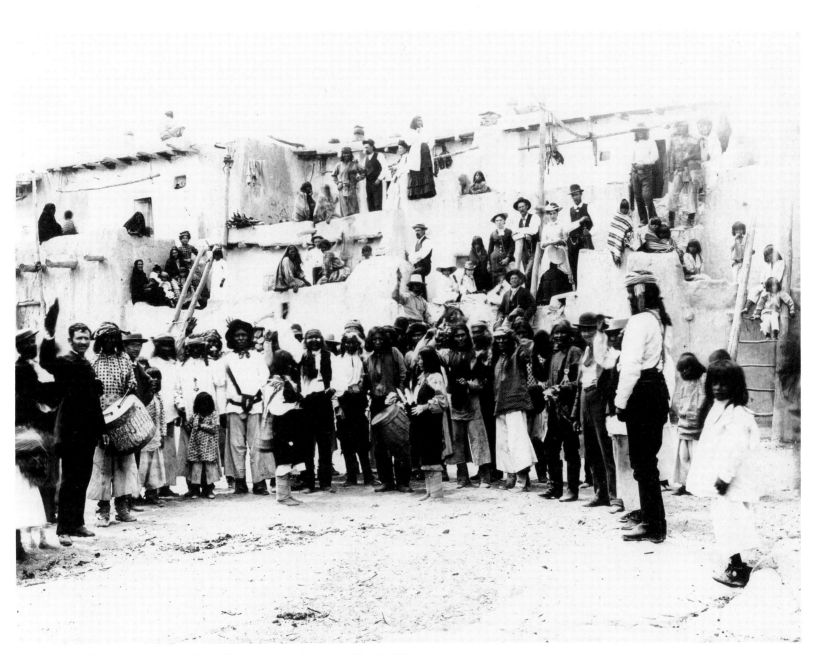

154. *Chorus and Dancers, Feast of San Estevan, Acoma Pueblo.* C. 1883.
Photo: Museum of New Mexico, Santa Fe

whether or not the inhabitants of the Pueblo welcomed the intrusion of strangers on their domestic and ceremonial lives.

Ben Wittick was an employee of the Atlantic & Pacific Railroad when he visited the Acoma Pueblo in 1883. He had just completed a trip across the New Mexican Territory to the Colorado River and, immediately after his return to Albuquerque, retraced his route as far west as the area just north of the Acoma Pueblo. He made stereoscopic and single-lens views of the historic mesa, views of the village streets and of the women descending the steep steps of the mesa as they began their arduous journey for water.

149, 159

The Cacique of the Pueblo received the visitors and permitted them to witness the public ceremonies of the Feast of Saint Estevan, the patron saint of the Pueblo, the major feast day named for a Christian saint. Wittick was permitted to photograph the chorus and spectators, both Anglo and Indian, but he was never allowed to wander at will or to photograph the domestic life of the people or attend those sacred ceremonies that for centuries had given meaning and dignity to life in the Pueblo world. Although Wittick photographed the exterior of the Cacique's house and the exterior and interior of the Catholic mission church, there was never a possibility that the Acoma people would pose for formal portraits, as had the inhabitants of Laguna and Isleta. The people of Acoma had little admiration for either the Spanish or the Anglos and had only minimal interest in the innovations of the white man. Their primary desire was to live peaceably and independently, undisturbed by the changes of the Anglo-European world. Those who lived in this historic Pueblo, high on the mesa, served as guardians of Acoma cultural integrity; they had learned the painful lessons of almost three centuries of conquest.

154

165 / 152 / 153

The Pueblo of Isleta is separated from the Pueblos of Acoma and Laguna by the Rio Puerco.[9] The first Pueblo encountered by the Spanish when they entered the northern Rio Grande area, Isleta lay directly in the main path of the Conquistadors.

The Isleta people speak a southern Tiwa language.[10]

Traditionally, the Isleta Pueblo had been divided into five corn groups, led by a Corn Father and a Corn Mother. Each group had specific ritual responsibilities. The Pueblo was also divided into two moieties, the Black Eye (Winter) and the Red Eye (Summer). Each moiety was in charge of fertility rituals for the Pueblo during a specific season. The historical chief of the Pueblo was the Cacique, who during all the years of Spanish control remained the supreme religious ruler of the Pueblo. In order for him to have the supernatural power necessary for ruling, it was an absolute necessity that he be given a ritual installation. The last sanctioned installation of a Cacique was in 1896, for after the division, in which the Pueblo lost part of its sacred paraphernalia, it was no longer possible to ritually install a Cacique.

The people at the Isleta Pueblo performed maskless Kachina dances until 1881, when they offered land for farms and homes to a group of conservative religious leaders who had fled from Laguna. The Laguna Kachina Priests agreed to accept the traditional laws of the Isleta Pueblo and promised never to remove their masks or fetishes from the village. Although many of the Laguna leaders subsequently returned to Mesita, a village only a few miles from the Laguna Pueblo, the Kachina Chief and his descendants were bound by oath to stay and serve as guardians of their masks.[11]

Wittick photographed the church at Isleta and made several formal portraits of the people of the Pueblo. Although the women posed in their traditional mantas (the one-sleeve overdress) and deerskin leggings, the men of the Pueblo wore predominantly Western clothes. It is clear from Wittick's photographs that his Isleta subjects were more than willing to assume stereotypical Western poses and made few objections to Wittick's incongruous backdrops.

155, 156
167, 168

frontis.

The Laguna Pueblo was founded by refugees from the Pueblos of Santo Domingo, Jemez, Cieneguilla, and Cochiti who, fol-

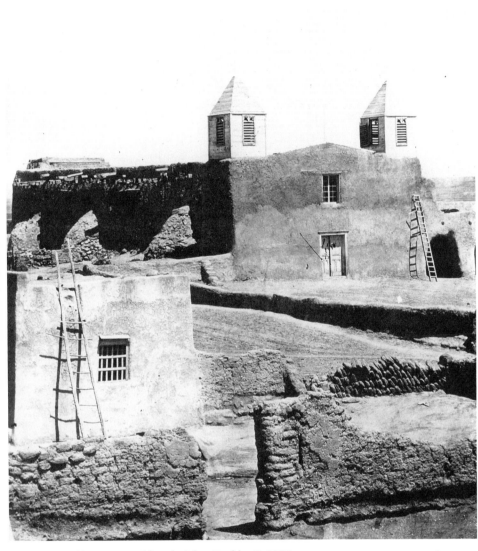

155. *Mission Church, Isleta Pueblo.* C. 1885. Photo: School of American Research
Collections in the Museum of New Mexico, Santa Fe

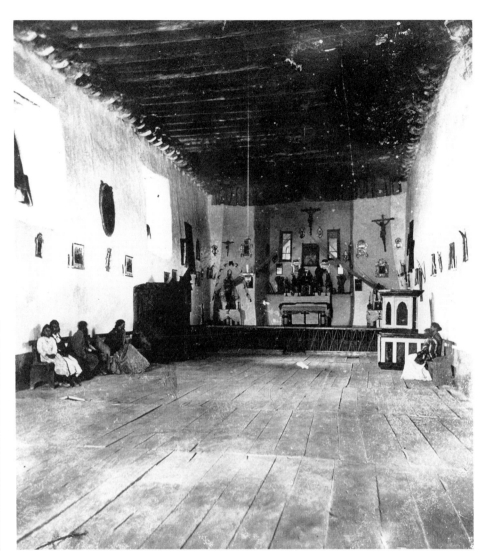

156. *Interior of Mission, Isleta Pueblo.* C. August 1881. Photo: School of American
Research Collections in the Museum of New Mexico, Santa Fe

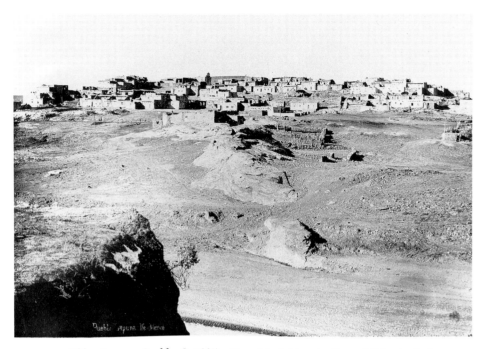

157. *Laguna Pueblo.* C. 1885. Photo: School of American Research Collections in the Museum of New Mexico, Santa Fe

158. *Mission Church, Laguna Pueblo.* C. 1885. Photo: School of American Research Collections in the Museum of New Mexico, Santa Fe

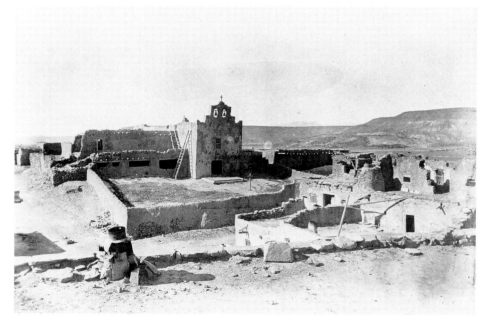

lowing Reconquest in 1692, were unable to accept Spanish control of their communities. The original group of over 100 refugees first sought asylum with the people of Acoma, but several members subsequently moved south to Zuni. In 1697 the remainder of the Acoma refugees, accompanied by a few dissident Acoma residents, established a new Pueblo fourteen miles northeast of the Acoma Pueblo.

In 1698 the inhabitants of Laguna made a peace offering to the Spanish, and a year later Pedro Rodriguez Cubero, the new Governor of New Mexico, accompanied by the Franciscan vice-custos, took official possession of the Pueblos of Laguna, Acoma, and Zuni and conferred a patron saint on each community. Laguna received a land grant from the Spanish crown, but as most of the documents conferring the official Spanish grant were lost, the United States Government did not set the official boundaries of the Pueblo until 1884.

The Laguna people had the same historical and cultural roots as the Acoma people, and both tribes spoke a similar Keresan language. Both Acoma and Laguna life focused on dry farming with ditch irrigation. The social organization of the Laguna Pueblo was similar to that of the Acoma Pueblo. The Laguna leader was the Hadjamunyi Kayokai (Holding-the-Prayer Stick), who prayed for the welfare of the people and acted as Father to the Kachinas. He was the representative of Earth Mother or Corn Mother. Although Laguna was matrilocal and matrilineal, children joined the Kivas of their fathers. All farmland was owned by the clan. Laguna had four medicine societies: Flint, Fire, Shahaye (Giant and Ant combined), and Shikami. The people of Laguna enjoyed a rich ceremonial life focused on Kachina rituals, while Koshares, or clowns, played an important role in Laguna's fertility rituals.

Laguna was situated on one of the main east-west thoroughfares of the New Mexico territory. During the mid–eighteenth century Spanish ranchers moved into the Laguna herding area, and, soon after this area became part of the United States, Anglo surveyors and Protestant missionaries began to focus their attention on the Pueblo communities. Protestant leaders who had the greatest influence on the Laguna Pueblo were the Marmon brothers, Walter G. Marmon, a boundary surveyor who arrived at the Laguna Pueblo in 1868 and began to teach at government school in 1871, and Robert G. Marmon, who arrived as a trader and surveyor in 1872. These men and Dr. John Menaul, a missionary and teacher, instituted a series of changes that, in the name of progress, eventually destroyed the long-standing hierarchy of the native Pueblo tradition and the Roman Catholic Church.

Dr. Menaul served as missionary and teacher of the Laguna school from 1875, when the Presbyterian Church took over the school, until 1887. The Marmons (who both married Laguna women) wrote a constitution for the Laguna Pueblo, using the United States Constitution as a model. In 1872 the people of Laguna for the first time voted for the Pueblo Governor and subsequently elected each of the Marmons Governor for one term. During Robert Marmon's term as Governor, the two major Kivas of the Laguna Pueblo were torn down and the Pueblo was without a major ceremonial chamber for many years. Marmon also planned to demolish the Catholic church, but Hami, a Shahaye shaman, staged a demonstration that saved the structure.

In the late 1870s there was a formal split between the Protestant and Catholic factions at the Pueblo and a group of Laguna conservatives carried Pueblo and Catholic ritual equipment, including an image of the patron saint of the Pueblo, to the village of Mesita, which historically had been a farm site where daily the men went to tend their crops. Governor Marmon ordered that the image of the saint be returned to the church and sanctioned the destruction of several altars.

The Protestant missionaries continued to encourage a break with Catholic religious traditions. The years that followed were filled with accusations of witchcraft and religious strife between the conservative and progressive factions. This conflict resulted in an irreconcilable religious division within the

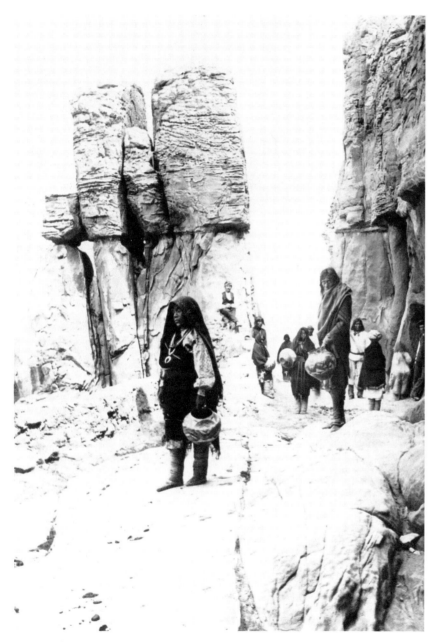

159. *Water Carriers, Approach to Acoma Pueblo. C. 1883.* Photo: School of American Research Collections in the Museum of New Mexico, Santa Fe

Pueblo. In about 1880 a group of conservative Laguna Catholics set out for Mesita, but when their elderly chief, Humika, was beaten to death, they changed their plans and moved to the Rio Grande Valley, taking with them some of the Pueblo's most sacred religious paraphernalia. Although the Laguna conservatives had planned to move to the Sandia Pueblo, they accepted an Isleta offer of land in return for the presence of the Laguna religious societies and the power of the masked dancers. Within a few years most of Lagunas returned to Mesita, with the exception of those pledged to remain with the ritual paraphernalia.

It was during this period of political division and religious strife that Wittick photographed the inhabitants in Laguna Pueblo, a pueblo that had accepted intermarriage, Anglo governors, and a Protestant church. It is easy to understand why there was little resistance to complying with the wishes of an Anglo photographer and no objection to Anglo backdrops and props.

The majority of Wittick's photographs of the Acoma Pueblo are field studies that offer a sharp contrast to his formal portraits of the Isleta and Laguna people. The more assimilated tribes accepted his standard props and backdrops, regardless of suitability, and participated in his Indian fantasies by posing with Indian artifacts and wearing examples of typical Indian clothing, regardless of tribal origin. Wittick returned many times to Isleta and Laguna and in the course of time developed personal relationships with several of his most cooperative subjects. His portraits became less stereotypical as he learned to approach them as individuals and to appreciate their friendships. He attended the wedding of Tzashima and the Governor of the Laguna Pueblo.

169

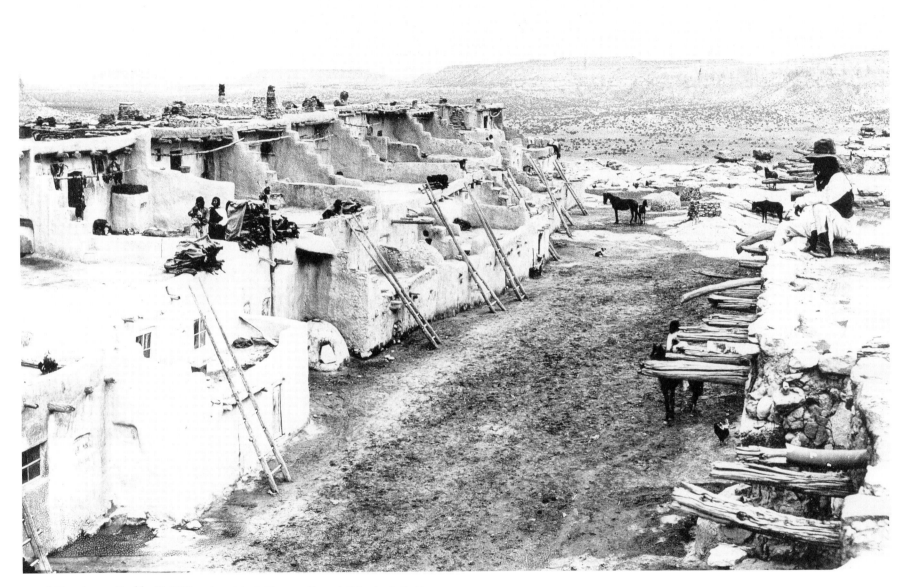

160. *Acoma Pueblo.* C. 1883. Photo: School of American Research Collections in the Museum
of New Mexico, Santa Fe

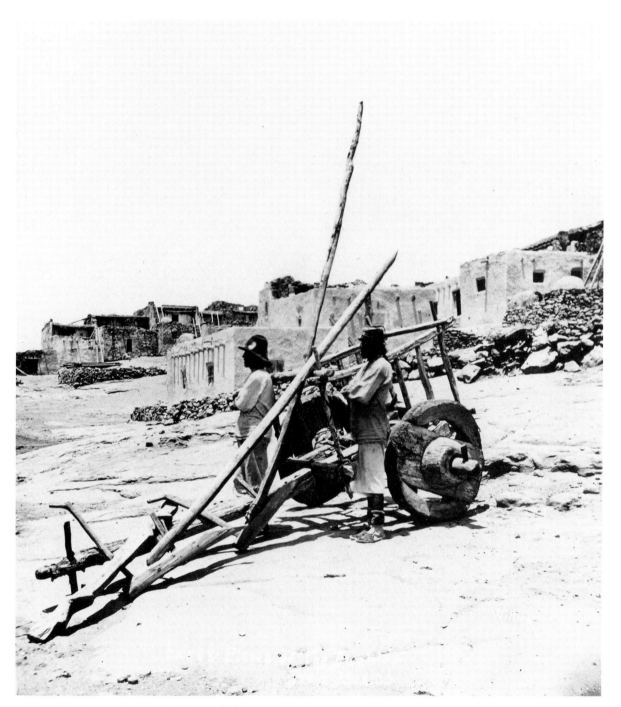

161. Carreta, Laguna Pueblo. C. 1885. Photo: School of American Research Collections in
the Museum of New Mexico, Santa Fe

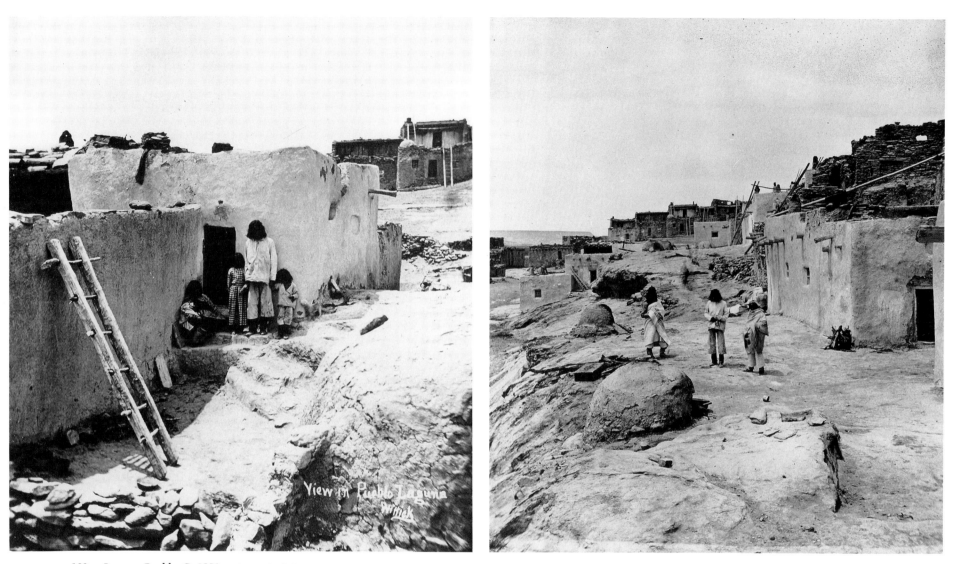

162. *Laguna Pueblo.* C. 1883. Photo: School of American Research Collections in the
Museum of New Mexico, Santa Fe

163. *Laguna Pueblo.* C. 1883. Photo: School of American Research Collections in the
Museum of New Mexico, Santa Fe

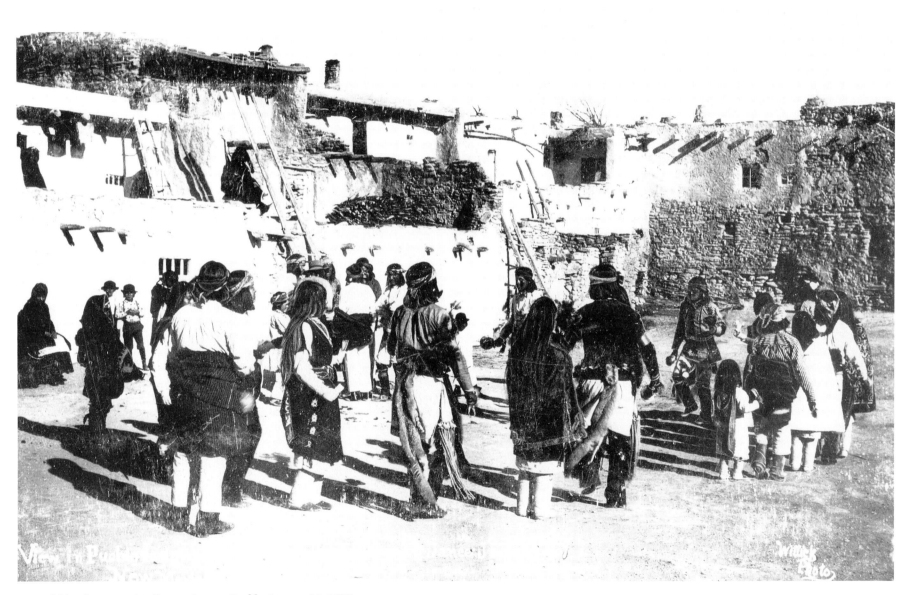

164. *Inauguration Dance, Laguna Pueblo.* January 12, 1887. Photo: School of
American Research Collections in the Museum of New Mexico, Santa Fe

165. Cacique's (Chief's) House, Acoma Pueblo. C. 1883. Photo: School of American
Research Collections in the Museum of New Mexico, Santa Fe

166. Acoma Pueblo. C. 1890. Photo: School of American Research Collections in the Museum
of New Mexico, Santa Fe

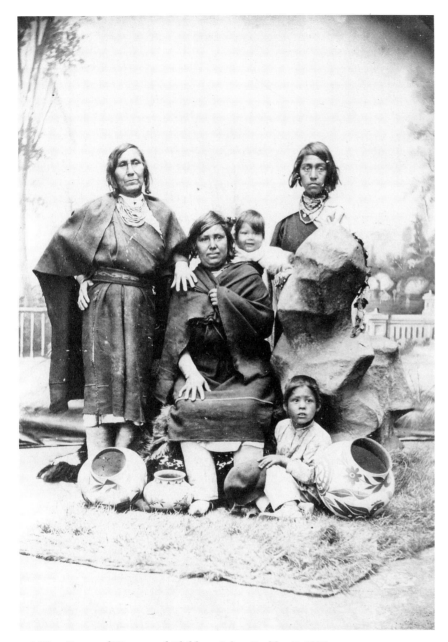

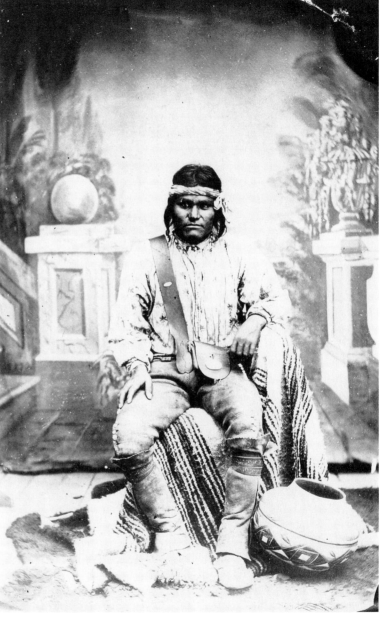

167. *Group of Women and Children, Isleta Pueblo.* C. 1885. Photo: School of American Research Collections in the Museum of New Mexico, Santa Fe

168. *Hash-i-wi-wi, Isleta Pueblo.* C. 1885. Photo: School of American Research Collections in the Museum of New Mexico, Santa Fe

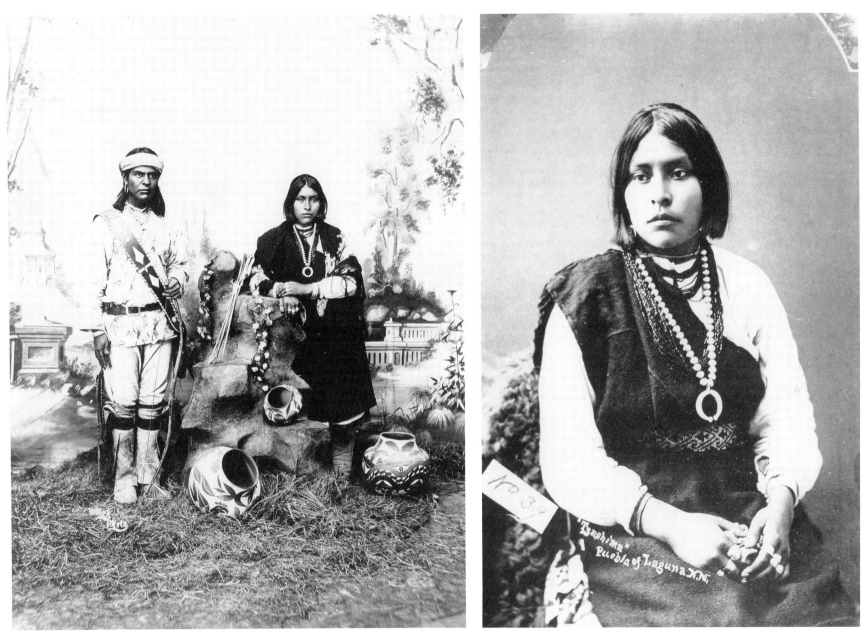

169. *Tzashima and her Husband, Governor of Laguna, Laguna Pueblo.*
C. 1885. Photo: School of American Research Collections in the Museum of New Mexico, Santa Fe

170. *Portrait of Tzashima, Laguna Pueblo.* C. 1885. Photo: Smithsonian Institution, National Anthropological Archives, Bureau of American Ethnology Collection, Washington, D.C.

*171. **Zuni Pueblo.** C. 1890.* Photo: School of American Research Collections in the Museum of
New Mexico, Santa Fe

8. The Zuni

◘

On March 15, 1877, President Rutherford B. Hayes signed an Executive Order giving formal recognition to the land claim of the Zuni people. This treaty confirmed the rights of the Zuni to 17,635 acres granted by the Spanish crown in 1689 and recognized by the United States Government in the Treaty of Guadalupe Hidalgo in 1848. Although President Chester A. Arthur twice amended the boundaries of the Reservation, in 1883 and 1885, since that critical period of history these acres of high desert grazing and farm country have remained the heart of the permanent homeland of the Zuni people.

During his twenty-five years in the Southwest Ben Wittick made many photographic expeditions to the Pueblo of Zuni. The majority of his Zuni photographs were made between 1881 and 1897, years distinguished by important changes throughout the Southwest. During these years the Zuni were forced to accept the inevitability of a United States military presence, the acceleration of industrial expansion by the American nation, and the advent of tourism in the Southwest.

Nineteenth-century visitors to the Zuni pueblo included ethnologists and other anthropologists, intent on studying and recording every aspect of the daily lives and the ceremonial rituals of the Zuni people, and tourists determined to wander into every corner of the Indian world in pursuit of adventure. Here was the opportunity to see the exotic aboriginal inhabitants of the Southwest, to visit their homes and witness ancient ceremonies. Before returning home, they purchased any available craft arts and other souvenirs as a reminder of these incredible experiences.

By 1880 the Zuni people were well aware that their land lay close to the Anglos' primary east-west thoroughfare across the Southwest. Several wagon roads ran directly through the heart of Pueblo country, and in 1881 the Atlantic & Pacific Railroad reached Gallup, forty miles due north of the Zuni Pueblo. From this time on, the Zuni were in constant contact with the Anglo world. Settlers, traders, missionaries, and tourists arrived in the Gallup area with the regularity of the railroad timetable.

The Zuni had learned many important lessons from their experiences with the Spanish, and despite the Anglo presence, they were able to maintain their tribal identity and to follow the fundamental philosophical and spiritual paths of their ancestors. But although they succeeded in retaining their most important sacred rituals, they were a conquered people and ultimately were forced to accept the dictates of Washington. Gradually they adopted many of the values and practices of the dominant European culture. During the last half of the nineteenth century, there were greater changes in traditional Zuni life than during three centuries of Spanish rule.

In 1539 Fray Marcos de Niza, a Franciscan friar who had arrived in the Southwest intent on discovering the riches of the

Seven Cities of Cibola, first learned of the Zuni pueblos from a Zuni man who described to him Hawikuh, the largest of six neighboring Zuni pueblos. Fray Marcos sent Estevan de Dorante, a black slave from the Barbary Coast who enjoyed a reputation for successful negotiations with strangers, to serve as scout and make the first contact. The Zuni refused to allow Estevan and his party to enter the village; when he persisted, they killed him and several of his followers. Only a few of the party escaped to report to Fray Marcos on the failure of their expedition.

The following year Francisco Vasquez de Coronado, determined to claim the fabled riches, set out with his soldiers to conquer the Zuni pueblos. On July 7, 1540, he attacked Hawikuh, and after a short battle (which Fray Marcos watched from a nearby mesa) he won a military victory over the Zuni, but failed to find either gold or jewels. Coronado left Zuni, planning to continue his search in the area of the Rio Grande Pueblos, but left behind several Mexican Indians from his party. They were still with the Zuni forty years later, when the next wave of Spanish conquistadors arrived. In contrast with their reception of Estevan and Coronado, the Zunis offered a peaceful welcome to Francisco Sánchez Chamuscado (1581), Antonio de Espejo (1583), and Juan de Onate (1598).

The Spanish friars began their formal Catholic missionary program at Zuni by establishing a mission at Hawikuh in 1629. In 1632, after they had completed the Hawikuh church and friary and had begun a second mission at Halona, the people of Hawikuh killed two priests. In 1680 the Zuni joined in the Pueblo Revolt and destroyed all Catholic missions.[1] Anticipating Spanish reprisals, the Zuni took refuge on several neighboring mesas. In 1692, after Reconquest, they returned to a single town, Halona, the site of the Zuni Pueblo today. The other five towns were abandoned and turned to ruin.

During the sixteenth and seventeenth centuries there were no Spanish settlements in the vicinity of the Zuni Pueblo. The death in 1703 of three Spanish missionaries served to discourage any further attempts at colonization in the land of the Zuni until the 1760s, when a few Spanish settled about thirty miles to the east of the Pueblo. Although the Catholic mission finally was rebuilt, in 1821 it was abandoned because of the severity of Navajo raids and fell to ruin. The Catholic missionaries did not return to the Zuni Pueblo for a hundred years.

From 1821 to 1846, the years of Mexican rule, there were no Mexican settlements in the area; however, for the first time Anglo traders were permitted to enter the Southwest Territory. The Zuni soon learned that their Pueblo was located on the major trade route between the United States and Mexico.

With the establishment of Mexican independence, the Spanish withdrew their troops from the Southwest and the Zuni Pueblo, like many of the pueblos in the area, became the target of an increasing number of Navajo and Apache raids. After 1850, when New Mexico officially became a Territory of the United States, government troops launched several campaigns against the Navajo and Apache raiders, but it was not until the establishment of Fort Wingate that the threat of constant raids finally ended.

Although there had been no Spanish settlements in Zuni territory, the Spaniards left many permanent marks on the Zuni world. They completely transformed Zuni farming and livestock practices by introducing wheat, oats, and peaches as primary food, and sheep and cattle, and horses and burros. The major contribution of the Spanish to the Zuni Pueblo, however, was the introduction of a system of secular government that coexisted with the hierarchy of traditional religious leadership.[2]

During the first years of United States rule in the Southwest there was limited contact between the Zuni and the Anglo settlers, but the discovery of gold in California in 1848 brought the Zuni directly in the path of fortune hunters traveling West. During the 1880s a few Anglo cattlemen moved into New Mexico and began to raise stock in the area near Zuni. Washington's

172. *Frank Cushing's House, Zuni Pueblo.* C. 1885. Photo: School of American
Research Collections in the Museum of New Mexico, Santa Fe

173. *Runners, Zuni Pueblo.* C. 1883. Photo: School of American Research Collections in
the Museum of New Mexico, Santa Fe

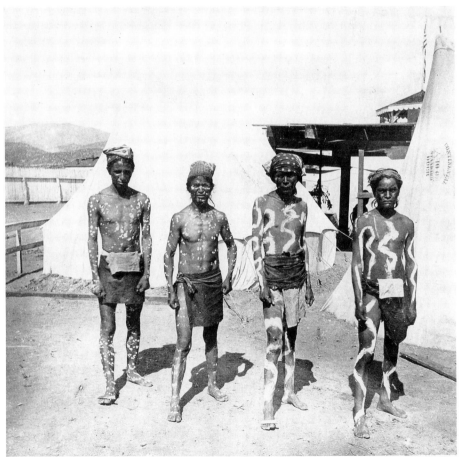

174. *The Gathering at the Shalako Dance, Zuni Pueblo.* C. 1896. Shalakos prepare to cross the river. Photo: Private Collection

175. *Shalako Dancers Crossing the River to Southside to Dance on the Plains, Zuni Pueblo.* C. 1896. Photo: School of American Research Collections in the Museum of New Mexico, Santa Fe

176. *The Shalakos Crossing the River, Shalako Dance, Zuni Pueblo.*
C. 1896. Photo: Private Collection

confirmation of their right to grazing land and natural springs deprived the Zuni of several major water sources.[3]

The decade preceding the arrival of the railroad in Zuni country was one of intensive contact with the American nation. In 1879 John Wesley Powell, first director of the Bureau of American Ethnology, a branch of the Smithsonian Institution, authorized James Stevenson to lead the first anthropological expedition to Zuni. His party included his wife, Matilda, and Frank Hamilton Cushing, a young ethnologist.[4]

Frank Cushing remained at the Zuni Pueblo for five years, studying every aspect of Zuni culture. He learned the language, and although he had great empathy with and respect for the Zuni, his scientific zeal caused him to intrude on even the most sacred ceremonial rites; at one point his life was threatened by a group of Zuni who resented his intrusive methods. Yet Cushing learned to live in peace with the Zuni and gradually was accepted by most tribal leaders. He was invited to become a Priest of the Bow, a sacred war society, and accepted the honor. The first non-Zuni to gain access to the political and ceremonial secrets of the Zuni people, he became an ardent defender of the tribe's rights.[5] After his return to Washington, Cushing published a detailed study of daily and ceremonial life in Zuni society. *My Adventures in Zuñi* remains a classic today.

In addition to the anthropologists, the first Mormon missionaries arrived at the Zuni Pueblo in 1876, and in 1877 the first Presbyterian missionaries built a mission and started a school, which offered a midday meal and clothing to about a hundred children. In 1897 the Reverend Andrew Vanderwagon, a preacher from a Christian Reformed Mission, and his wife arrived in Zuni. In appreciation of Mrs. Vanderwagon's professional nursing care during the smallpox epidemic of 1898–99, which claimed the lives of almost one fifth of the Zuni population, the tribal government gave the couple land for a chapel.

Anglo traders also had a major impact on life at the Zuni

Pueblo. With the establishment of the railhead at Gallup, they replaced the Mexican traders at the pueblo and introduced commercial goods to the Zuni. Thanks to the accessibility of the railroad and the presence of traders, the Zuni gradually shifted from a farming economy to a sheep and cattle economy and from a subsistence economy to a cash economy. The traders paved the way for these changes and the subsequent Zuni dependency on trade goods by establishing a value for livestock and introducing credit buying. Thanks to the traders, possessions were recognized as having a specific, cash value, and gradually a system of pawn—leaving possessions with the traders in exchange for cash—became the dominant way of life in the Gallup region. Although the maternal household continued to be the economic, social, and religious center of the Zuni family, economic activities began to separate from social and religious rituals.

The traders also helped to develop a curio industry by offering Indian-made souvenirs to the travelers. By commissioning specific tourist goods, they established a standard of tourist taste. By 1880 Zuni coiled pottery painted with ancient symbolic designs and small clay animals, especially owls, were features of the tourist trade.

The Zuni leaders who posed for formal portrait studies at Wittick's Fort Wingate and Gallup studios were members of the first generation to face the conflicts between the traditional Indian world and the Anglo world. In 1882 Cushing took six Zuni leaders to Washington on an expedition to meet the Great White Father, President Chester A. Arthur, and see the wonders of the modern industrial world. These leaders—Pa-li-wa-ti-wa, the Governor (and Cushing's host); Laiyuahtsailunkya; Laiyuaitsailu, a former Governor; Naiyuchi, a senior member of the Bow Priesthood; Kiasiwa, a junior member of the Bow Priesthood; and Nanahe, a Hopi adopted by the Zuni—traveled thousands of miles on the railroad to the capital of the United States. As part of their tour they visited the National

172

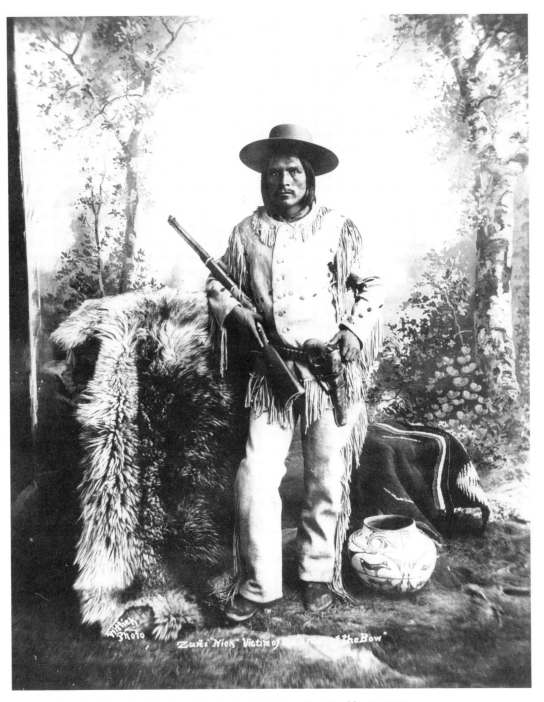

177. *Nick Tumaka, Victim of the Order of the Bow, Zuni Pueblo.* C. 1885.

Photo: School of American Research Collections in the Museum of New Mexico, Santa Fe

Academy of Sciences and the Iroquois Reservation at Tonawanda. Upon their return to the pueblo these men became the leaders of a progressive faction that advocated cooperation with the Anglo establishment.

During the 1880s open factionalism developed between those who insisted upon living according to Pueblo tradition and Pa-li-wa-ti-wa and other members of the Bow Priesthood who had gone to Washington and been impressed by the wonders of the modern world. In the years that followed, the latter group adopted the white man's attitudes as well as his manner of dress. Pa-li-wa-ti-wa was willing to pose for several pioneer photographers of the region. It is interesting to compare Wittick's formal portrait of 1885 with the photograph taken in 1890. In 1890 Pa-li-wa-ti-wa appears to be a specter of the man who was once a figure of authority and dignity.

190 / 191

During this period the Zuni continued to use their sacred ritual chambers, the rectilinear Kivas built above the ground, and to observe the ancient rituals of the cycle of the calendar year. Many of the most sacred ceremonies were performed by Kachina Priests, masked dancers who represented a complex pantheon of deities. Wittick photographed several Kachina ceremonies, including the daytime rituals of the Shalako Ceremony, the blessing of the houses built at the pueblo that year. This ceremony features ten-foot-tall masked Rain Spirits who offer prayers for the happiness, health, and survival of the Zuni and the fertility, germination, growth, and regeneration of all plants, animals, and people. The Shalako Ceremony, held in early winter, continues from just before sundown until dawn. It is the culmination of the forty-nine-day reenactment of the Emergence, the Zuni's search for their sacred home. In 1896 Wittick made a series of photographs of the Shalakos crossing the river at sundown, and in 1897 he made several exceptional photographs of the Koyemshi or Mudhead ceremonies performed on the final day.[6]

174, 175, 176

183, 184

At the time of Wittick's visit, two Caciques were the religious leaders of the Pueblo: the Winter Cacique, who was the Rain Priest of the North, and the Summer Cacique, who was the Speaker to the Sun. In the traditional Zuni world there are four interlocking systems that define the identity of the Zuni people: Kiva groups, Clans, Curing Societies, and Priesthoods.

Since ancient times the political and social leaders of the Zuni Pueblo had also been the religious leaders. The most powerful were the Bow Priests; the Chief Priest of the Bow often was the Governor of the Pueblo. After the Spanish instituted a form of civil government in Zuni, they followed tradition and generally appointed the Chief Bow Priest as Governor.

During Wittick's lifetime the members of the Bow Priesthood still had the greatest influence on Zuni life. (Cushing wrote in 1896 of the power of the Bow Priests in civic affairs.) Historically, this priesthood was a warrior society, open only to those who had taken enemy scalps. The Priests of the Bow had the responsibility of protecting the Pueblo from their enemies, both external and internal. By the second half of the nineteenth century, however, there was little warfare or scalp taking in the Pueblo world, and the principal responsibility of the Priests of the Bow became the protection of the Pueblo from witches, who the Zuni believed were the cause of sickness, death, and even drought. It was the job of the Bow Priests to force these witches to confess, which rendered them powerless. The Anglo residents of the Pueblo—teachers, traders, and missionaries—were horrified to see the priests force confessions by hanging the accused from a bar and beating them.[7] Determined to end the witch trials, they eventually called in United States troops from Fort Wingate, who arrested the Bow Priests and kept them prisoner until they promised to stop the confession tortures.

In 1897 Wittick photographed Marita, a Zuni woman accused of witchcraft, and Nick Tumaka, the first Zuni to triumph over the Bow Priests. Nick, who prior to his arrest had been a Zuni leader, refused to confess to witchcraft and sent

6

177

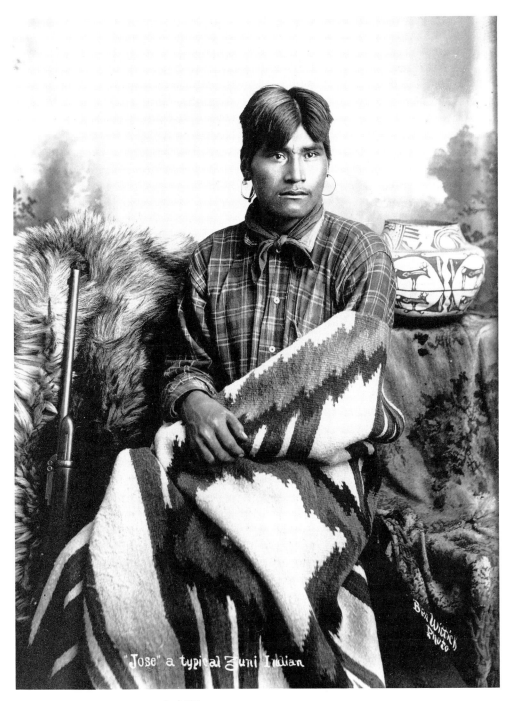

"Jose" a typical Zuni Indian

178. *Jose, Zuni Man.* C. 1890. Photo: El Paso Centennial Museum, El Paso, Texas

his father to bring in the troops from Fort Wingate. The troops arrived, arrested four Bow Priests, and established a military presence at the Pueblo. Since the white man had the power to arrest the Bow Priests and stop their trials, it was clear that the once all-powerful priests were vulnerable.[8]

During his years in the Southwest Wittick made many stereo and single-lens photographic studies of the Zuni Pueblo. His early photographs are overviews of the village, studies of the church and streets lined with multistory rectilineal stone buildings and scenes of daily life. He photographed the Governor on the footbridge leading to the Pueblo and the ceremonial runners, their bodies painted with sacred cornmeal in fertility, lightning, and rain designs.

Although both men and women at the Zuni Pueblo consented to sit for portraits, these photographs suggest a significant difference in the level of acculturation between the sexes. The majority of women in Wittick's photographs wear traditional dress: deerskin leggings, women's mantas, and blankets. In contrast, most men wear a combination of Spanish, Anglo, and traditional Zuni dress—for example, Spanish trousers and hats, Anglo work shirts, and Indian jewelry and blankets. Nick Tumaka, wearing a fringed buckskin suit, posed with his rifle in a romantic woodland setting that included a bearskin rug and a Zuni pot.

Wittick photographed the Zuni Pueblo during the years in which the People already had begun to yield to the forces of the modern Anglo world. When Wittick photographed the Shalako Ceremony in 1897, the Protestant Church was a firmly established institution. Although a year earlier the United States Government had taken over the only village school, the school had been part of the Presbyterian Mission for almost twenty years.

By the turn of the century the Zuni and the United States Government had signed a multitude of documents defining the rights and limitations of the Indian people. The Anglo residents at the Zuni Pueblo—government officials, missionaries, traders, anthropologists, teachers, even photographers—all were accepted as part of the modern world. Thanks to the completion of the Atlantic & Pacific Railroad route and the establishment of a railhead at Gallup, tourists and the growing market for tourist trade goods marked the direction of the future economy of the Pueblo. After three hundred years of Spanish domination, twenty-one years of Mexican rule, and fifty years of United States Government regulations, the Zuni world was about to undergo even more radical changes in its economic and social structure. Only the fundamental spiritual beliefs of the Zuni people would have the power to endure.

Today, about a hundred years after Ben Wittick first photographed the Zuni Pueblo, visitors find no trace of the ruined church and see cinder-block houses in place of the rectangular multistory stone houses that were the subject of many of Wittick's photographs. The sacred ceremonies, which still are the focus of Zuni life, offer the only chance to glimpse the world that Ben Wittick photographed. It is still possible to visit the Pueblo at sundown on a cold evening in early December and watch the procession of giant Shalakos cross the river, heralding the long night of ceremonial dances.

179. *Nutria Village, Zuni Pueblo.* C. 1890. Photo: School of American Research
Collections in the Museum of New Mexico, Santa Fe

180. *House interior, Zuni Pueblo.* C. 1890. Photo: School of American Research
Collections in the Museum of New Mexico, Santa Fe

181. *Hornos, Zuni Pueblo.* C. 1890. Photo: School of American Research Collections in the
Museum of New Mexico, Santa Fe

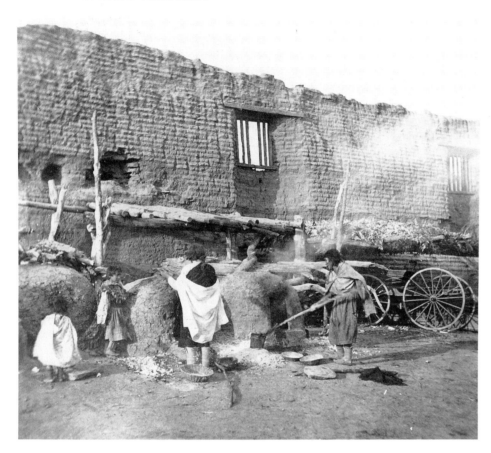

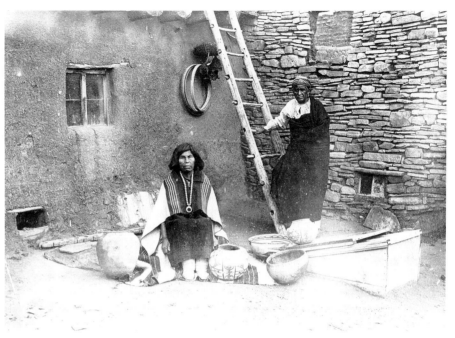

182. *Zuni Man and Woman, Zuni Pueblo.* C. 1890. Photo: School of American Research
Collections in the Museum of New Mexico, Santa Fe

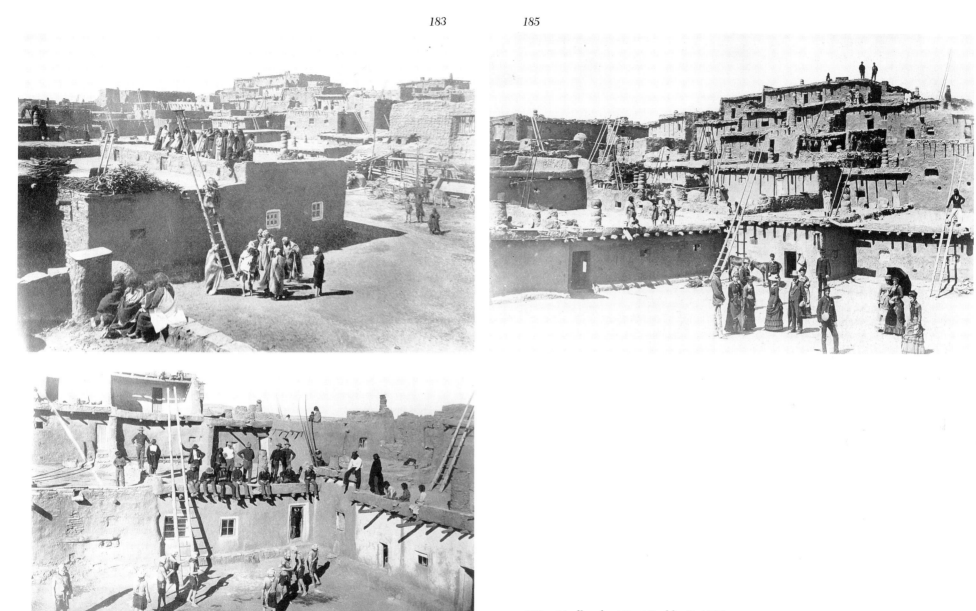

183. *Mudheads at Zuni Pueblo.* C. 1897. Photo: Private Collection

184. *A Trip to Zuni, Koy-ya-ma-shi (clowns) Making Merry After the Shalako Dance, Zuni Pueblo.* C. 1897. Photo: Private Collection

185. *Gen. John A. Logan and party, Zuni Pueblo.* C. 1890. Photo: Museum of New Mexico, Santa Fe

184

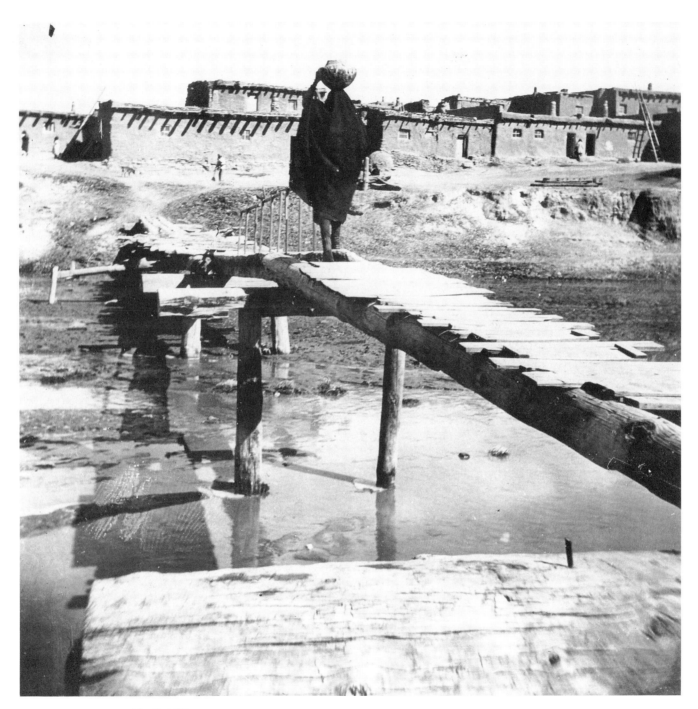

186. *Zuni Pueblo.* C. 1890. Photo: Museum of New Mexico, Santa Fe

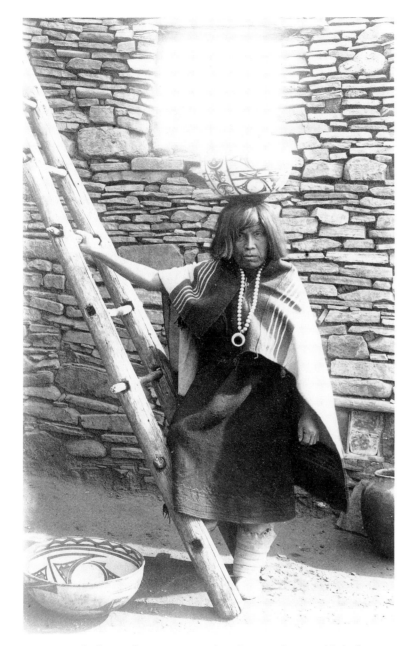

187. *A Zuni Woman of Advanced Age.* C. 1890. This photograph was published in Shufelt's *Indian Types of Beauty.* Photo: Smithsonian Institution, National Anthropological Archives, Bureau of American Ethnology Collection, Washington, D.C.

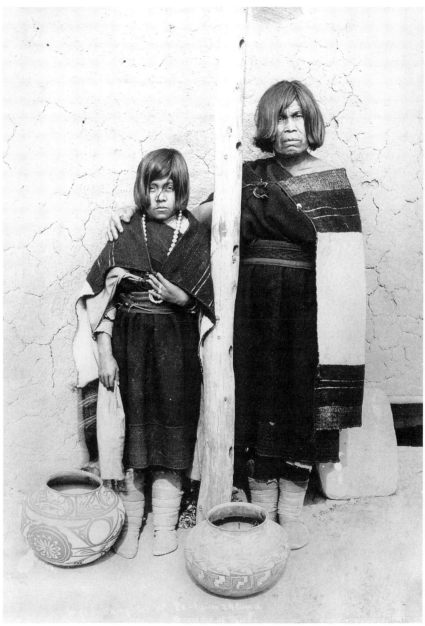

188. *Twai-wi-hah Ditza, and Tzaiowoh Ditza. Wife and Daughter of Pa-li-wa-tiwa, the Governor of Zuni Pueblo.* C. 1890. Photo: The Science Museum, Saint Paul, Minnesota

177

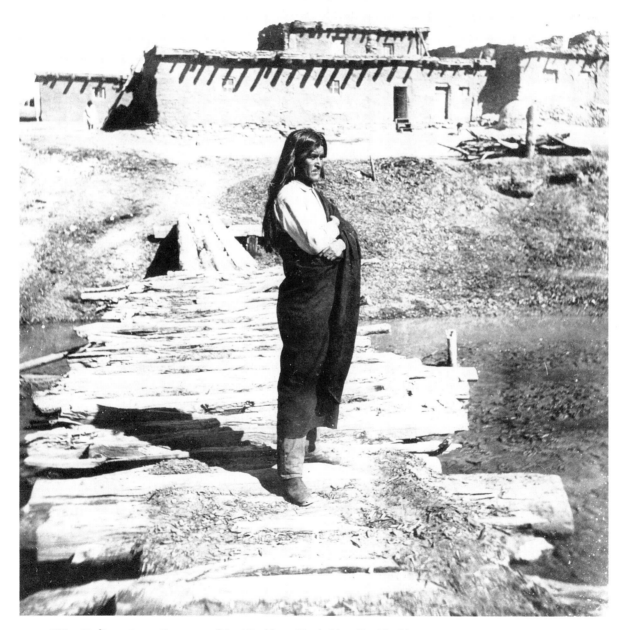

189. *Pa-li-wa-ti-wa, Governor of Zuni Pueblo on Footbridge, Zuni Pueblo.*
C. 1885. Photo: School of American Research Collections in the Museum of New Mexico,
Santa Fe

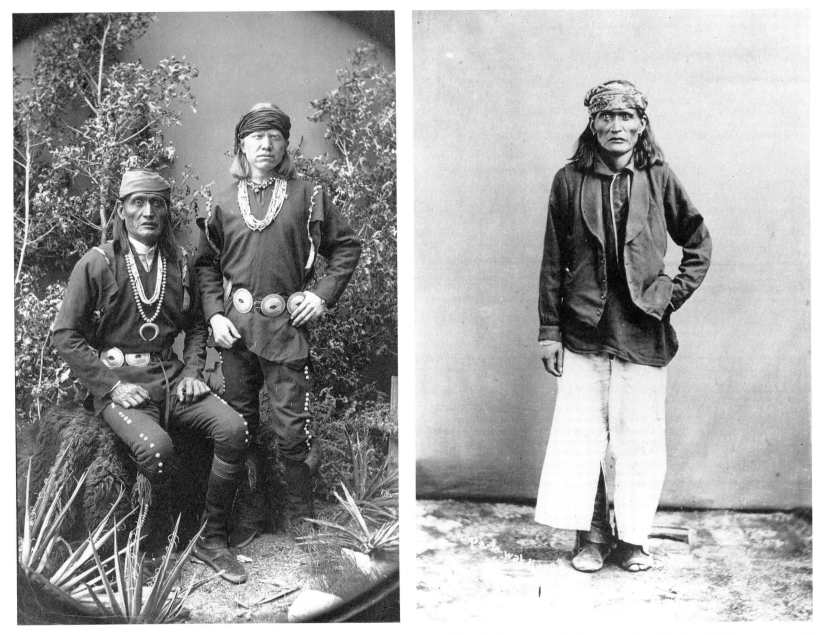

190. *Pa-li-wa-ti-wa, Governor of Zuni Pueblo, with Kai-i-tumi, a Zuni Albino,*
Zuni Pueblo. C. 1885. Photo: El Paso Centennial Museum, El Paso, Texas

191. *Pa-li-wa-ti-wa, Ex-Governor of Zuni Pueblo.* C. 1890. Photo: School of
American Research Collections in the Museum of New Mexico, Santa Fe

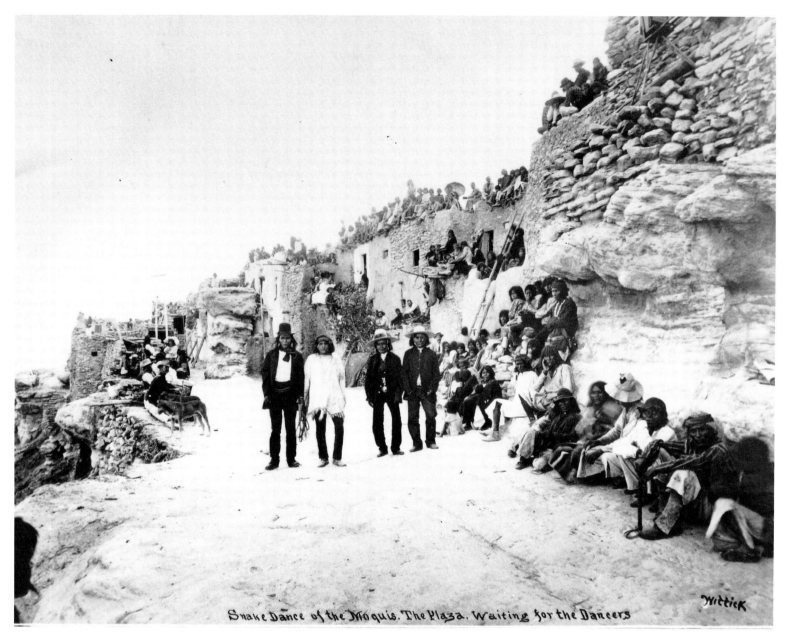

Snake Dance of the Moquis. The Plaza. Waiting for the Dancers

Wittick

192. *"Waiting for the Dancers," Snake Dance of the Hopis, Walpi Pueblo, Hopi*
Mesas. C. 1889. Photo: Private Collection

9. The Hopi

◘

Ben Wittick visited the Hopi Mesas for the first time in the summer of 1880. He became so fascinated with this unique stone world high above the vast desert of northwest Arizona that he returned almost yearly until his death in 1903. Wittick's death was a direct result of his desire to participate in Hopi life, for the snake that bit him fatally was intended for his Hopi friends' use in the sacred Snake Dance.

Since the 1880s, when Anglo-Americans first began to visit the Hopi villages, the Hopi world has held a magnetic attraction for those who find in this world of stone and sunshine a special sense of order and harmony between the land and those who inhabit it. For thousands of years the Hopi people and their ancestors have lived on these mesas and on the land surrounding them. In this dry, windy, desert world, each generation had learned to follow the Hopi Way to survival and prosperity. For centuries the Hopi have had a commitment to fundamental beliefs and values that have preserved the spiritual as well as physical well-being of the people.

The Hopi identify with their history, believing that the past is an inseparable part of the present and that the actions of the present inevitably will determine the course of the future. Two fundamental concepts that pervade all Hopi life are the Emergence and the Migrations. The Hopi believe that their ancestors entered this world, the fourth world to be created, through the Sepapu, a deep opening in the Grand Canyon at the confluence of the Colorado and Little Colorado Rivers.

Following the Emergence, they set out in four directions across the earth until they reached the land destined to be their sacred home. This period of wandering and searching is known as the Migrations.

In the traditional Hopi world, there is no division between secular and spiritual life. Ordinary daily activities and elaborate sacred ceremonies all focus on the same basic goals—the survival of the Hopi people and universal harmony. The Hopi believe that the universe was created and is sustained by supernatural spirits and deities and that the Spirit World is a dominant force in all of Hopi life. Every entity in the natural world—plants, animals, trees, even inanimate objects like pottery jars and rocks—possesses a spirit of its own and helps determine the course of life on Earth. They believe that, in both the natural and supernatural worlds, there is a fixed order, a Path of Life, determined by the Creator. In order for earthly life to prosper, the crops to flourish, and the Hopi to achieve universal progress, all spirits must be at harmony with this order. It is, therefore, necessary for the Hopi to follow the appropriate rites and ceremonies to maintain this order.

For centuries the Hopi have endeavored to propitiate the deities and spirits of the natural and supernatural worlds by celebrating the prescribed rituals of the ceremonial year. These rituals follow a perpetual rhythmic cycle, determined by the progression of the seasons. All ceremonies focus on the natural sequence of life—germination, fertilization, growth,

harvest, and regeneration. Every year the Hopi pray that the harvest will provide seed for the next cycle of germination, because each generation must provide the generative power and strength for the continuous renewal of life.

The Kachinas are the most important of the Hopi Spirits, for their beneficence is necessary to ensure prosperity and order in the Hopi world. The Hopi believe that many years ago, when their ancestors first came to live on the Mesas, the Kachinas lived in or near the Hopi villages, and whenever they danced, abundant rain fell on the Hopi crops. Although in the course of time the Kachinas moved to the San Francisco Mountains, each year they return for six months to dance while the Hopi pray for rain and the renewal of life.

The concept of the Kachinas is truly complex, for Kachinas exist on at least three levels. On the highest level, the Kachinas are the guardians of the Hopi people, ancestral spirits who carry the prayers of the Hopi to the Spirit World. There are hundreds of Kachinas in the Hopi pantheon, with great differences in their importance and function. On the second level, the Kachinas are human dancers who, in performing their masked rituals, are transformed into the embodiment of the ancestral spirits. On the third level, the name *Kachina* refers to dolls that the Hopi use to teach the children to identify the Spirits and understand their different functions. These figures, carved from the roots of the cottonwood tree, are purely educational tools and never are treated as sacred idols or icons.

The Kachina world is a microcosm of the Hopi world. From December to August the Kachinas participate in all of the activities and ceremonies needed for the germination and growth of the crops and the good health and spiritual well-being of people everywhere. The Kachinas, as part of their ceremonies, grind corn, grow beans, and participate in symbolic rites of procreation. The Whipper Kachinas serve as guardians of the Hopi and help to teach discipline to the children. The clowns satirize the weaknesses and errors of all who are human.

During his visits to the Mesas, Wittick witnessed many Kachina Dances and had the opportunity to photograph a variety of public dances. His most important ceremonial photographs are his views of the Snake Dances at Walpi, and Oraibi. The 206, 208 / 207 Snake-Antelope Ceremony and the Flute Dance are performed on alternate years as the first rituals after the Kachinas have returned to their homes on the San Francisco Peaks. The snakes, which in motion resemble lightning, are sacred messengers that carry the prayers of the Hopi to the Spirit World. The complex rituals of gathering, washing, blessing, and releasing the snakes are accompanied by prayers for rain.

The Hopi believe that their ancestral land is sacred and that absolute dedication to the Hopi Way—devotion to those ideals that govern every aspect of life—makes it possible to prosper and live in harmony on this sacred land. The beliefs and ceremonies of the past are an integral part of the present, because the basic goal of achieving a fruitful and meaningful life has never changed. It is the strength of tradition in Hopi life, the total identification of the Hopi people with their ancestral land, that has enabled them to survive the hardships of the natural world and retain their cultural identity despite three waves of conquerors.

The Hopi live in villages of stone on three mesas, fingered extensions of Black Mesa, which rises six thousand feet above sea level. The land of the Hopi lies about sixty miles north of present- 193, 201 day Winslow, Arizona, and a hundred miles east of the Grand Canyon. The Hopi live the farthest west of all of the Pueblo people. It is believed that the direct ancestors of the Hopi occupied villages in the region of the Mesas fifteen to sixteen hundred years ago. They were descendants of a prehistoric people who lived in the Southwest desert thousands of years ago.

The Hopi lived in relative isolation until 1540, when the Spanish conquistador Lieutenant Pedro de Tovar marched into the Jeddito Valley, the easternmost part of Hopi land. Ac-

194. *View in Walpi Pueblo Showing Entrance to Snake Society Kiva.*
C. 1890. Photo: Private Collection

193. *Mishongnovi and Shipalovi Pueblos, Hopi Mesas, Arizona.* C. 1890.
Photo: Museum of New Mexico, Santa Fe

companied by seventeen horsemen, foot soldiers, Zuni interpreters, and a Franciscan priest, Juan Padilla, De Tovar traveled as an emissary of Francisco Vasquez de Coronado, who remained in the Zuni village of Hawikuh. When De Tovar demanded entrance to Kawaiokuh, the easternmost Hopi village, and was refused and warned not to cross a line drawn on the ground, he ordered his men to attack and partially destroyed the village. The inhabitants of this village surrendered on behalf of all Hopi villages, and permitted De Tovar to visit each community before returning to Zuni to report his failure to find gold in the villages. Later that year Don Garcia Lopez de Cardenas, another of Coronado's lieutenants, visited the Mesas with twelve men. This time the Hopi permitted the group immediate entry and promptly gave them guides so they could continue on their way to the "Great River," the Grand Canyon, to search for the riches of the Southwest. Cardenas was the first white man to see the Grand Canyon.

The Spaniards continued to believe in lost mines of the desert, and in 1583 Antonio de Espejo arrived in the Jeddito Valley, to find that the villages of Kawaiokuh and Sikyatki had been abandoned. Again the Hopi pacified the Spaniards with gifts and furnished guides so that they could depart quickly.

In 1598 Juan de Onate arrived at the Mesas determined to conquer the Hopi villages in the name of Spain and win souls for the Catholic Church. The Hopi, remembering the tales of the brutality and inhumane treatment of the Acoma and the Zuni people, agreed to token submission and, in return, receive formal title to their own land from the Spanish crown. Although in 1604 Onate returned to the Mesas as he traveled west on his journey to the "Great South Sea" (the Gulf of California), for the next thirty years the Hopi remained free from Spanish colonizing and missionary zeal.

In 1628 the first Franciscan missionaries arrived on the Mesas, and the following year they began their building program. They built three churches directly over ancestral kivas. They forced the Hopi to serve as slaves, whose labors included car-

rying the giant logs used for ceiling beams from the San Francisco Peaks, forty miles away. When, in 1680, the Hopi joined in the Pueblo Revolt, they killed the four missionaries living on the Mesas, destroyed the churches, and rebuilt their kivas directly on the site of the Christian missions, using the slave-carried logs to support the new structures. They still remain as a symbol of Hopi enslavement.

During the years immediately following the Pueblo Revolt, the Hopi granted refuge to the Tano, Tiwo, Tewa, and Keres families from the Rio Grande Pueblos and, in preparation for Spanish reprisals, built two new villages, Payupki on Second Mesa and Hano on First Mesa. The Hopi moved three villages, Walpi, Shungopavi, and Mishongnovi, to the tops of their mesas and established a new village, Shipaulovi, on the most inaccessible point of Second Mesa in order to ensure the safety of their sacred ceremonial paraphernalia.

In 1692 Diego de Vargas arrived at the Mesas, demanding that the Hopi again acknowledge the authority of the Spanish crown. Sensing that the Hopi would resist armed reconquest, De Vargas agreed not to fight if the Hopi would swear allegiance to the Spanish crown and the Catholic Church. Most of the Hopi agreed and returned to their traditional way of life. The major exception was the village of Awatovi, in which several leaders already had been converted to Christianity.

In 1699 the Christian leaders of Awatovi welcomed back missionaries, who destroyed the sacred Hopi shrines, seized the religious paraphernalia, and demanded that the people of Awatovi abandon the beliefs and ways of their ancestors and rebuild their church. When the village chief of Awatovi, Francisco de Espeleta, sent a delegation to Santa Fe to ask for religious freedom, the right to pursue the Hopi Way, his request was denied.

Open conflict was inevitable, and Espeleta, with the conservative leaders of Awatovi, Walpi, Oraibi, Mishongnovi, and Shungopavi, devised and carried out a plan to destroy Awatovi. Most of the men were suffocated in the kiva; the women

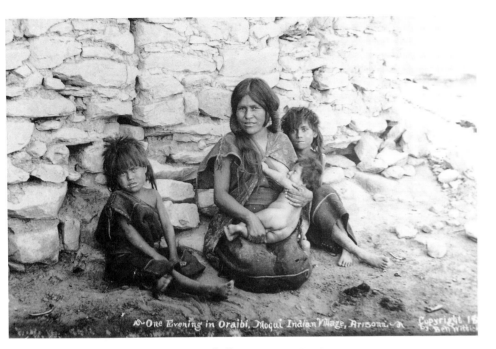

195. *"One Evening in Oraibi," Hopi Mesas.* C. 1896. Photo: Private Collection

196. *Hopi Women and Children.* C. 1890. Photo: El Paso Centennial Museum, El Paso, Texas

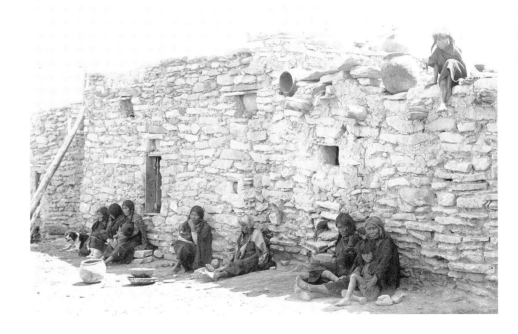

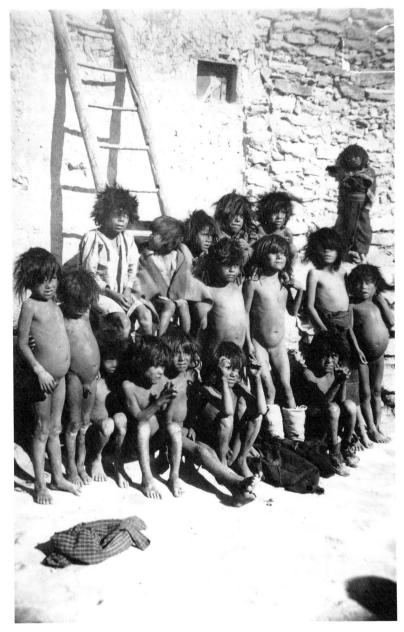

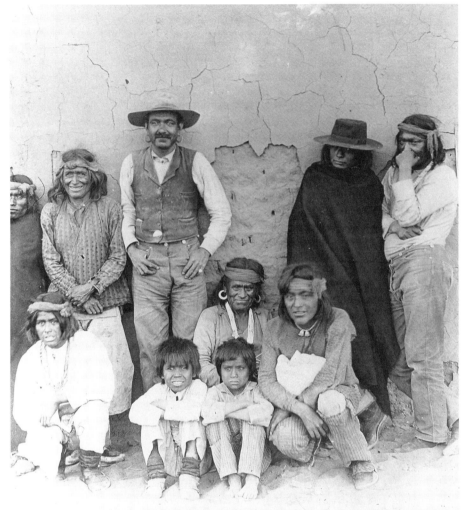

198. *Group of Men and Boys, Hopi Mesas.* C. 1890. Photo: School of American Research Collections in the Museum of New Mexico, Santa Fe

197. *Hopi Children, Oraibi Village, Hopi Mesas.* C. 1885. Photo: Private Collection

and children were divided among the victors in order to perpetuate traditional clans and rituals. Awatovi, which was abandoned and fell to ruin, from that time on was a primary symbol of the ability of the Hopi to resist oppression and protect their cultural integrity.

Although the Spanish spoke of reprisal and in 1701 sent a military expedition to punish the Hopi, this attempt failed, as did attempts in 1707 and 1716. The Spanish never accomplished their goal of conquering or converting the Hopi.[1] For almost two hundred years the Hopi remained united in their determination to remain an independent people. They succeeded in settling among themselves all disputes concerning allegiance to the Spanish crown and the Catholic Church and rejected all outside interference.

During the years of Mexican rule there was little contact between the Mexican Government and the Hopi. Although since about 1812 the Hopi occasionally had been troubled by Navajo and Apache raids, now, without the presence of Spanish troops in the Southwest, these raids became a constant threat. When the United States took control over the Southwest in 1850, government troops in the Arizona Territory provided the Hopi with some relief.

Until 1870 the Hopi, protected by geography, remained relatively isolated from the Anglo world. The majority of Anglo visitors to the Mesas were trappers and soldiers on military expeditions;[2] nevertheless, the Anglos slowly established a presence in the Hopi world. From 1864 to 1880 this Anglo presence was confined to traders, evangelical missionaries, schoolmasters, and Indian agents. In 1864 the first Indian agent was appointed over the Hopi, and in 1870 the United States Government established an independent Hopi Indian Agency at Oraibi. The Agency monitored Hopi activities until 1883, when it was incorporated into the Navajo Agency. In 1874 the government began the construction of an Indian agency center at Keams Canyon, a canyon named for the resident Englishman, Thomas Keam. In 1878 Keam opened the

first trading post in Hopi country, which remained the primary center for the area until 1894, when Tom Pavatea opened the first Indian-operated trading post at Polacca. In 1902 Lorenza Hubbel purchased the Keams Canyon trading post, and in 1907 he purchased the Volz trading post at the base of Second Mesa, near Oraibi.

In 1870 evangelical Protestant churches began a major campaign to convert the Hopi. That year the Moravian Church established a mission in Oraibi, the first non-Hopi mission to be built on the Mesas since the destruction of Awatovi. Five years later the Baptist Church founded a mission at Mishongnovi and the Mormon Church opened a mission at Moenkopi, a Hopi village forty-five miles east of Third Mesa, which had been a traditional farming colony of the Oraibi people. The Mormons, who since the 1850s had been trying to convert the Hopi, achieved their greatest success in 1878 with the founding of Tuba City, a small community outside Moenkopi. In 1893 H. R. Vroth established a Mennonite mission in Oraibi, and in 1901 he built a church directly on a Kachina Trail. (Vroth's church had great success in winning converts until it was struck by lightning in 1912, and again in 1942.) In 1894 the Baptist Church established a mission in Polacca, a Tewa community.

The first Anglo school on Hopi land was the Protestant Missionary School, established in 1875 in Keams Canyon. It was not until 1887 that the government established a "Federal *Moki* School" at Keams Canyon, on land purchased from the trader. The government opened day schools at Polacca and Oraibi in 1894 and the Toreva Day School in 1897.

The United States Government's zeal to establish schools intended to anglicize and educate the Hopi received little support from Hopi leaders until 1890, when the first Hopi leaders returned from their visit to urban industrial America. That year Thomas Keam took a group of Hopi leaders to Washington to meet the Great White Father, President Benjamin Harrison, and request his help in preventing the Navajo from en-

croaching on Hopi land. They also met with the Commissioner of Indian Affairs, but rejected his suggestion that they protect their land from Navajo raids by abandoning their mesa-top villages and building new settlements near their fields and grazing areas. One of the younger members of the group, Lololoma, who had been chosen Chief of the Oraibi in 1880, was greatly impressed by the wonders of urban America. Convinced that the Hopi could make major technical advances only with a white man's education, he became the leading advocate of Anglo schooling for Hopi children.

Lololoma's acceptance of the white man's way was facilitated by the Hopi belief in the historic prophecy of deliverance by the Bahana, their white brother from the East, who had emerged into this, the Fourth World, with the other tribes of humanity. During the sixteenth century, several of the Hopi had mistaken the Spanish conquistadors for the Bahana; three centuries later Lololoma believed the Anglos to be the messiah.

This position brought him into direct conflict with traditional leaders, who believed that the young man was rejecting the Hopi Way and advocating the abandonment of sacred traditions and beliefs. When conservative Hopi refused to send their children to the boarding school at Keams Canyon, Oraibi split into two factions—the Friendlies, led by Lololoma, and the Hostiles, led by Lomahongyoma, who disputed the progressive leaders' claim to chieftainship. Tensions between these factions heightened with the Indian Bureau's decision to divide Hopi land into individual holdings in accordance with the Dawes Severalty Act of 1887. Land allotment brought immediate protest from all Hopi leaders and active opposition from the Hostiles.[3]

By the turn of the century the conflict between the Friendlies and Hostiles had grown intense. When the dispute extended to the rights to ceremonial property, each group began to perform the sacred rituals independently. By 1906 it was no longer possible for the two factions to remain in the same village, and they settled their disputes over the right to land ownership by a bloodless battle, a push over a line on the ground. The Friendlies won, and the conservative Hostiles founded the new village of Hotevilla. Ironically, those who at the turn of the century were called the Friendlies, the progressives who won the the right to remain in Oraibi, eventually became the most conservative and traditional of all Hopi.[4]

In 1881 the Atlantic & Pacific Railroad completed a section of track across Arizona sixty miles south of the Hopi village. The following year the United States Government created a Hopi Reservation by Executive Order, defining Hopi land as the fifty miles surrounding the central villages.[5] The official Hopi Reservation was completely surrounded by Navajo land, and the Hopi were cut off from a large section of traditional grazing land and many sacred shrines.

With the completion of the railroad, anthropologists, photographers, and tourists regularly made the sixty-mile trek from the depot at Winslow to the Hopi villages. Each year a greater number of adventurers arrived to witness and record Hopi ceremonial and daily life. The anthropologists arrived intent on documenting in detail every aspect of Hopi sacred and secular life.[6] To the anthropologists, Indian land was a laboratory and the inhabitants were subjects to be studied. As they collected what they termed ethnological material, they felt no pangs of conscience at removing sacred ceremonial paraphernalia for display in private collections or museums.

The tourists also wished to return home with reminders of this exotic world. This demand for native souvenirs gave birth to a new economic activity on the Mesas, the creation of the first commercial Hopi craft arts—pottery and jewelry. Until the arrival of the Anglos, art was an integral part of Hopi life, a communal activity that focused on the universal goals of harmony, fertility, and the regeneration of life. Artists had no special identity, but were respected for their contributions to the temporal and spiritual well-being of the people.[7]

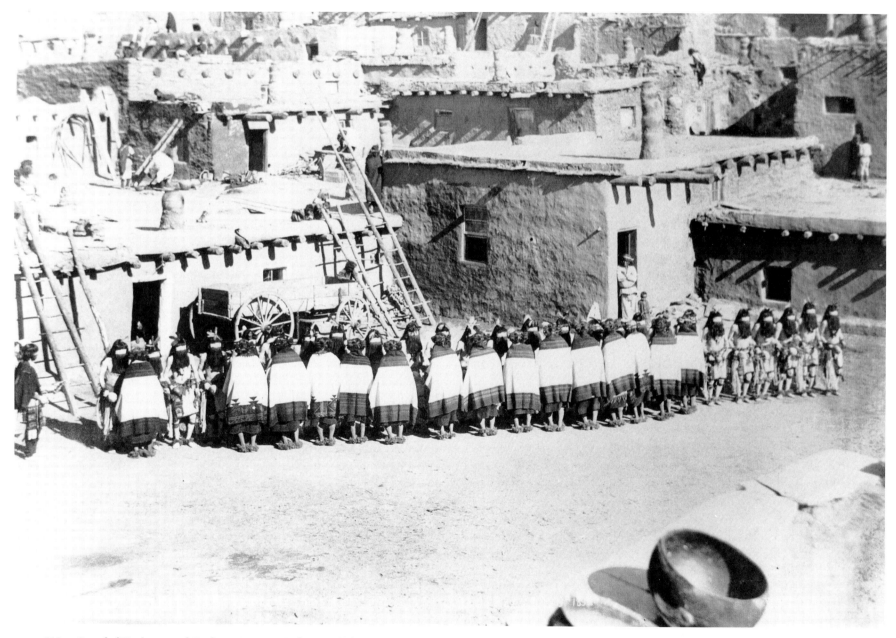

199. *Bearded Kachinas and Kachinas Manas, Kachina Dance, Hopi Mesas.*
C. 1890s. Photo: Private Collection

In about 1890 the Hopi made their first attempts at silverwork, a craft they had learned from the Zuni, who, in turn, had used Navajo work as a model. In 1895 Dr. Jesse Walter Fewkes headed an expedition to excavate the Sikyatki ruins in the Jeddito Valley. One of his workmen, Lesou, was married to Nampeyo, an expert potter, who frequently visited her husband at the excavation site. Inspired by the designs on the ancient pottery, she began to adapt these designs to her own work, which she offered for sale to the tourists.[8] In 1900 Fewkes commissioned four Hopi men, the first Hopi nonritual painters, to make two hundred drawings of Kachinas. These were published in the 1903 *Annual Report* of the United States Bureau of American Ethnology and Anthropology.[9]

By 1900 the Hopi had become aware of the importance of protecting their sacred heritage from commercialization. Determined to keep their ceremonial secrets from the microscopic probings of the anthropologists, they began to limit the perimeter of wandering visitors and confined photographers to sanctioned subjects and locations. In 1910 they banned the use of cameras on the Mesas.[10]

Wittick made his last visit to the Hopi Mesas in 1902, just four years before the historic conflict that resulted in the building of three new villages, each with the intent of reconciling traditional Hopi life with the inevitable presence of Anglos in the Hopi world. His first visit to the Mesas had been in 1880, the year before the railroad offered scheduled transportation across New Mexico and Arizona. Within a few years the railhead towns of Gallup, Holbrook, Winslow, and Flagstaff had become thriving commercial towns and the trip to the Mesas had been transformed from a formidable journey across the Great American Desert into a sixty-mile sightseeing adventure. At the time of Wittick's first visit to the Mesas, the United States Government had not yet proclaimed a Hopi Reservation. In these last days before a steady stream of government officials, anthropologists, tourists, and traders appeared on the Mesas, the arrival of an Anglo photographer was an unusual but not a problematic event. No Hopi had ever traveled to an eastern city or even considered adopting any of the practices or values of the white man. By the time of Wittick's final visit to the Mesas, the Hopi were divided into conservative and progressive factions and were experiencing internal conflict over two critical issues—required federal schooling for their children and land allotment.

Wittick's photographs capture a glimpse of the Hopi world during this critical period. Almost all of his Hopi photographs were field studies, for the Hopi people had little interest in participating in the studio photographer's world of make-believe. He made several genre photographs, including a study of a young woman grinding corn; however, Wittick's field photography undoubtedly was limited, since the Hopi elders decided exactly where the Anglo photographer could go and which subjects were permissible. 205

The Hopi women, rather than the men, appear to have been Wittick's most cooperative portrait subjects. His photographs of the Hopi maidens were among his most popular Indian photographs, and his image of Ng-nue-si was published as "A Girl of Moki" in 1891 in Robert Shufeldt's *Indian Types of Beauty.* Although Wittick's photographs of Hopi women belong to the nineteenth-century romantic tradition, his images of the girls and women of the Mesas in traditional Hopi dress capture the fundamental harmony of their lives. 209

200

Wittick's overviews of the Hopi villages and his images of the houses, kivas, and shrines reveal a stone world that has endured for centuries and through the centuries has remained fundamentally unchanged. The ceremonies Wittick photographed are the same as those performed long before the first Spaniards arrived in the Southwest and are still performed today. 194, 203

Wittick's photographs of the 1889 Snake Dance at Walpi capture the fundamental realities of the Hopi world at the turn of the century. Many Anglo men and women are present at the 192, 208

dance, but all photographers are confined to a sanctioned spot. The Hopi leaders who went to Washington to see the Great White Father appear in full white man's dress, yet no one pays much attention to them. Hopi men and women from every clan and village, young and old, progressive and conservative, have joined to witness a sacred ritual and to pray for the well-being of the Hopi people and the continuance of life in the Hopi world.

From this time on there would be factionalism in the Hopi world, a division between those who would advocate changes and those who would demand adherence to tradition. Hopi life would undergo many fundamental changes. For example, thanks to the traders and wage work, the Hopi would experience the transition from a subsistence to a cash economy, and Hopi life in the future would include highways and supermarkets.

Nevertheless, there are several fundamental differences between the Hopi and the other Pueblo people. Although the Hopi, like all of the Pueblo, experienced internal conflict during the years following the Pueblo Revolt and years of pressure by the United States Government for federal schooling and land allotment, they alone resolved their problems without outside interference. They are the only group to have retained their traditional religious beliefs. Although there have been some converts, the majority of the Hopi continue to uphold the fundamental faith of their ancestors. Even during years of the greatest conflict and division, the members of both progressive and conservative factions affirmed traditional values and goals, and today, regardless of political or social differences, all Hopi share a Hopi identity and commitment to the Hopi Way. Wittick's photographs of the Hopi people and the Hopi Mesas document a unique continuity of culture.

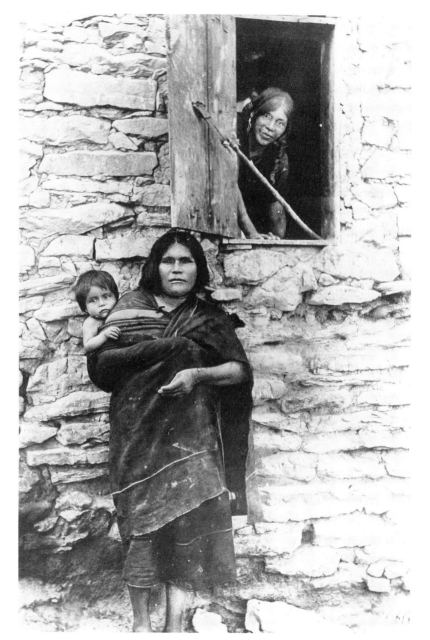

191

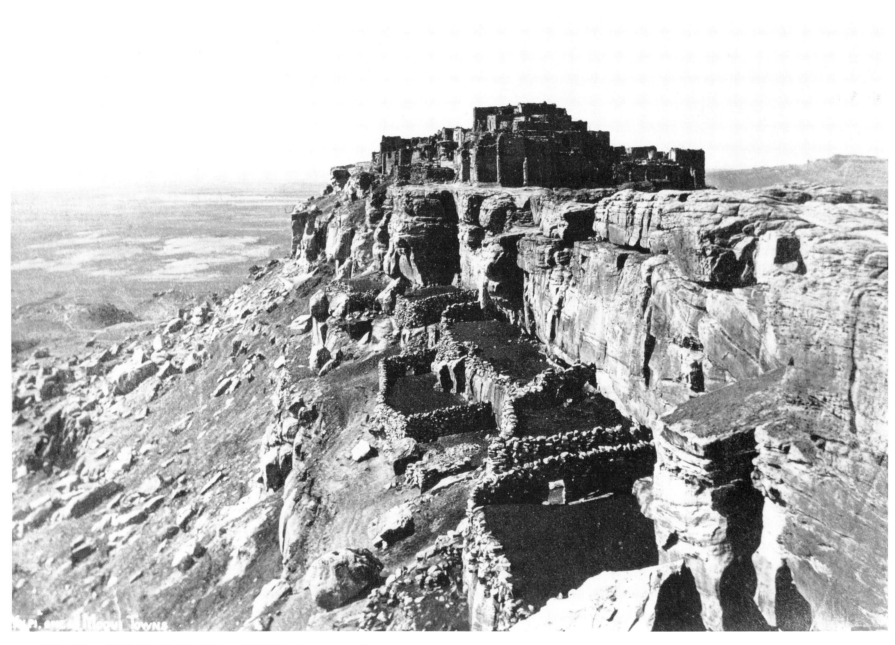

201. *View of Walpi Pueblo, Hopi Mesas.* C. 1890. Photo: Private Collection

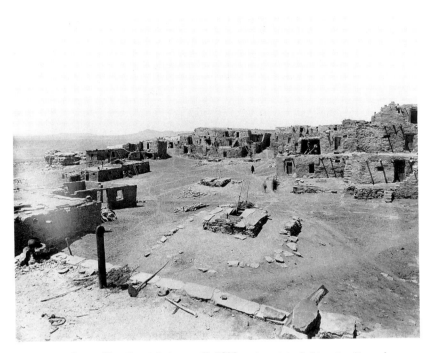

202. *Oraibi Pueblo, Hopi, Arizona.* C. 1890. Photo: School of American Research
Collections in the Museum of New Mexico, Santa Fe

203. *Oraibi Pueblo, Hopi Mesas, Arizona.* C. 1890. Photo: School of American
Research Collections in the Museum of New Mexico, Santa Fe

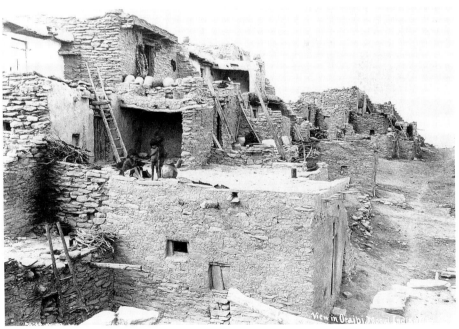

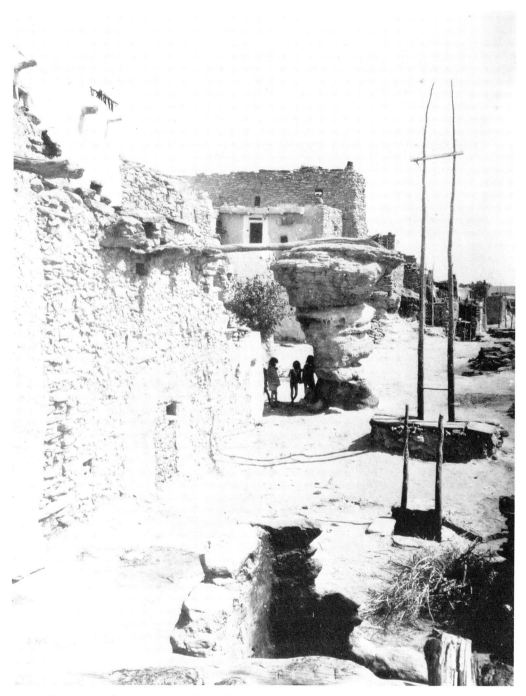

204. *View of Snake Rock, Walpi Pueblo, Hopi Mesas, Arizona.* C. 1890. Photo:
School of American Research Collections in the Museum of New Mexico, Santa Fe

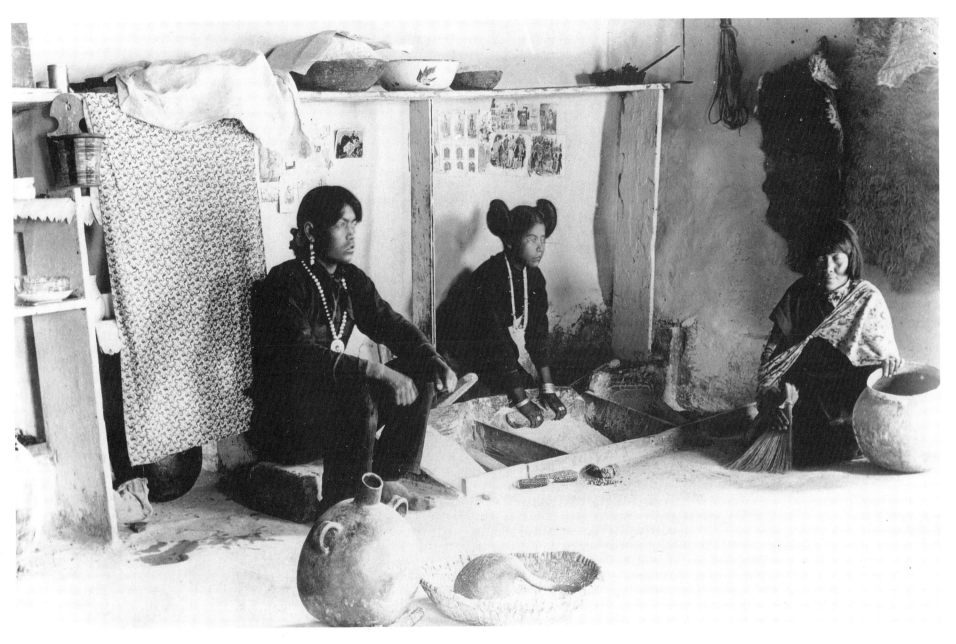

205. *Interior of Tewa House, Hopi Mesas, Arizona.* C. 1890. The young girl is grinding corn. Photo: School of American Research Collections in the Museum of New Mexico, Santa Fe

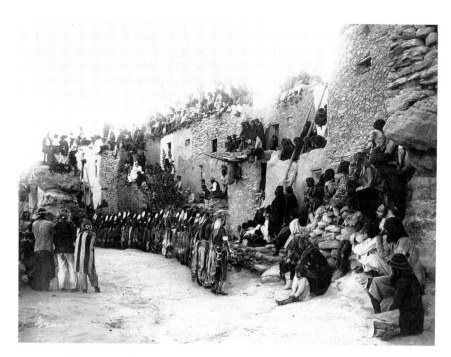

206. *Snake Dance ("The Rain Dance"), Walpi Pueblo, Hopi Mesas, Arizona.*
C. 1889. Photo: School of American Research Collections in the Museum of New Mexico, Santa Fe

207. *Snake Dance, Oraibi Pueblo, Hopi Mesas.* August 22, 1898. Photo: School of American Research Collections in the Museum of New Mexico, Santa Fe

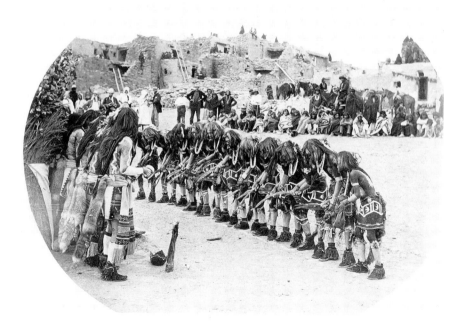

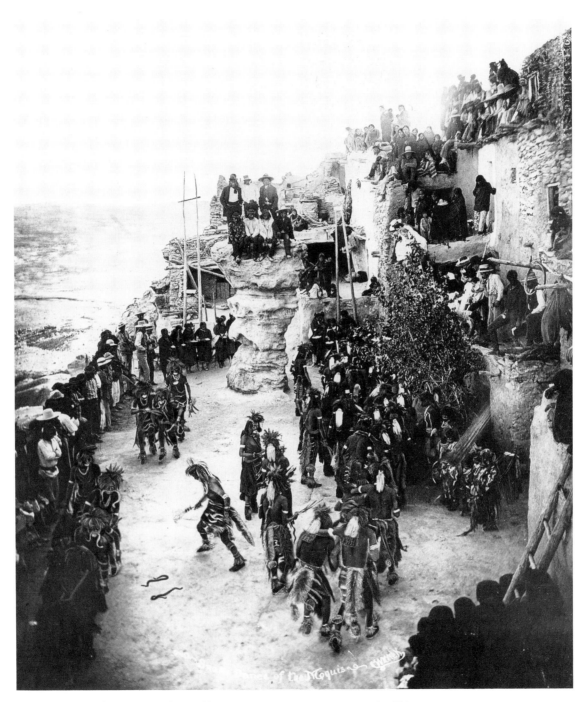

208. *Snake Dance, Walpi Pueblo, Hopi Mesas, Arizona.* August 17, 1889. Photo: Museum of New Mexico, Santa Fe

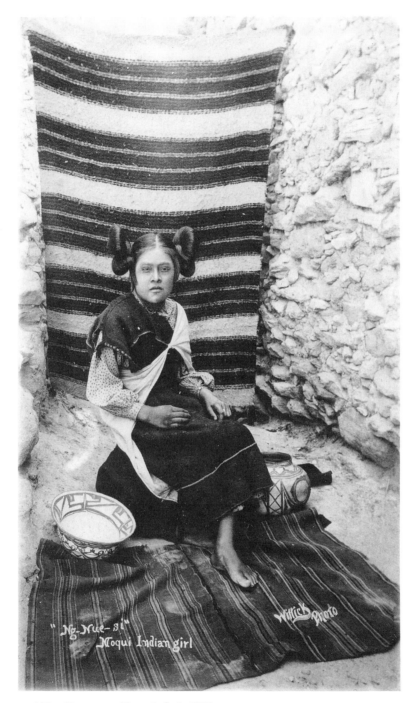

209. *Ng-nue-si, Hopi Girl.* C. 1885. Photo: Smithsonian Institution, National
Anthropological Archives, Bureau of American Ethnology Collection, Washington, D.C.

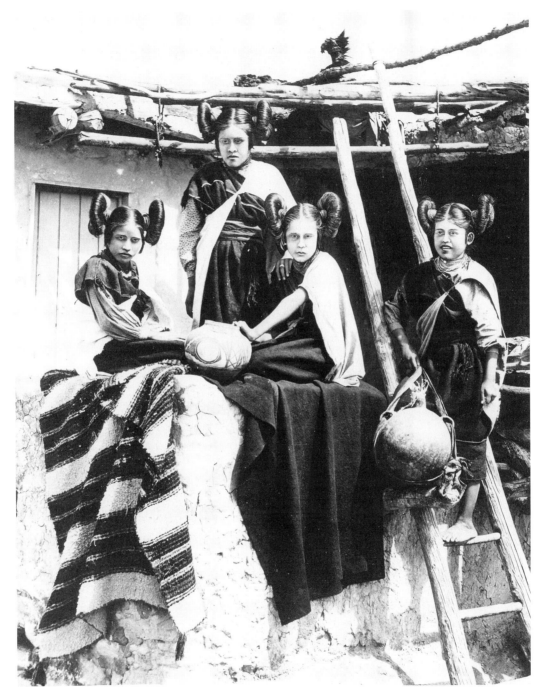

210. *Girls from Sichimovi Pueblo, Hopi Mesas.* C. 1885. Photo: Museum of New
Mexico, Santa Fe

Appendix

Pioneers of Frontier Photography: A Brief Overview

◘

In order to maintain a proper perspective in studying the work of Ben Wittick, it is helpful to review briefly the history of American frontier photography, outlining the contributions of the outstanding pioneers in the field and examining the work and ideals of a few of the most important of Wittick's contemporaries.

On January 7, 1839, Louis Jacques Mande Daguerre, a French citizen, addressed the Academy of Science in Paris and announced to the world the discovery of a process that for the first time made it possible to use sunlight, chemicals, and the principle of the camera obscura to make permanent images of objects, individuals, and outdoor views. Daguerre had developed this process in partnership with Joseph Nicephore Niepce, who had died prior to Daguerre's announcement. It is not possible to evaluate the contribution of each man.

The principle of the camera obscura had been known since the time of Euclid (300 B.C.). In the fifteenth century Leonardo da Vinci described a process in which a hole in a window shutter permitted a ray of light to enter a darkened room. When this light fell upon a white screen, the reverse image of exterior objects appeared on the screen. This process was refined so that a small box rather than a room could demonstrate the phenomenon of reflected light. Subsequently a lens was fitted over the shutter opening and ground glass was used to receive the reverse image. In Daguerre's process, a sensitized metal surface, a sheet of copper coated with iodide of silver, was placed in the camera and exposed to the rays of the sun for a period of time that varied from five to six minutes in the summer and from ten to twelve minutes in the winter. The plates were then exposed to the action of a developing agent, the fumes of boiling mercury, and washed with a hyposulphate of soda. After a final washing with distilled water, the metal plates were dried and placed under glass for protection.

Scientists around the world immediately recognized the potential of this revolutionary invention, and the leaders of the exploratory expeditions to the American West were no exception. Among the first daguerreotypists to record images of the West were W.C. Mayhew, who in 1851 made a series of photographs of Captain Lorenzo Sitgreaves's expedition along the Little Colorado and Zuni Rivers, and Solomon Nunez Carvalho, who, in 1863 joined Colonel John C. Fremont's Fifth Expedition across the Rocky Mountains. Unfortunately, all of Carvalho's daguerreotypes of the Rocky Mountains have been lost. That same year John Mix Stanley, accompanying Governor I.I. Stevens of Washington Territory on a survey of a northern route for the transcontinental railroad, completed both sketches and daguerreotypes in the course of the journey.

During the next few years many new photographic processes were developed. Among the most popular were the ambrotype and the tintype; however, these processes, like the daguerreotype, produced only a single image, which could not be reproduced.[1]

On January 31, 1839, three weeks after Daguerre's address, William Henry Fox Talbot, a young Englishman, announced to the Royal Society of London a process that enabled the photographer to fix the reverse image of the camera obscura on paper. Sir John Herschel, a distinguished English scientist, realizing the necessity for the duplication of the photographic image, transformed Talbot's paper negative process into one based on a glass negative. On March 14, 1839, following Talbot's precedent, Herschel announced the details of his method to the Royal Society.

Although Herschel's revolutionary process made possible the mass reproduction and publication of photographs, it was exceptionally time-consuming. During the 1840s John Adams Whipple, a Boston daguerreotypist, improved Herschel's process by utilizing albumen from hens' eggs as the binding vehicle. Finally, in 1851 English photographer and sculptor Frederick Scott Archer announced a procedure, ultimately known as "the wet-plate process," which for the first time enabled the photographer to prepare negative plates with relative ease; they were the most transparent, sensitive, and stable to date. During the 1850s adaptations of this process enabled the photographer to make enlargements, and within a decade the wet-plate process became one of the most widely accepted forms of photography.

A popular innovation of wet-plate photography was the card photograph, or *carte-de-visite*, which measured about 4 x 2½ inches. By the 1860s the family album filled with card photographs had become a traditional American treasure. For those who journeyed West, these images often served as the only tangible tie with those who remained in the East, and during the Civil War both the card photograph and the tintype enabled soldiers to leave behind a memento for family and friends. The card photographers introduced the use of painted backgrounds and props, a tradition that for decades was followed by those who photographed the pioneer, the military, and the Indian West.

One of the most important uses of the wet-plate process was stereoscopic photography. The stereoscopic camera was a double-lens camera that used a single glass plate to photograph the same image from slightly different angles. The viewer then used a stereoscope, an adjustable wooden support that held the two photographs, to see the world in three dimensions. As in ordinary vision, each eye focused on a separate image, thus re-creating the phenomena of volume, space, and distance.

The stereoscopic camera made it possible for those who never left home to see detailed images of the land and people, architecture, art treasures, and historic monuments from every part of the world. Thanks to the stereoscope, the American people could share the adventures and discoveries of explorers and scientists who traveled to unknown territories and encountered people of every tribal origin. By 1900 stereo cards had brought three-dimensional images of the American wilderness and its native inhabitants into drawing rooms around the world. Those who remained in the comfort of the parlor could experience the beauty, vastness, and power of the land of the American West and look with amazement at the fantastic geological forms. For the first time, they could gaze directly on images of the land that for centuries had been the home of the American Indian. Here was the opportunity to see an incredible variety of dwellings, gaze at the faces of Indian men, women, and children, and study their costumes, tools, and artifacts of ceremonial and daily life. It was possible to witness even the most exotic sacred and secular rituals. The public's appetite for stereoscopic views was insatiable, and photographers of the American West were sure to include the stereoscopic camera as a vital part of their expeditionary equipment.

The first photographers in the West were ambitious young men who in the 1840s and 1850s opened studios in Western towns and frontier settlements. Most of these pioneer photographers concentrated on portraiture, but a few of the most adventurous attempted field photography. One of the first to

travel with the heavy photographic equipment was Robert H. Vance, who in 1851 exhibited three hundred daguerreotypes, which included views of San Francisco and neighboring communities, Indian villages along the Pacific coast, and the gold rush camps at Sutter's Mill. Several wet-plate photographers based in San Francisco made photographic tours across the Sierra Nevada Mountains. Although in 1859 Charles L. Weed became the first to photograph Yosemite Valley, it was Carlton E. Watkins whose 1861 photographs brought the wonders of the region—the waterfalls, mountain vistas, rock formation, and giant sequoias—to the attention of the world. Both men carried single-lens and stereo equipment. Eadweard Muybridge, following the route of Weed and Watkins, photographed Yosemite Valley in 1868. In later years Muybridge won renown for his still photographs that captured the fundamental elements of movement by photographing sequential positions of bodies in motion.

Although the majority of West Coast and Rocky Mountain photographers concentrated on historic events and landscape views, a few of the outstanding photographers of the pre–Civil War period took an interest in frontier and military life and life in the Indian settlements. Peter Britt photographed frontier villages in southern Oregon, Lorenzo Lorain documented the military experience in the Washington and Oregon Territories, and Marsena Cannon became the chronicler of the Mormon settlement in Salt Lake City.

Initially it was feared that photography would bring ruin to artists; however, it slowly became evident that photography could serve as an aid, providing a permanent, detailed record that could be used later as reference for their work. When, in 1859, Albert Bierstadt joined Captain Frederick W. Lander as guest artist on a survey expedition from Puget Sound to the South Pass of the Wind River Range of Wyoming, he made both sketches and a set of stereoscopic views, which proved an excellent source of reference for many of his Rocky Mountain paintings.

During the Civil War Mathew B. Brady, a celebrated portrait photographer with studios in Washington and New York City, financed and trained the "Army of the Potomac," a corps of photographers who left the studio to capture firsthand images of the encampments and battlefields. Thanks to the stereoscopic views of these brave photographers, for the first time the American public came face to face with detailed images of the carnage of war.

By the end of the Civil War Americans had mastered the wet-plate process, and when collodion[2] became commercially available, many of these competent photographers set out to capture on glass images of the wonders of the American West. Andrew J. Russell, Alexander Gardner, and Timothy O'Sullivan, three of the most distinguished photographers of the American West, had been trained in the Brady photographic corps.

During the 1860s competing transcontinental railroads hired photographers to bring national attention to their progress. On May 10, 1869, at the historic meeting of East and West at Promontory Point, Utah, Andrew J. Russell was the official photographer for the Union Pacific Railroad and Alfred Hunt was the official photographer for the Southern Pacific Railroad. However, it was Charles R. Savage, the representative of the Mormon people of Utah, who won fame for his outstanding photograph of the event. Among the West's outstanding railroad photographers were Alexander Gardner, who made stereo views of Kansas prairie towns, forts, and Indian settlements and of the railroad construction crew who worked along the route of the Kansas Pacific Railroad;[3] Dr. William A. Bell, who in 1867 joined the Kansas Pacific Railroad's survey to determine the route from Kansas City to Denver; and Frank J. Haynes, who during the 1880s served as the official photographer for the Northern Pacific Railroad's survey of the route from Minneapolis–St. Paul across North Dakota, Montana, and Idaho to Washington and the Pacific Coast. During his years as railroad photographer, Haynes took

many pictures of the Indians along each route. In 1881 he photographed the Custer battlefield, in 1883 he accompanied President Chester A. Arthur on a camping expedition to the Yellowstone, and in 1885 he completed a government mission to photograph the Flathead Indians, a commission intended to illustrate the government's success in "civilizing the savage people." Haynes's best-known Indian photograph is his 1877 portrait of Chief Joseph of the Nez Perce, taken in Bismarck. Haynes later gained wealth and fame as the holder of the government concession to make and sell photographs of Yellowstone National Park.

The most famous frontier photographers were the three men who documented the major scientific surveys of the 1860s and 1870s—Timothy O'Sullivan, William Henry Jackson, and John K. Hillers. From 1867 to 1869 Timothy O'Sullivan accompanied Clarence King's survey of the 40th parallel. En route, O'Sullivan photographed the Comstock Lode, Pyramid Lake, Snake River, Shoshone Falls, the sand dunes near Carson City, and the Great Salt Lake. During his seven-year career as a Western photographer, O'Sullivan served with several other major scientific expeditions. In 1871 he joined the Wheeler survey of Utah, today known as the *U.S. Geological Survey West of the 100th Meridian*, and traveled extensively across Nevada, Arizona, New Mexico, Utah, and Colorado, photographing the spectacular land forms of the American Southwest. He also photographed the Grand Canyon, the Green River and the Green River Canyon, Flaming Gorge, and Shoshone Falls and was among the first to photograph Death Valley and Canyon de Chelly. Although O'Sullivan's work occasionally includes images of Indian dwellings, it is his panoramas of the West, celebrating the giant sweep of the land, the awe-inspiring rock formations, rivers, and mountains, that have won him a special place in American photographic history.

In 1871 William Henry Jackson and artist Thomas Moran accompanied Ferdinand V. Hayden on a geographical survey of the Yellowstone region. Jackson's first photographic voyage had been a three-month trip along the railroad route from Omaha to Salt Lake City. In 1871 and 1875 Jackson returned with Hayden to Yellowstone country, then, in 1876, accompanied Hayden on an expedition to the Grand Tetons. In 1877, using the new dry-plate process, which had the advantage of not having to be coated and developed in the field,[4] Jackson traveled throughout the Southwest, visiting Santa Fe and Taos and making over four hundred pictures of the Hopi Mesas, the Rio Grande Pueblos, the Pueblos of Acoma, Zuni, and Laguna. Jackson later described this trip as the most expensive failure of his career, for when he returned to Washington and had his films developed, all of the dry-plate images proved to be blank. In 1897 Jackson became a director of the Detroit Publishing Company, and in 1898 he began a series of trips across the United States to purchase from local photographers negatives suitable for publication. When, in 1902, he toured the Southwest with a company display, he had the opportunity to return to the Pueblos and mesas and photograph the land, the architecture, and the ceremonial life of the area.

In 1872 John K. Hillers joined Major John Wesley Powell's second survey expedition of the Colorado River. Hillers learned the fundamentals of photography while serving on the crew, then, midway in the expedition, was appointed photographic chief of the survey. Hillers proved to be the hero of the hazardous journey when he rescued Powell from a raging whirlpool. Hillers remained with Powell until 1879, when Congress consolidated all survey teams into the United States Geographical Survey. During his years with Powell he photographed Glen, Marble, and Kanab Canyons, and the area that is now Zion National Park, and made the first comprehensive pictorial record of the Paiute, Ute, and Shoshone Indians. In 1879 he traveled throughout Arizona and New Mexico, photographing historic ruins and Indian settlements and completing a series of portraits of the Indian people of the region. When Powell became director of the United States Geological Sur-

vey in 1881, he appointed Hillers director of the Photographic Laboratory.

By the time Ben Wittick arrived in the Southwest, the Indians, with the exception of the last renegade Apaches, were a defeated people, forced to abandon any hope of life as self-reliant members of independent nations. There was no question that they had to accept and adjust to the values and way of life of a dominant alien culture. Whereas the first generation of photographers had been pioneers, inspired by a sense of mission to capture the first photographic images of the indigenous people and the heroic landscape of the trans-Mississippi West, Wittick's generation was confronted with the changes in that world, the beginning of the transformation of the West from a frontier to a cohesive part of an urban, industrial nation.

Wittick and his contemporaries were masters of a new technology, competent practitioners of a recognized profession. Although they differed in motivation and focus, they were products of their time and culture and shared many beliefs and ideals. Adventurers, crusaders, nostalgic romantics, all looked upon the American Indian as a member of a vanishing race. They believed that the Indian was innately inferior to the white man, but had been blessed with a special knowledge of how to live a life of harmony—harmony within the tribe and harmony with nature. Several of Wittick's contemporaries turned to the Indian world as a sanctuary from the pressures of modern life. They felt drawn to the Southwest desert, where they experienced a spiritual awakening and a feeling of inner peace.

In 1879 Camillus Fly settled in Tombstone, Arizona, where he tried his luck as a miner, failed, then opened a succession of Arizona photographic studios. (Although Fly was present at the shoot-out at the O.K. Corral, he failed to photograph the event.) Fly's outstanding contribution is his 1886 dry-plate photographs of General Crook, the U.S. troops, and their Apache captives as they passed through Tombstone on their way to Mexico to sign a formal surrender. Fly sold four of these photographs of "wild Indians," posed groups of Geronimo, Nachez, and their followers, to *Harper's Weekly*, and in 1905 his wife privately published a book of fifteen images entitled *Scenes in Geronimo's Camp: The Apache Outlaw and Murderer.*

Between 1895 and 1903 George Wharton James completed a series of photographs of the Pueblo Indians of the Southwest. Trained as an anthropologist, he was particularly interested in the Hopi Snake Dance rituals and was among the first to recognize the artistic validity of the Indian craft arts of basketry, pottery, and weaving. James developed a series of lectures on the Southwest, based on his slides, and published several books on the subject.

While still a teenager, Frederick I. Monsen assisted his father with photographic work for the Denver and Rio Grande Railroad. Recognizing that photography offered a life of adventure, young Monsen worked as an itinerant photojournalist, traveling throughout the West and accepting assignments from some of the nation's best-known photographers, including William Henry Jackson. During the 1880s Monsen worked on the survey of the U.S.-Mexican border. In 1886 he joined General Crook and General Miles in their final pursuit of the Apache. In 1891 he photographed Death Valley; in 1896 he joined the Yosemite Park Survey; and in 1894–95 he traveled to the Southwest Indian country. Monsen subsequently marketed his Indian photographs and delivered a series of illustrated lectures. Unfortunately, almost all of his work from these years was destroyed in the San Francisco fire of 1906. In fact, only two trunks filled with lantern slides and prints, which had been packed for a lecture tour, were saved. In the years after the fire, Monsen devoted most of his time and energy to lecturing. Vehemently opposed to the government's Indian policy of forced assimilation, his dominant lecture theme was "The Destruction of Our Indians." Monsen was one of the first professional photographers in Indian country to use a Kodak camera to take candid pictures of tribal life. In 1909 the Eastman Ko-

dak Company published a book of Monsen's photographs *With a Kodak in the Land of the Navajo*.

Ethnologist, adventurer, and writer Charles F. Lummis was the most productive of his generation of Southwest photographers. Between 1884 and 1925 Lummis made about ten thousand photographs of New Mexico. A Harvard classmate of Theodore Roosevelt, Lummis walked from Chillicothe, Ohio, to Los Angeles as part of his agreement to begin writing a weekly newsletter for the *Los Angeles Times*. En route he stopped in New Mexico and Arizona, where he was inspired by a vision of a new life and a new purpose: "Once I had reached Spanish America and the hearts of its people, I realized that this was where I belonged.... The World's Wonderland is not in Europe, not in Egypt, not in Asia, but in the West of our own United States. Area for area no other land on earth is half so crowded with marvels of the first magnitude and of such range —of antiquities, scenery, anthropology and picturesqueness in every sort."[5]

In 1888, at age twenty-eight, Lummis suffered a stroke, which left him partially paralyzed and unable to speak. He returned to the Southwest, stopping in northern New Mexico to photograph the Easter crucifixion rites of the Spanish-American Penitente people, then lived for four years at the Pueblo of Isleta. Partially recovered, Lummis returned to Los Angeles in 1904 and for the rest of his life worked as an impassioned crusader against the government's treatment of the Indian. A pioneer advocate of tourism in the Southwest, he edited a tourist-oriented publication, *In the Land of the Southwest*, that won nationwide recognition. Lummis founded the Southwest Museum in Pasadena and served as its director for many years.

In 1895 Adam Clark Vroman, a Pasadena bookseller, made his first trip to the Southwest. Following in the footsteps of his mentor, Charles Lummis, he visited and photographed the landmarks of the American desert and attended the Snake Dance of the Hopi. Vroman felt a magnetic attraction to the Indian world and devoted most of the next decade to photographing the Indian people of the Southwest. He rejected the image of the Indian as a savage about to receive the gift of civilization or an exotic remnant of the dying culture worthy of preservation. Vroman was one of the first of his generation to disregard all of the predominant stereotypes of the day. His photographs testify to his recognition of the Indians as intelligent, sensitive, dignified members of the human race whose cultural achievements and way of life must be recognized and respected. His interest in photography was personal rather than professional, and after 1904 he turned to Japan and East Asia, never returning to the Southwest.

In the course of the twentieth century, photographers flocked in increasing numbers to the Southwest, in search of a world that in many instances had long since vanished. It became a standard practice for Indian photographers to seek out places seemingly untouched by time, hoping to give the illusion that each one was witness to the last remnants of a pre-contact Indian world. Whenever possible, these romantic photographers, unwilling to accept contemporary change, used traditional hairdos, costumes, and artifacts to transform present reality into a fantasy of the past. The work of Edward S. Curtis offers some of the most vivid examples of this nostalgic romanticism.

Ben Wittick photographed the Indian people and desert land of the Southwest during the last quarter of the nineteenth century. By this time, romantic beliefs in a paradisiacal wilderness, a land inhabited by noble children of nature, belonged to the world of fantasy and illusion. Yet to those accustomed to images of an illusionary Indian world, Ben Wittick's shadows on glass, photographs of a world of confusion and change taken over a century ago, offer a sharp rebuttal.

Notes

◘

1. PORTRAITS OF CHANGE

[1]For example, Curtis paid several of his Northwest Coast subjects to grow mustaches so as to more closely resemble their forebears.

2. A SEARCH FOR ADVENTURE: THE LIFE OF BEN WITTICK

[1]Ben Wittick, *Washing the Snakes* unpublished (Santa Fe: Photo Archives Museum of New Mexico.)

[2]Quoted in George Wickstrom, "The Town Crier: Valuable Pioneer Pictures May Repose in Home of Famous Photographer's Son," *Rock Island Argus* (July 1942).

[3]Once, during the 1890s, Wittick returned to Moline on a provisional basis and for a few months attempted to operate a local portrait gallery and photographic shop, but his restlessness prevailed and he returned to the West.

[4]Ben Wittick to Tom Hughes, Editor, *Albuquerque Citizen*, September 6, 1890.

[5]To emphasize the average American perception of the Indian as an exotic species of American wildlife and the persistence of these stereotypes, it is important to note that the first bronze portraits of these men and women were Olin Levi Warner's portraits of Indian Chiefs, which became landmarks in the history of American sculpture. Completed between 1889 and 1891, these relief medallions were the first identifiable bronze portraits of specific Indians. Prior to this time, sculptures of Indians carried such titles as *The Savage* and *The Indian Hunter*. Out of respect to the Indian people, I have not used many of Wittick's titles as my captions and have substituted simple descriptions, e.g., *Apache Man*, *Mohave Woman*, and *Women of Isleta*.

[6]Wittick, like many of his contemporaries, used the word *Moki* when referring to the Hopi. (The Bureau of Indian Affairs' Agency on the Hopi Reservation was called the Moki Agency.) *Mókwi* (phoneticized) was the original self-designation of the Hopi people. The Spanish used the name *Moqui*, which in English became *Moki*, a word that sounded similar to the Hopi word *mó·ki*, "dies, is dead." The use of the term *Moki* deeply offended the Hopi people, but it was not until 1923 that the BIA renamed its agency and refrained from using the term. See John C. Connelly, "Hopi Social Agency, *Handbook of North American Indians*, vol. 9: *Southwest* (Washington, D.C.: Smithsonian Institution 1979), p. 551. Although Wittick uses the term *Moki* in several of his titles, out of respect to the Hopi people I use *Hopi* in my captions.

[7]Tom Wittick to "Hermano Mio" (Charlie Wittick), August 11, 1883, (Santa Fe: Photo Archives, Museum of New Mexico).

[8]Tom Wittick to "Mammy, Grandmam and the boys," January 7, 1882 (Santa Fe: Photo Archives, Museum of New Mexico).

[9]Ibid.

[10]Tom Wittick to "Charlie, Mammy, Grandmam, and the boys," April 1883 (Santa Fe: Photo Archives, Museum of New Mexico).

[11]Ibid.

[12]Ibid. Wittick's spelling of Indian names was primarily phonetic. The spelling in my text is that used by the tribal governments today; e.g., *Hualapai* rather than *Walapai*.

[13]Tom Wittick to "Hermano Mio," August 11, 1883 (Santa Fe: Photo Archives, Museum of New Mexico).

[14]Ibid.

[15]Ibid.

[16]Ibid.

[17]Ibid.

[18]Ibid.

[19]Ben Wittick to Tom Hughes, September 6, 1890 (Santa Fe: Photo Archives, Museum of New Mexico).

[20]He developed a friendship with post surgeon Robert Shufelt, who permitted him to watch several operations in order to develop an understanding of human

anatomy.

[21]Tom changed his name to Frank T. Averill, using his mother's maiden name. Known for his quick temper and restlessness, Tom drifted from town to town in search of adventure and wealth. He soon married, but his first wife died in childbirth. A hard-drinking man, Tom fell into the life of an itinerant miner. He went to work in the onyx mine in Mayer, Arizona, where he settled a card game dispute with his guns and was forced to leave town. The *Arizona Journal-Miner* on November 18, 1904, reported the incident: "A dispute over cards in Mayer has resulted in one death, one wounded, and a third on his way to Mexico (T. F. Averill)."

Tom returned to Arizona and in 1907 married his second wife, May Wickham, a Phoenix schoolteacher, and returned to work in the mine in Mayer. He was killed in a gunfight that resembled a Western melodrama. The *Arizona Journal-Miner* of September 30, 1910, carried the story: "Placer miner T. F. Averill (alias Tom Wittick, son of the famed New Mexico photographer Ben Wittick) threatened to kill bartender C. Wells, but was blast in the face with buckshot when he walked through the swinging doors of Cook Wells' saloon at Mayer. Wells was exonerated."

Tom's first child, Mary Frances, was born ten days later. His wife did not learn her husband's true identity until after his death. When her child was two months old, she returned to her family home in Dodgeville, Wisconsin, where she worked as a schoolteacher.

[22]Letter from Charles F. Lummis to Mamie Wittick Maxwell, Los Angeles, September 8, 1928.

[23]After Wittick's death, his son Charlie, confronted with countless boxes of Wittick's photographs, made an effort to sort them and sent what he believed were a few of the best to the Nevada State Museum. Showing only minimal interest in his father's lifework, he recalled that he "had thrown away skads of old pictures but there are other skads left." Quoted in George Wickstrom, "The Town Cryer."

[24]Quoted in Karen Current, *Photography and the Old West* (New York: Harry N. Abrams, 1978), p. 238.

3. THE HUALAPAI AND THE HAVASUPAI

[1]Bertha P. Dutton, *American Indians of the Southwest* (Albuquerque: University of New Mexico Press, 1983), p. 178.

[2]In the Southwest the term *Anglo* refers to any person who is neither Indian nor Hispanic.

[3]Letter from Tom Wittick to "Charlie, Mammy Grandmam and the boys," April 1883 (Santa Fe: Photo Archives, Museum of New Mexico).

[4]Ibid.

[5]Ben Wittick to Tom Hughes, September 6, 1890 (Santa Fe: Photo Archives, Museum of New Mexico).

[6]In Thomas R. McGuire "Walapai," *Handbook of North American Indians* 10, *Southwest* Smithsonian Institution (1983): 27–28.

4. THE MOHAVE

[1]Letter from Tom Wittick to Charlie Wittick (Hermano Mio) dated August 11, 1883, written in Albuquerque (Santa Fe: Photo Archives Museum of New Mexico).

[2]Ibid.

[3]Ibid.

[4]Ibid.

[5]Ibid.

[6]Ibid.

[7]The Mohave were also photographed by R. D. Heureuse in 1862 and by Alexander Gardner in 1868.

5. THE APACHE

[1]No formal portrait of Geronimo by Wittick has been located, but for many years Wittick sold the portrait of Geronimo by Jack Hillers as a Wittick photograph. Wittick had made a glass positive of an original Hillers print, which he then photographed to make the negative for his reproductions.

[2]Seven tribes belonged to the Southern Athapascan language group: the Western Apache, Chiricahua Apache, Mescalero Apache, Jicarilla Apache, Lipan Apache, Kiowa Apache, and Navajo. (The political and economic history of the Navajo differs considerably from other Athapascan-speaking tribes, and today the Navajo have established a separate identity from their Athapascan relatives.) Today linguistic relations of the Apache can be found in northwestern Canada and Alaska.

By the nineteenth century there were three primary groups of bands of Chihuahua Apache: the Central, the Southern, and the Eastern or Warm Springs groups. The Warm Springs group were called the Chihinee or Red People because of the band of red clay warriors drew across their faces. The Warm Spring Apache wore yellow buckskin bands, drawn over their right shoulder and under their left arm and fastened under the belt.

[3]The word *Apache* was first used by the Spanish in the late sixteenth century. Many believe the term derived from the Zuni word *Apachu*, meaning enemy.

[4]Carleton and the United States military were determined to abolish all Apache claims to the area. It is estimated between 1862 and 1871 the United States military spent $38,000,000, but failed to accomplish this end.

[5]De Benavides gave the group of related bands of hunters and gatherers the name

Apache de Perillo (a local landmark).

[6]The mescal plant, a species of the agave, gave the tribe its name; however, all of the Apache tribes used mescal for food.

[7]When the Chiricahua were ordered to leave their land for resettlement on the San Carlos Reservation, government officials accused the Mescalero of giving sanctuary to Victorio and his group of followers. The army took punitive action and ordered the Mescalero to Fort Stanton to surrender all arms and horses. During the next decade the Mescalero were told to share their reservation with the Jicarilla Apache, and although the present dimensions of the reservation were determined in 1883, it was not until 1922 that they were given clear title to the limited land set aside for them.

[8]Edward H. Spicer, *Cycles of Conquest* (Tucson: University of Arizona Press, 1962), p. 250.

[9]*Ibid.*, p. 251.

[10]Eve Ball, *In the Days of Victorio* (Tucson: University of Arizona Press, 1970), p. 50.

[11]The Apache leaders were also angered by the prohibition against their brewing tiswin, a native intoxicant, and the prohibition against men's cutting off the fleshy part of their wives' noses as punishment for infidelity.

6 . T H E N A V A J O

[1]Bertha P. Dutton, *American Indians of the Southwest* (Albuquerque: University of New Mexico Press, 1983), p. 65.

[2]Robert A. Roessel, Jr., *Dinétah* (Rough Rock, Ariz.: Rough Rock Demonstration School, Navajo Curriculum Center, 1983), p. 94.

[3]A Navajo tribal historian suggests that the Navajo attack on the area influenced the Spanish decision to abandon their first capital at San Gabriel and move the government center to Santa Fe.

[4]Another Spanish name for Navajo was *Querechos*, meaning "wanderers," but Benavides reported that the Navajo meant great planted fields, an observation which indicates that by this time the Navajo had a more highly developed agricultural tradition than any other Apache group.

[5]During these years the Pueblo who sought refuge with the Navajos settled in pueblitas, communities distinguished by defense walls and adobe towers that stood alongside Navajo hogans.

[6]Hostility between the Navajo and the army increased in 1849, when, during negotiations, soldiers killed Narbona, thus angering his son-in-law, War Chief Manuelito, who became one of the principal leaders of renewed animal and food raids.

[7]It is estimated that between 1846 and 1850 eight hundred thousand sheep and cattle and about twenty thousand horses and mules were reported stolen in

northwestern New Mexico. See Edward H. Spicer, *Cycles of Conquest* (Tucson: University of Arizona Press, 1962), p. 216.

[8]Dodge is credited with bringing a blacksmith into the area to teach metalworking, which he believed would develop into an important Navajo craft art.

[9]The New Mexican government made no effort to prevent the capture of the Navajo, for the use of Navajo as slaves had become well established in the area. It is estimated that five to six thousand Navajo served as slaves to New Mexican families.

[10]Ruth Roessel, ed., *Navajo Stories of the Long Walk Period* (Tsaile, Ariz.: Navajo Community College Press, 1973), pp. 103–104.

[11]Robert A. Roessel, Jr., *Pictorial History of the Navajo from 1860 to 1910* (Rough Rock, Ariz.: Rough Rock Demonstration School, Navajo Curriculum Center, 1980), pp. 23–24.

[12]Ibid., p. 24.

[13]Ruth Roessel, ed., *Navajo Studies at Navajo Community College* (1971), p. 32.

[14]The twelve Navajo leaders who signed the treaty were Manuelito, Largo, Narbono, Narbono Segundo, Ganado Mucho, Armijo, Delgado, Chiquito, Herrero, Muerta de Hombre (Biwos), and Hombro.

[15]The government spent less to feed the Navajo than the more warlike tribes that still offered the threat of raids. The rationalization was that it was cheaper to feed the more hostile tribes than fight them. In 1880 the Navajo received $0.39 per capita value of foodstuffs per year, while the San Carlos Apache received $34.61 of food. See Robert A. Roessel, Jr., *Pictorial History of the Navajo from 1860 to 1910*, p. 69.

[16]By 1877, the year before Wittick came to the area, there were six trading posts on the Reservation.

7 . T H E P U E B L O S O F A C O M A , L A G U N A , A N D I S L E T A

[1]In 1863 Lincoln ordered black ebony canes with silver tops inscribed "A. Lincoln" to be presented to each of the nineteen Pueblos as a reward to the Indians for maintaining neutrality during the Civil War. To this day, a Lincoln cane is a symbol of authority at these pueblos.

[2]Six years earlier, on his trip across the Southwest, William Henry Jackson had attempted to photograph the Acoma Pueblo, but his decision to use a new and still experimental dry-plate process, to avoid developing his work in the field, proved to be one of the most costly mistakes of his career. Upon his return to Washington, he discovered that he did not have a single image of the Acoma Pueblo. Every one of his plates was blank.

[3]For centuries the Acoma women have won praise for their thin glazed pottery with intricate symbolic geometric designs. Acoma pottery is distinguished

from Zuni pottery by use of volcanic ash to temper the clay.

[4] The name *Acoma* or *Acu* has no meaning in the contemporary Acoma language; however, *Haku* means "place of preparedness."

[5] George P. Winship, "The Coronado Expedition, 1540-1542." *14th Annual Report of the Bureau of American Ethnology for the years 1892–1893* Part 1 (1896), pp. 490–91.

[6] Velma Garcia-Mason, "Acoma Pueblo," *Southwest*, vol. 9, *Handbook of North American Indians* (1979), p. 457.

[7] Today the majority of the Acoma people make their winter homes in the area surrounding the mesa, but the ancient village atop the mesa remains their ceremonial home.

[8] The land dispute between the Acoma people and the United States was not decided until 1928, when the United States issued an Executive Order restoring over 151,000 additional acres of Acoma land. However, the government allocated 258.6 acres within the Acoma territory to the Atchison, Topeka and Santa Fe Railroad.

[9] The name *Isleta* dates back to the Spanish mission San Antonio de la Isleta (Saint Anthony of the Little Island), founded in the seventeenth century and abandoned in 1681. The mission was renamed San Agustin de la Isleta when it was refounded in 1681. The original name was given to the Pueblo near El Paso, which was founded by a group that fled south from the original Pueblo in 1681.

[10] The inhabitants of the Taos and Picuris Pueblos speak a northern Tiwa language, whereas the inhabitants of the Sandia Pueblo and the Isleta Pueblo speak a southern Tiwa language.

[11] Mesita and the neighboring village of Paraje did not become permanent settlements until the late nineteenth century, when there was no longer a threat from raids from neighboring nomadic tribes. Until this time both Acoma and Laguna sheep and horses had been the target of Apache raids in the south and Navajo raids in the north.

8 . THE ZUNI

[1] At the time of Reconquest (1692) the Zuni of Dowa Yalanne, one of the six historic Zuni villages, were the only Pueblo people to preserve Catholic ritual objects.

[2] The Spanish did not introduce silversmithing directly to the Zuni. It is believed that the first Zuni silversmith learned his craft from a Navajo who visited the Pueblo in 1872.

[3] In 1889 a dispute between the Zuni and the Anglos over the Anglo theft of Zuni horses ended in a shoot-out in which five Zunis were killed by ranchers. In contrast with the usual Indian-army scenario, the Zuni called in the government troops at Fort Wingate, who took the horse thieves to prison.

[4] During his years in the Southwest Wittick became friends with Matilda Stevenson. She appears in several of his expeditionary photographs. Matilda Steven-

son visited the Zuni Pueblo many times during her husband's life and after his death worked for the Bureau of American Ethnology, where she concentrated on the study of Zuni ceremonial life. When Wittick first visited the Zuni, Cushing was in residence at the Pueblo, living in the Governor's house.

[5] In 1884 Senator John A. Logan of Illinois succeeded in having Cushing recalled to Washington for opposing a group of Anglos (including the senator's son-in-law) who had attempted to take over Zuni land for a cattle ranch.

[6] For a year prior to the ceremony the Koyemshi are involved in religious and household activities. Those whose houses are to be blessed must feed and provide all of the necessities for the Koyemshi.

[7] The Bureau of Indian Affairs recorded fourteen witchcraft trials between 1880 and 1900.

[8] Nevertheless, the search for witches continued at the Pueblo, and the last public witch trial was in 1925. Even today the belief persists that witches are a fundamental cause of misfortune.

9 . THE HOPI

[1] In 1719 the king of Spain, disappointed that the Franciscans had failed to convert the Hopi, gave jurisdiction over the Province of Tusayan, the district of the Mesas, to Jesuits, who made little effort to succeed in their new mission. Despite several attempts to communicate with the Hopi, they were never able to reach the Mesas, while the Franciscans, hoping to win back jurisdiction over the Hopi, submitted false reports of winning thousands of converts. In 1744 the king reversed his decision and supported the Franciscans' claim to the district.

Father Silvestre Velez Escalante passed through the Hopi region in 1775, en route to the Colorado River. He determined that only a military action would bring success with the Hopi. The Hopi openly rejected Father Francisco Garcés in 1776, and in 1780 they refused to negotiate with Governor Juan Bautista de Anza, who later became the founder of San Francisco.

[2] Anglo-Hopi relations deteriorated in 1864, when, during a period of drought, Hopi delegates went to the capital of the new Arizona Territory to request help and were jailed. Following the drought, a smallpox epidemic drastically reducéd the Hopi population and forced several families to take residence at Zuni.

[3] From January to May 1895, Lomahongyoma and a group of Hostile leaders were imprisoned at Alcatraz for their protest against the Land Allotment Act. Once released, they returned to the Mesas, determined to resist all attempts to legitimize the presence of the Anglos or impose governmental or educational changes. Land allotment was never carried out on the Hopi Reservation, and

the program was abandoned in 1911.

[4]The Superintendent from Keams Canyon arrested the Hostile men and sentenced them to a year in prison, then sent Friendly leaders to a government school in Riverside, California, to learn "civilized behavior." The Friendlies returned to Oraibi determined to maintain the traditions of their ancestors. For many years Anglos were forbidden to enter Oraibi.

[5]The treaty did not name the Hopi but was worded "For whatever tribes the Secretary of Interior might designate."

[6]The first resident anthropologist, Alexander M. Stephen, arrived in 1880.

[7]In 1893 Hopi leaders protested the exhibition by Thomas Keam and his associates of sacred Hopi ceremonial objects at the World's Columbian Exposition at Chicago.

[8]Historically, First Mesa, the easternmost mesa, had been the most receptive to contact with the Anglo world. During the twentieth century the women of First Mesa, following in Nampeyo's footsteps, became world famous for their trade pottery.

[9]The village elders, angered by the use of sacred images for secular purposes, severely criticized the painters and condemned their work. After the Fewkes commission, all four men ended their careers as commercial artists.

[10]Occasionally permission was granted to a special friend or for a special project.

APPENDIX
PIONEERS OF FRONTIER
PHOTOGRAPHY

[1]This chapter offers only the briefest overview. For a full discussion of the history of photography see books listed in the bibliography.

[2]Collodion, a solution of gun cotton in ether and alcohol, was discovered in 1847 and first used as a protective coating for wounds. In the photographic process collodion forms a film on the glass plate.

[3]First called the Union Pacific Railroad, Eastern Division.

[4]The new dry-plate process was known as "sensitive negative tissue," which came in rolls of twenty-four 8 x 10-inch exposures.

[5]Karen Current, *Photography and the Old West* (1978), p. 228.

Bibliography

◘

Frontier photography

Andrews, Ralph W. *Photographers of the Frontier West: Their Lives and Works, 1875 to 1915*. New York: Bonanza Books, 1965.

Blackman, Margaret B. *The Northern and Kaigani Haida: A Study in Photographic Ethnohistory*. Ph.D. diss., Ohio State University, 1973.

Blodgett, Richard. *Photographs: A Collector's Guide*. New York: Ballantine Books, 1979.

Brown, Mark H., and W. R. Felton. *Before Barbed Wire*. New York: Bramhall House, 1956.

———. *The Frontier Years*. New York: Bramhall House, 1955.

Bry, Doris. *Alfred Stieglitz: Photographer*. Boston: Museum of the Arts, 1965.

Caffin, Charles H. *Photography as a Fine Art*. Hastings-on-Hudson, N.Y.: Morgan and Morgan, 1971.

Casagrande, Louis B., and Phillips Bourns. *Side Trips: The Photography of Sumner W. Matteson, 1898–1908*. Milwaukee: Milwaukee Public Museum, 1983.

Coke, Van Deren. *Photography in New Mexico: From the Daguerreotype to the Present*. Albuquerque: University of New Mexico Press, 1979.

———. *The Painter and the Photograph from Delacroix to Warhol*. Albuquerque: University of New Mexico Press, 1964.

Coles, Robert. *The Old Ones of New Mexico*. Albuquerque: University of New Mexico Press, 1973.

Current, Karen. *Photography and the Old West*. New York: Harry N. Abrams, 1978.

Curtis, Edward S. *In a Sacred Manner We Live: Photographs of the North American Indian*. New York: Weathervane Books, 1972.

———. *Portraits from North American Life*. Introductions by A. D. Coleman and T. C. McLuhan. New York: Promontory Press, 1972.

———. *The North American Indian: Being a Series of Volumes Picturing and Describing the Indians of the United States, and Alaska*. Edited by Frederick W. Hodge. 20 vols. Norwood, Mass.: Plimpton Press, 1907–30. Reprint. New York: Johnson Reprint, 1970.

Dennis, Landt, and Lisl Dennis. *Collecting Photographs: A Guide to the New Art Boom*. New York: E. P. Dutton, 1977.

Doty, Robert. *Photo-Secession: Stieglitz and the Fine-Art Movement in Photography*. New York: Dover Publications, 1978.

Fiske, Turbé L., and Keith Lummis. *Charles F. Lummis: The Man and His West*. Norman: University of Oklahoma Press, 1975.

Frederick Monsen at Hopi. Santa Fe: Museum of New Mexico, 1979.

Heski, Thomas M. *"Icastinyanka Cikala Hanzi" (The Little Shadow Catcher)*. Seattle: Superior Publishing Company, 1978.

Hoobler, Dorothy, and Thomas Hoobler. *Photographing the Frontier*. New York: G. P. Putnam's Sons, 1980.

Horan, James D. *Mathew Brady: Historian with a Camera*. New York: Bonanza Books, 1955.

Images of the Southwest: Photographs of the American Indian. St. Paul: Kramer Gallery and Studio, 1980.

Jackson, Clarence S. *Picture Maker of the Old West: William H. Jackson*. New York: Bonanza Books, 1947.

Mahood, Ruth I., ed. *Photographer of the Southwest: Adam Clark Vroman, 1856–1916*. Los Angeles: Ward Ritchie Press, 1974.

McLuhan, T. C. *Touch the Earth: A Self-Portrait of Indian Existence*. New York: Promontory Press, 1971.

Meier, Peg, comp. *Bring Warm Clothes: Letters and Photos from Minnesota's Past*. Minneapolis: Minneapolis Star and Tribune Company, 1981.

Newhall, Beaumont. *The Daguerreotype in America*. New York: Dover

Publications, 1976.

———. *The History of Photography: From 1839 to the Present Day.* New York: Museum of Modern Art, 1964.

Olivas, Arthur, Richard Rudisill, and Marcus Zafarano, comps. *The Portrait.* Santa Fe: Museum of New Mexico, 1980.

Rudisill, Richard, comp. *Photographers of the New Mexico Territory: 1854–1912.* Santa Fe: Museum of New Mexico, 1973.

Sarber, Mary A. *Photographs from the Border: The Otis A. Aultman Collection.* El Paso: El Paso Public Library Association, 1977.

Snyder, Joel. *American Frontiers: The Photographs of Timothy H. O'Sullivan, 1867–1874.* Millerton, N.Y.: Aperture, 1981.

Sturhahn, Joan. *Carvalho: Artist—Photographer—Adventurer—Patriot.* Merrick, N.Y.: Richwood Publishing Co., 1976.

Taft, Robert. *Photography and the American Scene: A Social History, 1839–1899.* New York: Dover Publications, 1964.

Webb, William, and Robert A. Weinstein. *Dwellers at the Source: Southwestern Indian Photographs of A.C. Vroman, 1895–1904.* New York: Grossman, 1973.

General History

Bancroft, Hubert H. *History of Arizona and New Mexico, 1530–1888.* San Francisco: History Company, 1889. Reprinted. Albuquerque: Horn and Wallace, 1962.

Bandelier, Adolph F. A. *A History of the Southwest: A Study of the Civilization and Conversion of the Indians in Southwestern United States and Northwestern New Mexico from the Earliest Times to 1700.* Vol. 1, *A Catalogue of the Bandelier Collection in the Vatican Library.* Rome and St. Louis: Jesuit Historical Institute, 1969.

Beebe, Lucius, and Charles Clegg. *The American West: The Pictorial Epic of a Continent.* New York: E. P. Dutton, 1955.

Benedict, Ruth. *Patterns of Culture.* Boston and New York: Houghton Mifflin, 1934.

Bolton, Herbert E. *Coronado on the Turquoise Trail: Knight of the Pueblos and Plains.* Albuquerque: University of New Mexico Press; New York: McGraw-Hill, 1949.

Coues, Elliott, ed. and trans. *On the Trail of a Spanish Pioneer; The Diary and Itinerary of Francisco Garces.* New York: F. P. Harper, 1900.

Dale, Edward E. *The Indians of the Southwest: A Century of Development Under the United States.* Norman: University of Oklahoma Press, 1949.

Dozier, Edward P. *The Pueblo Indians of North America.* New York: Holt, Rinehart, and Winston, 1970.

Dutton, Bertha P. *American Indians of the Southwest.* Albuquerque: University of New Mexico Press, 1983.

———. *Indians of the American Southwest.* Englewood Cliffs, N.J.: Prentice-Hall, 1975.

Espinosa, Manuál J., ed. *Crusaders of the Rio Grande. The Story of Don Diego de Vargas and the Reconquest and Refounding of New Mexico.* Chicago: Institute of Jesuit History, 1942.

Frazer, Robert W. *Forts of the West: Military Forts and Presidios, and Posts Commonly Called Forts, West of the Mississippi River, to 1898.* Norman: University of Oklahoma Press, 1965.

Hall-Quest, Olga (Wilbourne). *Conquistadors and Pueblos: The Story of the American Southwest, 1540–1848.* New York: E. P. Dutton, 1969.

Hammond, George P., and Agapito Rey, eds. and trans. *The Rediscovery of New Mexico, 1580–1594: The Explorations of Chamuscado Espejo Castaño, Je Susa Morlete and Leyva de Bonilla and Humana.* Albuquerque: University of New Mexico Press, 1966.

———. *Don Juan de Oñate, Colonizer of New Mexico, 1595–1628.* Albuquerque: University of New Mexico Press, 1953.

———. *Narratives of the Coronado Expedition, 1540–1542.* Albuquerque: University of New Mexico Press, 1940.

James, G. Wharton. *The Indians of the Painted Desert Region: Hopis, Navahos, Wallapais, Havasupais.* Boston: Little, Brown, 1903.

Josephy, Alvin M., Jr. *The Indian Heritage of America.* New York: Alfred A. Knopf, 1968.

———. *The American Heritage Book of Indians.* New York: American Heritage Publishing Company, 1961.

Kessell, John L. *Friars, Soldiers and Reformers: Hispanic Arizona and the Sonora Mission Frontier, 1767–1856.* Tucson: University of Arizona Press, 1976.

La Farge, Oliver. *A Pictorial History of the American Indian.* New York: Crown Publishers, 1956.

Riley, Glenda. *Women and Indians on the Frontier, 1825–1915.* Albuquerque: University of New Mexico Press, 1984.

Spencer, Robert F., and Jesse Jennings. *The Native Americans: Prehistory and Ethnology of the North American Indians.* New York: Harper and Row, 1965.

Spicer, Edward H. *A Short History of the Indians of the United States.* New York: Van Nostrand Reinhold, 1969.

———. *Cycles of Conquest: The Impact of Spain, Mexico, and the United*

States on the Indians of the Southwest, 1533–1960. Tucson: University of Arizona Press, 1962.

———. *Perspectives in American Indian Culture Change*. Chicago: University of Chicago Press, 1961.

Sturtevant, William C., ed. *Handbook of North American Indians*. Vol. 10, *Southwest*. Washington, D.C.: Smithsonian Institution, 1983.

Biography

Arizona Journal-Miner, October 5, 1904 (Description of death of Tom Wittick).

"Ben Wittick Views the Pueblo." *El Palacio* 73 (Summer 1966): 4–9.

Olivas, Arthur, photo archivist. *The Wittick Collection*. Vol. 1. Santa Fe: Museum of New Mexico, 1971.

Packard, Gar, and Maggy Packard. *Southwest 1880 with Ben Wittick Pioneer Photographer of Indian and Frontier Life*. Santa Fe: Packard Publications, 1970.

Van Valkenburgh, Richard. "Ben Wittick…Pioneer Photographer of the Southwest." *Arizona Highways* 18 (August 1942): 36–39.

Wickstrom, George. "Valuable Pioneer Pictures May Repose in Home of Famous Photographer's Son," *Rock Island Argus*, July 1942.

Wittick, Ben. "Washing the Snakes." Unpublished manuscript in the Photographic Archives of the Museum of New Mexico, Santa Fe.

Wittick, Tom. "An 1883 Expedition to the Grand Canyon: Pioneer Photographer Ben Wittick Views the Marvels of the Colorado." Introduction by Terence Murphy. *The American West* 10 (March 1973): 38–47.

Hualapai

Dobyns, Henry F., and Robert C. Euler. *The Walapai People*. Phoenix: Indian Tribal Series, 1976.

Iliff, Flora G. *People of the Blue Water: My Adventures Among the Walapai and Havasupai Indians*. New York: Harper and Brothers, 1954.

Havasupai

Breed, Jack. "Land of the Havasupai." *National Geographic* 93 (May 1948): 655–74.

Collins, George L. "People of the Blue-Green Water." *Arizona Highways* 12 (May 1936): 2–3.

Cushing, Frank Hamilton. "The Nation of the Willows." *Atlantic Monthly* 50 (October 1882): 541–59.

———. "The Nation of the Willows." *Atlantic Monthly* 50 (September 1882): 362–74.

Dobyns, Henry F., and Robert C. Euler. *The Havasupai People*. Phoenix: Indian Tribal Series, 1971.

———. *Wauba Yuma's People: The Comparative Socio-Political Structure of the Pai Indians of Arizona*. Prescott, Ariz.: Prescott College Press, 1970.

Hirst, Stephen. *Havasuw' Banja: People of the Blue Green Water*. Supai, Ariz.: Havasupai Tribe, 1985.

———. *Life in a Narrow Place*. Photographs by Terry Eiler and Lyntha Eiler. New York: David McKay, 1976.

Iliff, Flora Gregg. *People of the Blue Water*. New York: Harper and Brothers, 1954.

Martin, John F. *The Havasupai*. Flagstaff, Ariz.: Museum of Northern Arizona, 1986.

———. "Continuity and Change in Havasupai Social and Economic Organization." Ph.D. diss. Chicago: University of Chicago, 1966.

Schroeder, A. L. "A Brief History of Havasupai." *Plateau* 25 (January 1953): 45–52.

Schwartz, Douglas W. "The Havasupai 600 A.D.–1955 A.D.: Short Culture History." *Plateau* 28 (1955): 77–85.

Smithson, Carma Lee. *The Havasupai Woman*. University of Utah Anthropological Paper 68. Salt Lake City: University of Utah, 1964.

Spier, Leslie. "The Havasupai of Cataract Canyon. *American Museum Journal* 18 (1918): 637–45.

Stegner, Wallace Earle. "Packhorse Paradise." *Atlantic Monthly* 180 (September 1947): 21–26.

Wampler, Joseph. *Havasu Canyon: Gem of the Grand Canyon*. Berkeley, Calif.: Howell-North Press, 1959.

Weber, Steven A., and David Seaman, eds. *Havasupai Habitat: A.F. Whiting's Ethnology of a Traditional Indian Culture*. Tucson: University of Arizona Press, 1985.

Mohave

Devereux, George. "Mohave Chieftainship in Action: A Narrative of the First Contacts of the Mohave Indians with the United States." *Plateau* 23 (January 1951): 33–43.

Kroeber, Alfred L. *Handbook of the Indians of California*. Bureau of American Ethnology Bulletin 18. Washington, D.C.: Smithsonian Institution, 1925. Reprinted in 1953.

Sherer, Lorraine M. "Great Chieftains of the Mojave Indians." *Southern California Quarterly* 48 (1966).

Stewart, Kenneth M. "A Brief History of the Mohave Indians Since 1850." *The Kiva* 34 (1969): 219–36.

Taylor, Edith S., and William W. Wallace. "Mohave Tattooing and Face-painting." *MasterKey* 21 (1947): 183–95.

Apache

Baldwin, Gordon C. *The Warrior Apaches: The Story of the Chiricahua and Western Apaches.* Tucson, Ariz.: Dale Stuart King, 1965.

Ball, Eve. *In the Days of Victorio.* Tucson: University of Arizona Press, 1970.

Basso, Keith H., ed. *Western Apache Raiding and Warfare: From Notes of Grenville Goodwin.* Tucson: University of Arizona Press, 1971.

Bender, Averam B. "A Study of Mescalero Indians, 1846–1880." *American Indian Ethnohistory: Indians of the Southwest.* New York: Garland, 1974, pp. 61–279 in *Apache Indians*, vol XI.

———. "A Study of Western Apache Indians, 1846–1886." *American Indian Ethnohistory: Indians of the Southwest.* New York: Garland, 1974, pp. 9–15 in *Apache Indians*, Vol. V.

Bouke, John G. *On the Border with Crook.* Lincoln: University of Nebraska Press, 1971.

———. *An Apache Campaign in the Sierra Madre: An Account of the Expedition in Pursuit of the Hostile Chiricahua Apaches in the Spring of 1883.* New York: Charles Scribner's Sons, 1958.

Colyer, Vincent. "Report on the Apache Indians of Arizona and New Mexico." *Report of the Commissioner of Indian Affairs for the Year 1871.* Washington, D.C.: U.S. Government Printing Office, 1872, pp. 41–68.

Crook, George. *General George Crook: His Autobiography.* Edited by Martin F. Schmitt. Norman: University of Oklahoma Press, 1946.

Davis, Britton. *The Truth About Geronimo.* Edited by M. M. Quaife. New Haven, Conn.: Yale University Press, 1963.

Debo, Angie. *Geronimo: The Man, His Time, His Place.* Norman: University of Oklahoma Press, 1976.

Dutton, Bertha P. *Navahos and Apaches: The Athapascan Peoples.* Englewood Cliffs, N.J.: Prentice-Hall, 1976.

Forbes, Jack D. *Apache, Navaho, and Spaniard.* Norman: University of Oklahoma Press, 1960.

Mails, Thomas. *The People Called Apache.* Englewood Cliffs, N.J.: Prentice-Hall, 1974.

Miles, Nelson A. *Prsonal Recollections and Observations of General Nelson A. Miles, Embracing a Brief View of the Civil War, or From New England to the Golden Gate and the Story of His Indian Campaigns with Comments on the Exploration, Development and Progress of Our Great Western Empire.* Chicago: Werner Company, 1896.

Moorhead, Max L. *The Apache Frontier: Jacobo Ugarte and Spanish-Indian Relations in Northern New Spain, 1769–1791.* Norman: University of Oklahoma Press, 1968.

New Mexico Lifeways: The Apache Indians. Santa Fe: Museum of New Mexico, 1983.

"An Outline of Chiricahua Apache Social Organization." *Social Anthropology of North American Tribes.* Edited by Fred Eggan. Chicago: University of Chicago Press, 1937. Reprinted in 1955.

Sonnichsen, C. L. *The Mescalero Apaches.* Norman: University of Oklahoma Press, 1958.

Thrapp, Dan. L. *The Conquest of Apacheria.* Norman: University of Oklahoma Press, 1967.

Worcester, Donald E. *The Apaches: Eagles of the Southwest.* Norman: University of Oklahoma Press, 1979.

Navajo

Begay, Shirley M. *Kinaaldá: A Navajo Puberty Ceremony.* Rough Rock, Ariz.: Rough Rock Demonstration School, Navajo Curriculum Center, 1983.

Brugge, David M. *Long Ago in Navajoland.* Navajoland Publication Series 6. Window Rock, Ariz.: 1965.

Bulow, Ernest L. *Navajo Taboos.* Gallup, N.M.: The Southwesterner Books, 1982.

Correll, J. Lee. *Through White Men's Eyes: A Contribution to Navajo History.* 6 vols. Window Rock, Ariz.: Navajo Heritage Center, 1979.

Frink, Maurice. *Fort Defiance and the Navajos.* Boulder, Colo.: Pruett Press, 1968.

Gilpin, Laura. *The Enduring Navaho.* Austin: University of Texas Press, 1968.

Grant, Campbell. *Canyon de Chelly: Its People and Rock Art.* Tucson: University of Arizona Press, 1978.

Hoffman, Virginia, and Broderick H. Johnson. *Navajo Biographies.* Rough Rock, Ariz.: Rough Rock Demonstration School, Navajo Curriculum Center, 1970.

Link, Martin A., ed. *Navajo: A Century of Progress, 1868–1968.* Window Rock, Ariz.: Navajo Tribe, 1968.

McNitt, Frank. "The Long March: 1863–1867." *The Changing Ways of*

Southwestern Indians: A Historic Perspective. Edited by Albert H. Schroeder. Glorieta, N.M.: Rio Grande Press, 1973, pp. 145–69.

———. *Navajo Wars: Military Campaigns, Slave Raids, and Reprisals.* Albuquerque: University of New Mexico Press, 1972.

Navajos and World War II. Tsaile, Ariz.: *Navajo Community College Press,* 1977.

New Mexico Lifeways: The Navajo Indians. Santa Fe: Museum of New Mexico, 1983.

O'Bryan, Aileen. *The Dîné: Origin Myths of the Navajo Indians.* Bureau of American Ethnology Bulletin 163. Washington, D.C.: U.S. Government Printing Office, 1956.

Perceval, Don. *A Navajo Sketch Book.* Flagstaff, Ariz.: Northland Press, 1962.

Robinson, Dorothy F. *Navajo Indians Today.* San Antonio: Naylor Company, 1972.

Roessel, Robert A., Jr. *Dinétah. Navajo History,* vol. 2. Rough Rock, Ariz.: Rough Rock Demonstration School, Navajo Curriculum Center, 1983.

———. *Pictorial History of the Navajo Nation from 1860 to 1910.* Rough Rock, Ariz.: Rough Rock Demonstration School, Navajo Curriculum Center, 1980.

Roessel, Ruth. *Women in Navajo Society.* Rough Rock, Ariz.: Navajo Resource Center, 1981.

———. ed. *Navajo Stories of the Long Walk Period.* Tsaile, Ariz.: Navajo Community College Press, 1973.

Stories of Traditional Navajo Life and Culture. Tsaile, Ariz.: Navajo Community College Press, 1977.

Thompson, Gerald. *The Army and the Navajo: The Bosque Redondo Reservation Experiment, 1863–1868.* Tucson: University of Arizona Press, 1976.

Underhill, Ruth M. *The Navajos.* Norman: University of Oklahoma Press, 1956, revised 1967.

Yazzie, Ethelou, ed. *Navajo History.* Many Farms, Ariz.: Navajo Community College Press, 1971.

Pueblo

Ellis, Florence (Hawley). "Pueblo Witchcraft and Medicine." *Systems of North American Witchcraft and Sorcery.* Edited by Deward E. Walker, Jr. *Anthropologial Monograph of the University of Idaho.* Moscow: 1970.

French, David H. *Factionalism in Isleta Pueblo.* Monograph of the American Ethnological Society 14. Seattle: 1948. Reprint. Norman: University of Oklahoma Press, 1966.

Harvey, Byron, III. "Masks at a Maskless Pueblo: The Laguna Colony Kachina Organization at Isleta." *Ethnology* 2 (1963): 478–89.

Minge, Ward A. *Acoma: Pueblo in the Sky.* Albuquerque: University of New Mexico Press, 1976.

Parsons, Elsie Clews. *Pueblo Indian Religion.* 2 vols. Chicago: University of Chicago Press, 1939.

———. "The Laguna Migration to Isleta." *Anthropologist* 30 (1928): 602–13.

Sedgwick, Mary K. (Rice). *Acoma, the Sky City: A Study in Pueblo Indian History and Civilization.* Cambridge, Mass.: Harvard University Press, 1926.

Simmons, Marc. *Witchcraft in the Southwest: Spanish and Indian Supernaturalism on the Rio Grande.* Flagstaff, Ariz.: Northland Press, 1974.

Tyler, Hamilton A. *Pueblo Gods and Myths.* Norman: University of Oklahoma Press, 1964.

White, Leslie A. "The Acoma Indians." *47th Annual Report of the Bureau of American Ethnology for the Years 1929–1930.* Washington: 1932, pp. 17–192. Reprint. Glorieta, N.M.: Rio Grande Press, 1973.

Zuni

Bunzel, Ruth L. "Introduction to Zuñi Ceremonialism." *47th Annual Report of the Bureau of Ethnology for the Years 1929–1930.* Washington, D.C.: 1932, pp. 467–544.

———. "Zuñi Katcinas." *47th Annual Report of the Bureau of American Ethnology for the Years 1929–1930.* Washington, D.C.: 1932, pp. 837–1086.

———. "Zuñi Origin Myths." *47th Annual Report of the Bureau of Ethnology for the Years 1929–1930.* Washington, D.C.: 1932, pp. 545–609.

———. "Zuñi Ritual Poetry." *47th Annual Report of the Bureau of Ethnology for the Years 1929–1930.* Washington, D.C.: 1932, pp. 611–835.

Crampton, C. Gregory. *The Zunis of Cibola.* Salt Lake City: University of Utah Press, 1977.

Cushing, Frank H. *My Adventures in Zuñi (1882).* Santa Fe, N.M.: Peripatetic Press, 1941. Reprint. Palo Alto, Calif.: American West Publishing Company, 1970.

Stevenson, Matilda Coxe. "The Zuni Indians: Their Mythology, Esoteric Fraternities, and Ceremonies." *23d Annual Report of the Bureau of American Ethnology for the Years 1901–1902.* Washington, D.C.: 1904, pp. 3–634.

Walker, Willard. "Palowahtiwa and the Economic Redevelopment of Zuni Pueblo." *Ethnohistory* 21 (1974): 65–75.

Zuni: The Art and the People. 3 vols. Dallas: Taylor Publishing Company, 1975.

Hopi

Colton, Harold S. *Hopi Kachina Dolls, With a Key to Their Identification.* Albuquerque: University of New Mexico Press, 1949, 1959.

Courlander, Harold. *The Fourth World of the Hopis.* New York: Crown Publishers, 1971.

Dockstader, Frederick J. "The Kachina and the White Man." *Cranbrook Institute of Science Bulletin.* Bloomfield Hills, Mich., 1954. Revised edition. Albuquerque: University of New Mexico Press, 1985.

Dorsey, George A., and Henry R. Voth. *The Mishongnovi Ceremonies of the Snake and Antelope Fraternities.* Field Museum of Natural History Publication 66, Anthropological Series. Chicago: 1902.

———. *The Oraibi Soyal Ceremony.* Field Museum of Natural History Publication 55, Anthropological Series 3. Chicago: 1902.

Forrest, Earle R. *The Snake Dance…of the Hopi Indians.* Los Angeles: Westernlore Press, 1961.

Hackett, Charles Wilson. *The Revolt of the Pueblo Indians of New Mexico and Otermin's Attempted Reconquest, 1680–1682.* 2 vols. Albuquerque: University of New Mexico Press, 1942.

Hammond, George P., and Agapito Rey. *The Rediscovery of New Mexico, 1580–1594.* Albuquerque:University of New Mexico Press, 1966.

James, Harry C. *Pages from Hopi History.* Tucson: University of Arizona Press, 1974.

Lummis, Charles F. *Bullying the Moqui.* Prescott, Ariz.: Prescott College Press, 1968.

"Moqui Indians of Arizona and Pueblo Indians of New Mexico." *Extra census Bulletin.* U.S. Census Office. Eleventh Census of the United States. Washington, D.C.: U.S. Government Printing Office, 1893.

Nequatewa, Edmund. *Truth of a Hopi: Stories Related to the Origin, Myths, and Clan Histories of the Hopi.* Flagstaff, Ariz.: Northland Press, 1967.

O'Kane, Walter Collins. *The Hopis: Portrait of a Desert People.* Norman: University of Oklahoma Press, 1953.

———. *Sun in the Sky.* Norman: University of Oklahoma Press, 1950.

Parsons, Elsie Clews. *Pueblo Indian Religion.* 2 vols. Chicago: University of Chicago Press, 1939.

Qoyawayma, Polingaysi (Elizabeth White). *No Turning Back.* Albuquerque: University of New Mexico Press, 1964.

Spicer, Edward H. *Cycles of Conquest: The Impact of Spain, Mexico, and the United States on the Indians of the Southwest, 1533–1960.* Tucson: University of Arizona Press, 1962.

Stephen, Alexander M. *Hopi Journal of Alexander M. Steven.* Edited by Elsie C. Parsons. 2 vols. Columbia University Contributions to Anthropology 23. New York: 1936.

Talayesva, Don C. *Sun Chief: The Autobiography of a Hopi Indian.* Edited by Leon W. Simmons. New Haven, Conn.: Yale University Press, 1963.

Thomson, Laura. *Culture in Crisis: A Study of the Hopi Indian.* New York: Harper and Brothers, 1950.

Titiev, Mischa. *The Hopi Indians of Old Oraibi.* Ann Arbor: University of Michigan Press, 1972.

———. *Old Oraibi: A Study of the Hopi Indians of Third Mesa.* Papers of the Peabody Museum of American Archaeology and Ethnology, Harvard University 22 Cambridge, Mass.: 1944.

Index

Note: Italic page numbers refer to illustrations